Postcards from Vermont

Postcards from Vermont

A Social History, 1905–1945

Allen F. Davis

UNIVERSITY PRESS OF NEW ENGLAND HANOVER AND LONDON

University Press of New England, Hanover, NH 03755

© 2002 by Allen F. Davis

All rights reserved

Printed in the United States of America

5 4 3 2 1

Library of Congress Cataloging-in-Publication Data

Davis, Allen Freeman, 1931–

 Postcards from Vermont : a social history, 1905–1945 / Allen F. Davis.

 p. cm.

 ISBN 1–58465–158–X (pbk. : alk. paper)

 1. Vermont—Social life and customs—20th century. 2. Vermont—

History—20th century. 3. Vermont—Social life and customs—

20th century—Pictorial works. 4. Postcards—Social aspects—

Vermont—History—20th century. 5. Postcards—Vermont.

F54 .D38 2001

974.3'043—dc21 2001005973

contents

Preface

This is a book about postcards and about Vermont, but it is not the usual book about either. It uses postcards to tell various aspects of the social and cultural history of Vermont from about 1905 to 1945, but in no sense is it a comprehensive history of the state during that time. Politics and religion, for example, play only background roles in this study, but the economic structure gets more attention than elections. My focus is on the postcards and on what they can tell us about a particular time, and how they illustrate the cultural revolution that was going on in Vermont and the nation in the first decades of the twentieth century.

On one level this is a Vermont family album. It is filled with photographs of ordinary people who look out at us from the past. There are a few celebrities in this book, Theodore Roosevelt, Charles Lindbergh, and Calvin Coolidge, but most of the people are unknown and unnamed. We see them working, walking, and playing. They are driving horse-drawn vehicles and automobiles. Most of the people are carefully posed by the photographers, but some are caught off guard. Their body language, and their facial expressions are captured by the camera at a particular moment, and now that moment is preserved. It is hard to imagine that many of the children looking out from these postcards would now be over 100 years old. What kind of lives did they live after these photographs were taken?

On another level this is a Vermont memory book. It is organized topically, but it also charts change over time. It documents the transition from the horse to the automobile. It explores the changing look of the landscape, and the altered appearance of Main Street. It records the

clothes, the hats, the material culture, and the vernacular architecture from another era. It is easy to assume that nothing happened before our memory, or that familiar scenes always looked approximately the way they do today. By studying these postcards we can extend and expand our memory, and relate places and events to the stories told us by our parents and grandparents. Vermont looked different in 1910 or 1930 than it does today. One of the fascinating benefits of studying old photos is that we can see a street before a building burned or was torn down, before a road was paved or trees removed. And it is fun to study the look of clothes, hats, and cars from another era.

Vermont is often pictured as a special world of rolling green hills, peaceful villages nestled under the mountains, well-kept farms, and neat white houses, symbolizing a world in harmony. There is a certain truth to the image, and postcards, which often depicted an ideal and tranquil world, a world as "pretty as a postcard," helped to create the image. But postcards also reveal another side to Vermont's history, a world of industrialism, of gritty cities and towns, of disasters and accidents, of work as well as play. Throughout the book I try to relate the myth to the reality, the ideal to the real.

This is a serious book, based on considerable scholarship, but it has no footnotes and only selected references. It is meant to be savored and enjoyed by all those who love Vermont , and by those who are fascinated by old postcards. It can be read from beginning to end, but it also can be picked up at any point because many of the postcards can be appreciated as separate portraits, even as art. The brief introduction to each chapter and the captions are designed to provide a context for understanding the postcards, but readers can provide their own context, their own memory.

This is a book not only about Vermont but also about postcards, and I try to provide a history of the postcard and a sense of how it relates to the culture of time and place. Although I had written many postcards and saved a few over the years, I first got interested in postcards as history quite accidently. In the spring of 1983, on leave from Temple University, I was teaching as a visiting professor at the University of Texas in Austin. I read in the newspaper about a postcard show at one of the hotels. I went out of curiosity and to my amazement discovered that even in

Texas the dealers had large numbers of Vermont postcards. I bought a few, put them in an envelope, and promptly forgot about them. Two years later I was in Minneapolis at a convention when I discovered another postcard show near my hotel, and there I bought a few more Vermont cards. The next year I taught at the University of Amsterdam, where I discovered that on weekends the postcard dealers in great numbers, along with those who sold stamps and coins, offered their colorful cards from all over the world for sale in the outdoor markets. I found no Vermont cards, though there may well have been some, but I learned that collecting old postcards was an international hobby. When I returned to the United States I soon became an addicted collector. I discovered that there are thousands of dealers and millions of collectors. There are postcard magazines and postcard clubs, postcard auctions and online sites, and even a pretentious name for the hobby — deltiology. At first I collected cards from Vermont's Northeast Kingdom. I was born and grew up in Hardwick and return to Greensboro every summer. Then I expanded my collecting to the entire state. I might have picked all of New England, or Philadelphia where I live for most of the year, but Vermont seemed manageable and I had long been fascinated by the state. I became especially interested in the postcards that collectors call "real photo" postcards. It is a redundant description, but they use the term to describe the cards that are actual photographs developed on postcard paper, rather than the mass-produced cards made through the halftone process. I also became intrigued by the messages written on the back, and sometimes around and even over the illustrations, on the postcards. Sometimes I felt like I was reading a stranger's mail, but these cryptic sentences scrawled hurriedly many years ago opened a window into the past.

Selecting the postcards for inclusion in this book has been difficult. To a certain extent, luck and chance played a role in my discovering the cards included here, and there are other, perhaps more compelling cards, waiting to be discovered. I have tried to pick cards that are visually interesting and that reveal the way Vermont looked early in the twentieth century. Most of the cards come from my own collection, but I have borrowed a few from the Vermont Historical Society, the Aldrich Public Library in Barre, and the Fairbanks Museum and Planetarium archives

in St. Johnsbury. The Vermont Historical Society and the Special Collections Department, University of Vermont, Burlington, have the largest collections of postcards in the state. There is a small group of postcards in the Vermont Collection at Middlebury College, and the Orleans County Historical Society in Browington has an excellent collection covering Orleans County. Many other local historical societies and public libraries have some postcards. Fortunately, many institutions now realize how important postcards are for documenting local history, and they are organizing and adding to their collections. Others appreciate the quality of the photographs on many real photo postcards, and they are collecting them as examples of the history of photography.

In selecting the cards for this book I have tried to cover every section of the state, the small villages as well as the bigger towns, but I could not possibly include every town. I did, however, once meet a collector at a postcard show in New York who was a member of Vermont's "251 Club," and was trying to find a real photo postcard for all 251 towns in the state. It is an interesting endeavor, but it has never been my goal. Unlike collecting stamps or baseball cards, there is no way of knowing how many postcards exist. Many of the most interesting cards are those produced by amateurs, and there may have been only one card printed. The great majority of postcards are not very compelling: Most are routine views of public buildings, schools, churches, or street scenes with no people present, or traditional views of the landscape. I have tried to avoid the routine and to include the most visually interesting, but there are some subjects that do not appear on postcards very frequently. There are not as many of people working as I would have liked. And, despite the fact that Vermont is a rural state, there are not very many postcards depicting farming. World War I and the Depression of the 1930s get scant attention. There are few interior views. Although I have a section on winter, most photographs were taken in the summer when the weather was perfect. I include some shots of accidents and fires, but most postcards clearly celebrate Vermont.

Readers of this book will discover that some towns are overrepresented and some not represented at all. That is because some towns, perhaps because of a particular photographer, seem to have better, more interesting cards than others. But many more postcards are wait-

ing to be discovered. I hope this book inspires people to look through their own attics and photo albums, to haunt the flea markets, and to search for those special postcards that give us a chance to glimpse a world we have lost.

Acknowledgments

Many postcard collectors and dealers have helped me in my search for Vermont postcards, and they have taught me a great deal along the way. I especially want to thank Kenneth and Mel Davis, Jim and Kaycee Dimond, Dick Gumpert, Bruce Nelson, David S. Perham, Frank Rathke, James Sholan, and Bob Streeter and Dave Warden of That Book Store in St. Johnsbury. Many archivists and librarians have answered my questions and allowed me to search their collections. They even seemed genuinely interested in my project. I am especially indebted to Tracy Martin of the Old Stone House Museum in Brownington, Karen Lane of the Aldrich Public Library in Barre, Anne Lawless and Selene Colburn of the Fairbanks Museum and Planetarium archives in St. Johnsbury, and Paul Carnahan and Gainor Davis of the Vermont Historical Society. Charles T. Morrissey and Sam B. Hand have taught me a lot about Vermont History over the years. They both have read the entire manuscript, prevented serious errors and improved the book in many ways. My son, Greg, bailed me out on several occasions when my computer refused to cooperate. Philip Pochoda of University Press of New England believed in this project from the beginning, and has offered support and encouragement as well as expert advice along the way.

Postcards from Vermont

Introduction

The postcard that we now accept without thinking was all the rage early in the twentieth century. "Just a card to let you no [*sic*] we are all well and hope you are the same," one Vermonter scrawled on a postcard in 1912. "Your letter rec'd. Will answer later," another wrote. "I am having a swell time, but miss you, of course," a young woman wrote her boyfriend in 1907. The messages written hurriedly, as well as the photographs and illustrations on the fronts of the cards, reveal a great deal about a fascinating time when the world was being transformed by the telephone, the camera, the fountain pen (invented 1884), the modern magazine, the train, and the automobile. The postcard was very much a part of this emerging world of consumption, advertising, and accelerated communication.

The postcard has a relatively short history. Before about 1860, postal regulations in both Europe and America allowed only sealed envelopes. The first copyright for a "mailing card" in the United States was granted to John P. Charltron of Philadelphia in 1861 and transferred soon after to H. L. Lipman, also of Philadelphia. "Lipman Postal Cards," which circulated in the 1860s and 1870s, were used primarily for advertising. The first official United States Government postal card was authorized in 1873. The back, with printed stamp, was for the address only. The front was blank and could be used for a message, a photo, or for advertising. These cards gained in popularity in the late nineteenth century and were often used by cities and towns to send out their tax bills. They were also used to advertise fairs, expositions, and other events. In 1893 a series of ten commemorative postcards issued by the World's Columbian

Exposition in Chicago was so popular (they sold for five cents apiece or fifty cents for the set) that they added to the growing support for a private mailing card. Great Britain introduced a private card in 1894. Congress finally authorized a private card in 1898, and until the end of 1901 all postcards carried the message: "Private Mailing Card, Authorized by Congress, May 19, 1898." This bill was part of the expansion of postal services at the end of the nineteenth century that included bulk mail rates, postal money orders, and Rural Free Delivery (RFD). The RFD Act passed in 1896 was strongly supported by the Grange and other farm organizations and opposed by store owners and express companies. Before Rural Free Delivery, only communities of more than 10,000 had mail delivery, and many rural and small-town Americans picked up their mail once a week, or less frequently.

It took a few years before the RFD system was in place, but by 1905 even the most remote farmers and small-town residents of Vermont could receive letters and the Sears Roebuck Catalog in their roadside mailboxes. Rural Free Delivery also helped to increase the use of post-cards. Before 1907 in the United States the entire back of the card was for the address only, forcing writers to scrawl their messages around and sometimes over the picture on the front of the card. Great Britain changed its rules in 1902, but it was not until January 28, 1907, that the United States permitted a divided back with a place for both a message and the address. This helped to launch the "golden age" of postcards, which lasted from 1907 to 1915. Nearly everyone caught "postcard mania." In the fiscal year ending January 30, 1908, over 677 million post-cards were mailed in the United States, and the next year nearly a billion, and those numbers do not include the many postcards purchased as souvenirs and not mailed. The rise of the postcard was a worldwide phenomenon; it was popular not only in Europe and North America, but also in South America, Africa, and Asia. It cost one cent to mail a postcard in the United States (two cents if mailed out of the country.) The price went up to two cents during World War I, but came back down to one cent in 1920. It remained there until 1951, when it began a trend that led to the twenty-one-cent postcard in 2001.

The popularity of the postcard was directly related to the growth of tourism. Railroads produced postcards to advertise the scenic sights

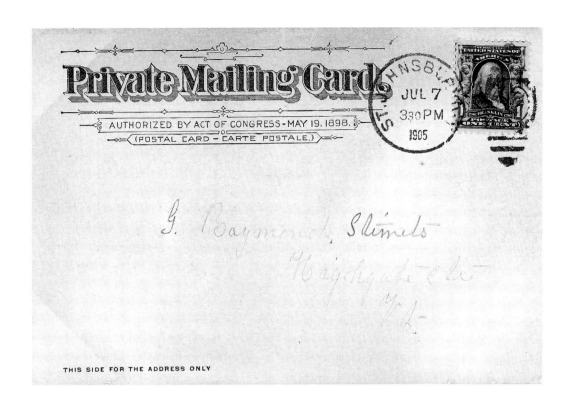

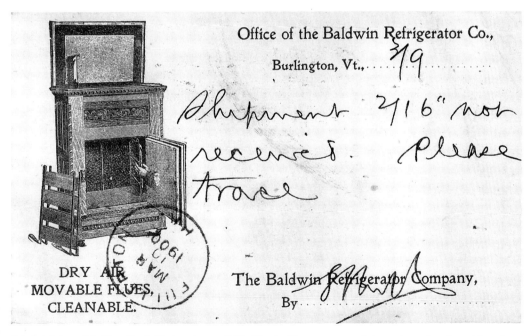

(*Top*) A Private Mailing Card. Notice the undivided back. (*Bottom*, reverse) An early postcard used for advertising and business correspondence by the Baldwin Refrigerator Company of Burlington. The card was mailed in 1900.

along their routes and to encourage more people to travel. In Vermont the postcard era coincided with the state's effort to encourage more tourists to come to the state. The Rutland Railroad and the Boston and Maine, along with many resorts and hotels, produced postcards. The railroads carried passengers on business or pleasure to remote spots where they were inspired to send postcards back to their friends with a message that became a cliché: "Having wonderful time. Wish you were here." But the automobile was just as important in promoting the use of postcards. In the years before World War I, the auto trip was still such an unusual adventure that many sought to document their trips by purchasing postcards along the way, not only to send to friends, but also to save or to place in an album along with their photographs. Susan Sontag has remarked that "it seems positively unnatural to travel for pleasure without taking a camera along." By the same token, to travel and not buy postcards is almost to deny that you went on a trip. Postcards enabled the tourist to preserve the memory of travel, and to put those memories in order.

There were many kinds of postcards—copies of paintings, signed original portraits, patriotic cards, Thanksgiving and Halloween cards, humorous cards, and some that depicted unflattering images of Jews, Indians, and African-Americans. Some cards were blatantly racist and others were pornographic. But the most common cards depicted scenic views and local buildings. Tourist attractions received the most attention, but even the smallest towns had their special postcards. Many of these cards depicted idealized versions of cities and towns and the rural landscape. Thus "like a picture postcard" and "picture-postcard perfect" became a part of the language. The highest quality color lithograph cards were printed in Germany. When the outbreak of World War I in 1914 cut off that source of supply, American companies were forced to print their own, but they were not usually as good quality as the German cards. One American company that did produce high-quality colored cards was the Detroit Photograph Company (later the Detroit Publishing Company), which in 1898 purchased the negative files of the famous American landscape photographer William Henry Jackson, who was an artist and photographer in Rutland and Burlington, Vermont, before a broken romance sent him West. The Detroit Publishing

Some postcards projected a rather humorous view of Vermont and Vermonters. This card even has bootleggers being fired at by the police, and illegal Chinese immigrants crossing the border.

Company used an elaborate and secret process that required ten lithographic stones for each negative. The company produced more than 16,000 view cards, including several hundred of Vermont scenes.

Mass-produced postcards, both black and white and colored, were produced by the halftone process, which had been invented in 1880, but which did not come into general use until the turn of the century. In this process a photograph was projected through a grid screen creating a pattern of dots on a photosensitive plate. A coarse screen was used to reproduce a photo in a newspaper, and a finer screen (with dots closer together) for postcards. For color lithograph postcards, a stack of prints would be run through the press four to ten times, each time adding a different color or shade. The halftone process led to a revolution in journalism and allowed newspapers and magazines to publish photographs. It also made the modern postcard possible.

A great many color lithograph cards of Vermont were distributed by the Hugh C. Leighton Company of Portland, Maine, which owned a

factory in Frankfurt, Germany. It sold standard views of tourist attractions but also accepted special orders and made up cards based on photographs using the halftone process. One of the company's advertising cards asked: "Why not deal direct with the manufacturer? Our stock of over 40 million colored Souvenir Postcards give you an assortment that sells." The Rotograph Company of New York, which also published Vermont view cards, advertised that they could have cards printed in Germany at the cost of nine dollars a thousand if at least 3,000 of any subject were ordered. "We require good sharp photographs," the ad announced. "It is very necessary when ordering colored cards to give the color scheme." The company promised delivery in three to five months. The Green Mountain Card Company of White River Junction in 1912 advertised a selection of 3,500,000 cards including more than one hundred Vermont views, including "Vermont Nature Paintings," "Vermont Sunset Series," and the "Scenic Vermont Series." Newspapers, print shops, stationery stores, and local entrepreneurs, recognizing a hot item, also produced postcards. E. T. Griswold, a bookseller in Bennington, printed several series of postcards featuring the scenic sights in the Bennington area. Robert L. Duffus, who grew up in Waterbury, recalls in his memoir, *Waterbury Record* (1959), that when he worked as a boy for a local newspaper he fed picture postcards of Lake Champlain into a small press at the rate of 1,800 an hour. He was so bored by the task that he dreamed of Indians paddling canoes on the lake, and he imagined that they had more fun than he did at his job.

After 1907 the postcard industry became big business, with thousands employed worldwide. In 1908 E. I. Dail, a salesman from Lansing, Michigan, invented a revolving steel rack to display cards on a store counter. The rack allowed customers to wait on themselves and to select their own postcards; it was one of the first forms of self-service merchandising. Soon every drugstore, general store, and stationery store had a rack or two of postcards, and they often ordered their own with the name of their business printed on the back or the front. Many Vermont cards carry messages such as Bigelow's Pharmacy, Newport, Vermont; A. L. Cheney, Druggist, Morrisville, Vermont; Geo. E. Chalmers, Rutland, Vermont; Buswell's Bookstore, Montpelier; W. D. Clough, Woodstock; H. L. Chapman, Windham; Carl Hughes Station-

ers, Fair Haven; and many more. Not only did they make a profit on the cards, they also used them as a form of advertising. But individual entrepreneurs sold postcards as well. Kenneth E. McIntyre, who grew up in East Hardwick, recalled that as a young boy he "used to earn money selling postcards which came from a factory in Orleans, then called Barton's Landing." He paid one half cent a card and sold them for one cent.

Drugstores and general stores also stocked real photo cards, cards made from photographs of local scenes, taken by professional photographers. At the same time, amateur photographers turned their family snapshots into postcards. The photo postcard was made possible by the revolution in photography, which began with the invention of the dry plate negative and the development of the hand-held camera. In 1888 Kodak introduced the box camera. All one had to do was point and shoot and then send the whole camera back to the factory when the 100 negatives were exposed. The factory replaced the film and sent the camera and the developed photos back to the owner. "You push the button, we do the rest" was the Kodak motto, and it ushered in an era of candid, snapshot photography, but initially the box camera cost five dollars, which put it beyond the reach of many people. The photo postcard could be made with any camera, but the professional usually preferred a large box-like camera, which required a tripod and took a 5- by 7-inch glass plate negative. The 35-mm camera, which took many photos in rapid order, was not perfected until the 1920s and was not widely adopted for another decade. The amateur photographer could develop negatives on presensitized and preprinted postcard paper produced by Kodak as early as 1902, but many photographers preferred to let a photographic studio turn their photo into a postcard. Kodak and other companies also marketed cameras such as the Graflex Postcard Camera and the No. 3A Folding Pocket Kodak Camera, which produced negatives 3¼ × 5½ inches, the standard postcard size. Amateur and professional alike gave titles and sometimes dates to their photographs by printing or writing in reverse on the negative, which came out white on a black background, or they could use a stamp that did the job more quickly.

In the days before the weekly, or even the daily, newspaper could afford to publish halftone illustrations, the local photographer often

acted as a photojournalist. He (and it was almost always a man) would rush out to take photos of a train wreck, a fire, a parade, or another event and then turn the negatives into postcards. Local citizens could buy them as souvenirs, or send them to their friends to announce, "I was there." The local photographer could often have photo postcards on sale within a few hours. One could not do that with color lithographs, which had to be sent to Germany and might take six months to produce.

Some of these photo postcards were not "pretty as a postcard," because they recorded ugly and disturbing events. Viewers were shocked in the winter and spring of 2000 by an exhibit in New York of photographs, many of them postcards, of lynchings. The photos came from the Allen-Littlefield Collection on deposit at the Robert W. Woodruff Library at Emory University in Atlanta, Georgia. One of the photo postcards was entitled, "Lynching of Jesse Washington, May 16, 1916, Robinson, Texas." A man who observed the lynching sent the card to his father with the message: "This is the barbecue we had last night my picture is to the left with a cross over it."

There are no Vermont lynching postcards because there were no lynchings in Vermont, but Annie Proulx writes that she got the idea for her novel *Postcards* (1991) from a group of Vermont postcards depicting mug shots of prison inmates. The novel is the story of a murderer, Loyal Blood, who flees from Vermont to the West. Each chapter begins with a postcard sent by Blood to his family in Vermont. In a 1999 interview, Proulx revealed that she got the idea for the book when a friend sent her a group of photo postcards of criminals sent out by the warden's office at the Vermont State Prison in Windsor in the 1930s. I have never seen such a postcard, but I do have many of fires, accidents, and floods, and one of a jury in a murder trial.

Most postcards give us a selective view of the Vermont countryside and the small towns and cities. Most of the photos are carefully composed, and many of the shots of public buildings, churches, schools, and houses are formal portraits with no people present. But when the photographer set up his tripod to take a picture of a main street he inevitably captured people and objects he did not intend to preserve. Today these things accidently recorded are often the most interesting. Still, we seldom see postcards of back alleys and the poor sections of

towns. The postcard photographers in Vermont seem not to have been influenced by Jacob Riis, Lewis Hine, and the other "progressive" photographers who set out to depict urban slums and the horrors of child labor in order to promote reform. Lewis Hine did make a trip to Vermont while he was working for the National Child Labor Committee in 1909. He photographed young boys and girls working in textile mills and engaged in other occupations, but none of these photos seem to have been made into postcards. A few photographers appear to have been influenced by pictorialism, as represented by Alfred Stieglitz and his circle in New York. He tried to establish photography as an art; sometimes he even altered a negative to create an impressionistic scene. The influence of pictorialism and the search for the picturesque is especially present in some of the stylized photos of the Vermont landscape.

Most photographers who took the photographs that appear on Vermont postcards remain anonymous. Many did not think it important to place their names on the photographs. Some remain only names: F. D. Burt, Bennington, F. Smart, Hardwick, F. Tims, Burlington, B. W. Graves, Sheldon, H. B. Rood, Poultney, H. A. Boss, Ludlow. One photographer that we know a little about is Harry Wendell Richardson (1894–1960), who operated a shop in Newport and took well-framed and carefully composed photographs from about 1918 to the end of the 1950s. Most of his photo cards are of the northern part of the state, but he roamed as far as Bennington and Springfield and even took shots from an airplane. With his wife Alice he traveled in an open car and took photographs of people, buildings, events, and landscapes. Some of his photographs survive at the Orleans County Historical Society Old Stone House Museum in Brownington, but many were thrown out when his house and studio were sold, an indication of how little an important photographic record was valued even as late as 1960.

The Eastern Illustrating and Publishing Company of Belfast, Maine, produced a large number of high-quality photo postcards of Vermont scenes. Founded in 1909 by Herman Cassens, a thirty-four-year-old former printer who had dropped out of school at sixteen, the company expanded in the next two decades to include several photographer-salesmen who roamed the countryside in Northern New England and New York State taking photographs of scenic views, main streets, and

roadside architecture. The Eastern Illustrating Company employees traveled in clearly marked company cars, with trunks mounted on the back to carry large box cameras, tripods, and other photo equipment. They took photos, but even more important they aggressively marketed the Eastern Illustrating line of postcards to drugstores, general stores, and hotels. They even supplied circular metal racks to display their cards. The factory in Camden could produce lots of from twenty-five to a thousand cards from one negative, and the job of the salesman was to keep those racks full and constantly update the stock. Herman's older brother Fred, who lived in Rockland, Maine, probably took most of the Vermont photo cards published by the Eastern Illustrating Company. His photos were always carefully composed and clearly focused.

Vermont postcard photographers often took realistic views of small towns and farms, but they do not seem to have been influenced by the Farm Security Administration photographers' starkly realistic portraits of Depression America, although many of the photographers working for FSA traveled in Vermont in the 1930s and recorded scenes of rural poverty and everyday life. Walker Evans, perhaps the most famous of these photographers, was fascinated by postcards. He did not travel in Vermont in the 1930s, but he did make a brief trip toward the end of his life. From the age of ten in 1913, he collected postcards, and he eventually amassed a total of more than 9,000, which he carefully organized. Late in his career, when asked to lecture, he chose to talk about postcards. In 1936, in collaboration with the Museum of Modern Art, he launched a plan to reproduce a number of the FSA photographs in a postcard format, but he later abandoned the idea. He also never completed a projected book based on his collection.

Evans seems to have been especially fascinated by the direct, unsophisticated style of most of the postcard photographers, which, he maintained, represented an important aspect of American realism. He seems to have been more interested in the color lithograph cards than with real photo postcards. In an article published in 1948 in *Fortune Magazine*, he described a postcard view of Main Street.

> The mood is quiet, innocent, and honest beyond words. This, faithfully, is the way East Main Street looked on a midweek, summer afternoon. This is how the county courthouse rose from the pavement in sharp,

endearing ugliness. These precisely are the downtown telegraph poles fretting the sky, looped and threaded from High Street to the depot and back again, humming of deaths and transactions. Not everyone could love those avenues just emerged from the mud-rut period, or those trolley cars under the high elms. But those who did loved well, and were somehow nourished thereby.

Like Walker Evans, we can appreciate the way Vermont postcards capture a moment in time and allow us to observe vernacular architecture, clothes, automobiles, billboards, and the material culture and texture of another time.

Just as fascinating as the photographs are the messages written many years ago, for postcards were used early in the century as we use the telephone, the fax machine, or e-mail today. On one level, postcards were souvenirs, and one of the most common messages written on them is some version of "Having wonderful time, wish you were here." Some travelers make the postcard their own by marking it or writing over it. "The 'X' is where we stayed." "Our camp is about here." Some cards make reference to the photograph: "Does this look familiar?" "This is our street after a snowstorm." Others ignore the illustration and use the card to deliver a message. Many used postcards to substitute for birthday cards or Christmas cards. Especially in the years before World War I when only a few Vermonters had telephones, the postcard was a convenient way to communicate with friends and family living only a few miles away. By the 1920s, with telephones more common and cars more numerous, the custom of using postcards for quick messages declined, but it continued longer in rural Vermont than in the urban areas. Many messages report on health or the weather. "Colds are better this morning." "All well, hope you are the same." Some messages seem to be simply a way of staying in touch. "Have been expecting you over, but haven't seen anything of you." "How are things in Barre, about the same I suppose." One gets a sense of the rhythm of Vermont speech by reading the messages on cards because people tended to write the way they spoke. "Had been thinking I would get over to see you, but if it is hay weather don't know as I will."

In part because the early postcards had so little space, a kind of postcard shorthand developed that included abbreviations, incomplete sen-

tences, casual spelling. and almost no punctuation. "Rec'd your card. I am now looking for your letter," one woman wrote. "Staid here last night, " a traveling salesman reported. "Arrived here this eve, roads nearly impassable," another wrote. "I thought you were dead or something ailed you so I thought I would wright [*sic*]," a man scrawled on a card sent to a neighboring town. A number of articles appeared in the popular magazines after 1905 criticizing postcards for encouraging poor grammar, sloppy spelling, and poor writing, as well as encouraging intellectual laziness. Many predicted that the postcard would lead to the decline of the art of letter writing. The postcard, unlike the letter, could be read by anyone, especially the postmaster and the rural letter carrier, so some people learned to write in code. Because of the extensive railroad network, most Vermonters could expect to receive a card the day after it was mailed, and some mailed in the morning arrived in the afternoon. Many trains had a postal car where mail was sorted and stamped while the train was in motion. Many Vermont postcards have these Railroad Post Office (RPO) cancellations.

Postcards were a means of quick communication early in the century, less formal than the letter, less urgent than the telegram, but postcards were also collectable. Some preserved the exotic images of foreign countries sent to them by friends who traveled, but many saved photo postcards from their hometown, or they traded cards with their friends. "Here is another card for your collection," one man wrote. "Dear classmate, are you among the number who is making a collection of postcards?" a woman wrote. "I can get a few of this village and should be pleased to exchange with you." Some even exchanged cards with pen pals in Europe. A man who signed himself C. M. Parker mailed a color lithograph card of the St. Johnsbury train station on October 10, 1910, to a young woman in London and wrote, "Many thanks for the card. Would you like to have me send you some views of the White Mountains. They are near here." It took the card nine days to get to London. Kodak and other companies quickly realized the extent of the new hobby and they issued special postcard albums. These could be filled to commemorate a special trip or to preserve the streets and buildings of a particular place. The postcard album soon took its place in the American parlor next to the family photograph album and near

the outdated collection of stereograph slides. The photo postcard in a variety of ways represented the accelerated pace and the visual nature of American culture early in the twentieth century.

Vermont in the age of the postcard was a state in transition. The population remained almost static, gaining only about 3½% per decade between 1890 and 1910 and actually losing population between 1910 and 1920. More than half of Vermont towns lost population between 1850 and 1920, and the number of farms declined from 33,820 in 1890 to 29,075 in 1920. But many of the larger towns prospered, and the farm abandonment was not as serious as some suggested.

The Vermont State Department of Agriculture began in 1891 to publish pamphlets listing farms and vacation property for sale, and other pamphlets designed to attract tourists and new residents to the state by picturing a rural paradise, untouched by the forces transforming the urban, industrial world beyond the state's borders. "To tired bodies and weary minds, The Green Mountains bring peace and renewed health," the Publicity Bureau announced in 1919. "From the din and turmoil of the great city the transition to quietness and repose of the mountains is almost like entering a new world." But in truth, although Vermont remained a rural, agricultural state, it was connected by rail and telephone to the rest of the nation, and transformed by the auto. Although it had no large cities, Burlington, Rutland, Barre, St. Johnsbury, Brattleboro, and many smaller towns had busy main streets, and many opportunities for workers and businessmen. Vermont had factories that belched smoke and polluted streams. The state also had ethnic conflict, labor discontent, and rural poverty. If Vermont was a special world, as the Publicity Department liked to suggest, it was also a world very much influenced by the forces transforming America.

Vermont postcards reflect this dualism. Postcards, along with advertising brochures and pamphlets, helped to promote Vermont as a tourist destination, to highlight the scenic beauty and the peaceful vistas. At the same time, many postcards reflect pride in modern factories, busy commercial centers, and efficient transportation systems. Postcards don't tell us everything about Vermont history in the first decades of the twentieth century, but they do reveal a fascinating time, an era of paradox and contradiction.

1

Pastoral Landscapes—
Peaceful Villages

Vermont postcard photographers, borrowing from landscape painters such as George Innes and John Constable, and from nineteenth-century landscape photographers, captured many tranquil rural scenes. These pastoral photographs give no hint of industry or even of busy main streets. Some are distant views; others frame a river or a lake. Many of the views have a person (most often a woman) in the foreground, but following the fashion of landscape painting, that person is never looking at the camera but is gazing pensively into the distance.

Other rural landscape photo cards feature a peaceful dirt road, sometimes with a single horse and carriage, or later a lone automobile, pausing along the way. These rural roads, never photographed during mud season or winter, are surrounded by trees and fences, and they sometimes border lakes or streams. Occasionally there is a farm in the distance, but these photographs are carefully composed in order to avoid anything that might disturb the neat, orderly scene. Depicting scenes from rural life, they were produced in great numbers by postcard photographers, and they helped to create an image of Vermont as a placid, rural paradise, the very image that the state was trying to project in order to attract more tourists. Wallace Nutting made these tranquil rural scenes famous in his book *Vermont Beautiful*, published in 1922.

There are no towns or villages in Nuttting's book, but many postcards depict an idealized version of the small Vermont village that adds to the image of peace and tranquility. One technique, practiced by a large number of photographers, was to take a long-distance shot of a village,

usually from a hillside. We look down on a scene with the white church spire dominating the middle of the photo. Some photo cards reveal the land surrounding the village with hills gradually being reclaimed by the forest. Most of the cards hide the flaws and complexity of village life as they depict a world of order and grace. But occasionally they record a more realistic and gritty scene. Yet, many of the postcards of Vermont villages add to the image of the state as peaceful and pastoral, a tranquil middle ground between the wilderness and a more settled, confused urban landscape.

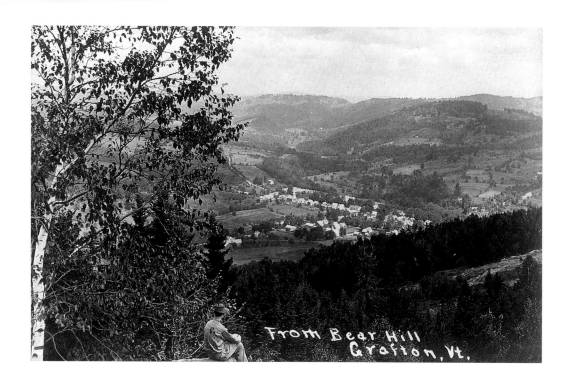

From Bear Hill
Grafton, Vt.

(*Above*) A distant view of Grafton, circa 1915, showing hillsides that would have been mostly bare fifty years before but now are nearly reforested. Notice the careful framing with the tree at left and the solitary figure peacefully contemplating the rural scene. (*Top and bottom right*) Fashionably dressed women (with spectacular hats) gaze pensively at a pond in Athens (Population 201 in 1910), and a waterfall in Glover (population 932 in 1910).

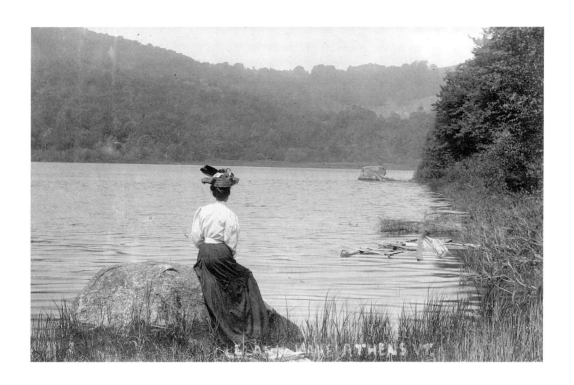

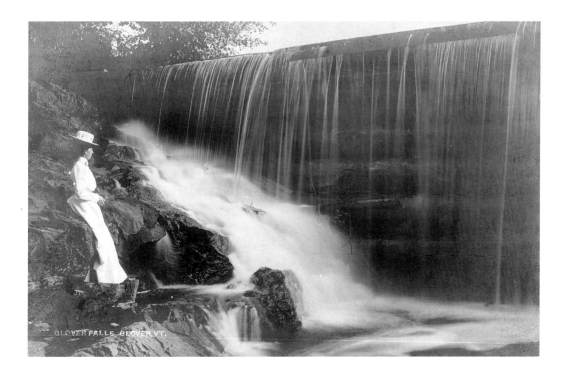

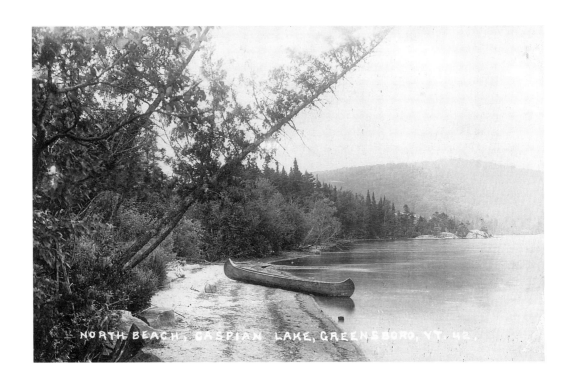

NORTH BEACH, CASPIAN LAKE, GREENSBORO, VT. 42.

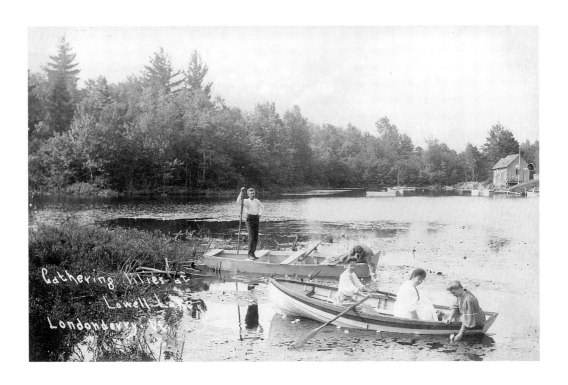

Gathering Lilies at
Lowell Lake
Londonderry, Vt.

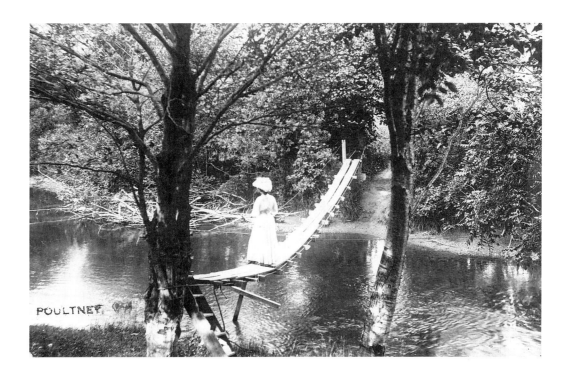

POULTNEY

A boat or canoe on a lonely lakeshore was a favorite subject for artists and photographers alike. (*Top left*) A peaceful scene with canoe on Caspian Lake in Greensboro. (*Bottom left*) Whether consciously or unconsciously, this photo card, "Gathering lilies at Lowell Lake, Londonderry, Vt.," is almost an exact imitation of a famous 1886 photograph taken by English photographer Peter Henry Emerson, called "Gathering Lilies." (*Above*) An elegantly dressed lady tries to look calm as she contemplates a picturesque stream from a rickety bridge in Poultney (circa 1910). Obviously posed by photographer H. B. Rood, this model is trying her best to help create a bucolic scene. One hopes that Rood didn't take too long to focus his camera.

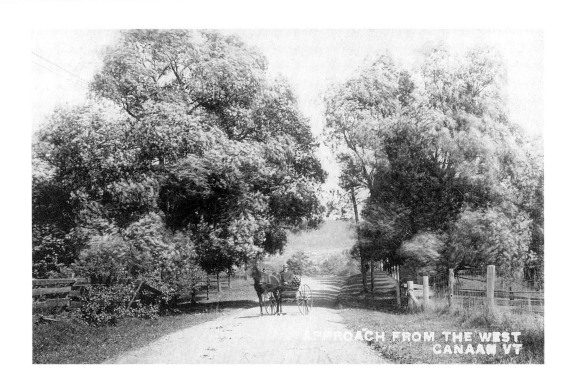

APPROACH FROM THE WEST
CANAAN VT

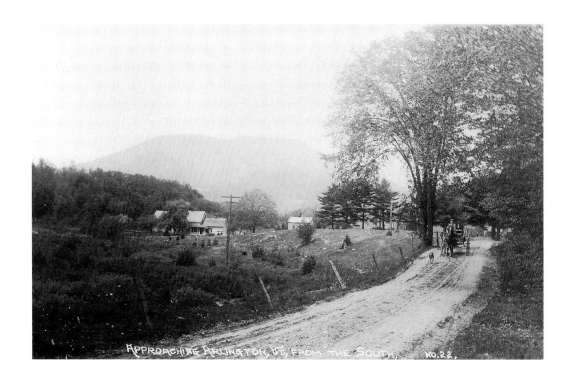

APPROACHING ARLINGTON, VT, FROM THE SOUTH. NO.22.

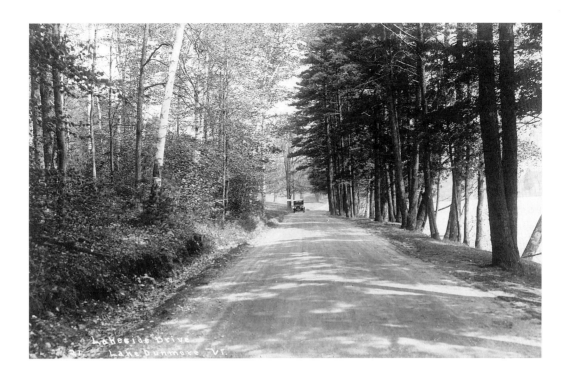

(*Top left*) A single horse and buggy on a country road in Canaan in the far northeast corner of Vermont. (*Bottom left*) A similar scene near Arlington. Both photos are carefully framed and give the sense of rural peace and tranquility. (*Above*) Beginning about 1910 a lone auto began to replace the horse and buggy in the rural scenes. Here, circa 1925, an auto, probably belonging to the photographer, can be seen in the distance along a road near Lake Dunmore in Salisbury.

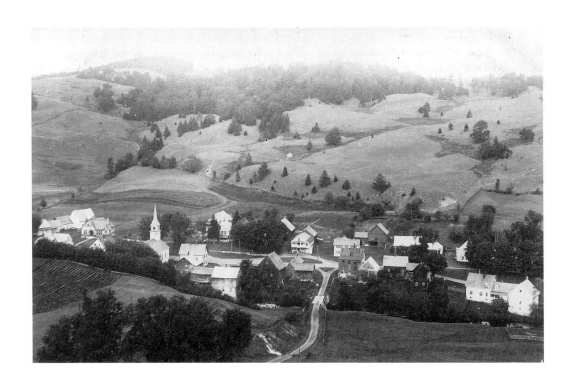

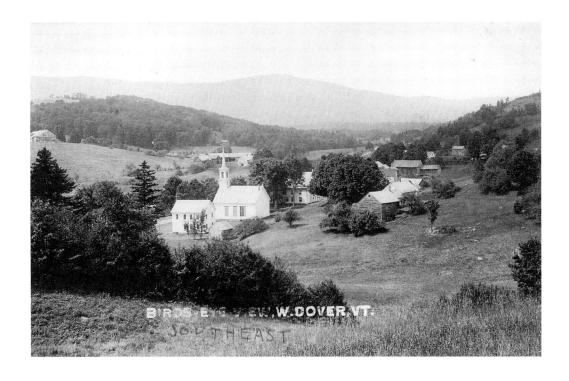

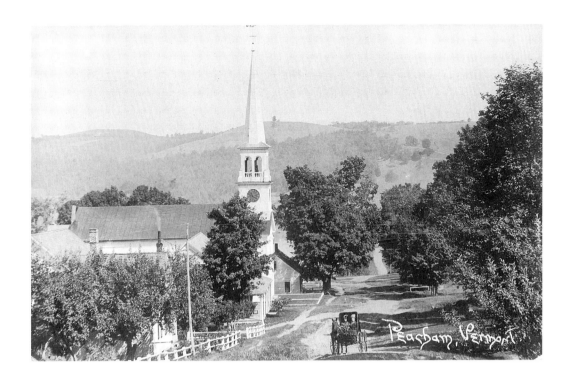

(*Top left*) East Corinth. (*Bottom left*) West Dover. These are two much-photographed towns, with white church spires dominating the photographs. Pastures extend high into the hills in both photographs. (*Above*) Peacham is another town that attracted (and still attracts) many photographers seeking peaceful Vermont village scenes. All three of these hill villages were bypassed by the railroad.

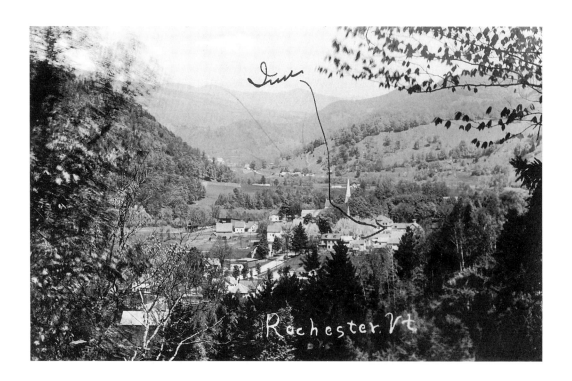

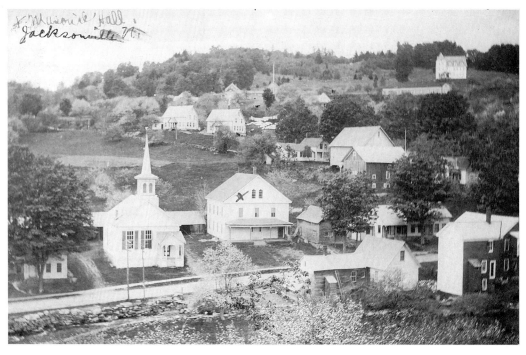

(*Top*) Rochester and (*bottom*) Jacksonville, with notations by the card senders to identify an inn in Rochester and the Masonic Hall in Jacksonville. The Rochester photo is the more traditional shot, taken from on top of a hill and showing the town nestled in the valley. The Jacksonville photo reveals barns, houses, and outbuildings.

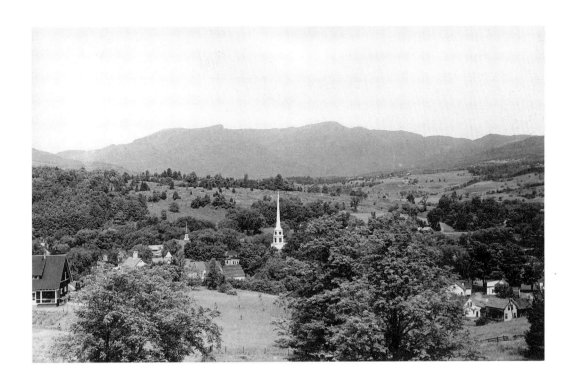

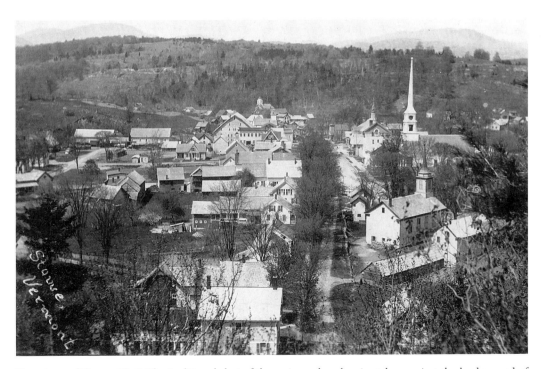

Two views of Stowe: (*Top*) The traditional shot of the unique church spire taken against the background of Mt. Mansfield. This is the angle preferred by both artists and photographers to depict one of Vermont's most famous village scenes. (*Bottom*) Taken about the same time, but from a different angle, this Stowe photo reveals a small town that is not perfect, but filled with chaos and disorder.

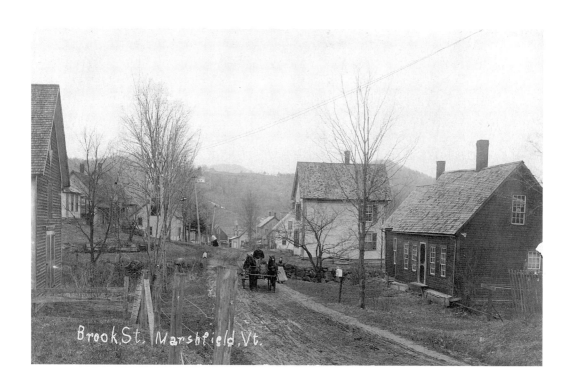

Brook St. Marshfield, Vt.

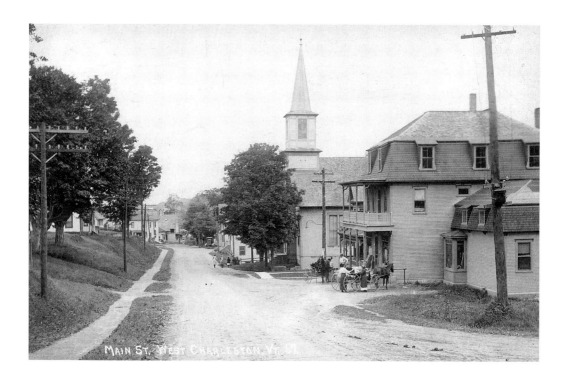

MAIN ST. WEST CHARLESTON, VT.

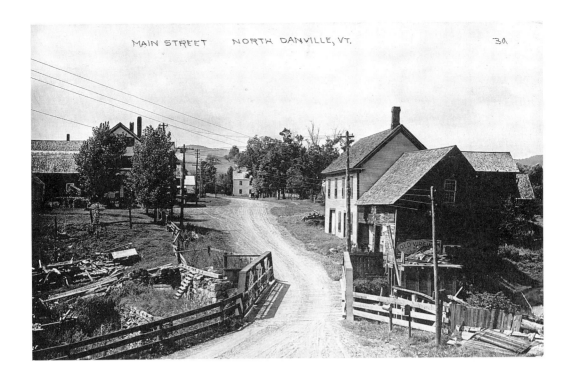

(*Top left*) An unusual photograph of Marshfield taken during mud season and (*bottom left*) a realistic photo of the main street in West Charleston. (*Above*) North Danville, circa 1910, featuring a narrow iron bridge, a dirt road, telephone lines, debris, and a partially covered sign advertising "Old Virginia Chewing Tobacco." These three cards depict Vermont small towns as isolated, provincial, and more gritty than picturesque.

Country Stores and One-Room Schools

Those who look back nostalgically to a time in the past when things were more simple, when there was a real sense of community and neighborliness, often focus on institutions such as the country store and the one-room school. It is easy to exaggerate their benefits and overlook their flaws, but both school and store appear on postcards from the past.

The country store, with its potbelly stove, its cracker barrel, and a kindly storekeeper who dispensed down-home wisdom, is part of Vermont folklore. The image was enhanced by Norman Rockwell paintings, but there is an element of truth in this ideal picture. Yet the reality often included a jumble of merchandise, hoes and shovels, barrels of salt cod, and bins filled with beans, dried fruit, and other bulk items. There was also a well-used spittoon, and a mixture of odors that included kerosene and molasses, together with the aroma of wet wool, and the smell of customers who had just emerged from the barn. But the store, unlike the livery stable, was not exclusively male territory. There usually was a counter where bolts of cloth could be measured and cut, and there were cabinets filled with spools of thread and drawers where buttons, buckles, and lace could be found. Most stores would also take special orders for coats and hats and other items not usually stocked, but that could be obtained from New York or Boston.

The time when the Vermont country store was most dominant was from mid-century to about 1880. During these years even the smallest store had wholesale as well as retail business and served as a link in a growing market economy. Store owners bought or traded for wool,

maple sugar, eggs, lumber, and especially butter. After Vermont farmers switched from raising sheep to raising cows, their chief cash crop was butter, which was placed in tubs and brought once a week to the local store. The store owner "freighted" the butter to the nearest depot, where it was shipped to Boston. With the development of cream separators and the building of commercial creameries at the end of the nineteenth century, the country store owner ceased to be the middleman in the butter business. At the same time, as the larger towns developed specialty stores and peddlers penetrated even the most remote Vermont village, the country store had more and more competition. The coming of the automobile in the twentieth century, along with Rural Free Delivery and the Sears Roebuck Catalogue, sounded the death knell for many country stores.

Some stores survived by adding a gas pump. Others gradually developed into self-service markets, but they had to compete with chain stores like A&P. Some store owners, realizing the nostalgia value of the country store, altered their appearance and their stock to appeal to the tourists who saw the country store along with the Vermont village and farm as part of the old way, the very reason they traveled from the city to Vermont. Still, the country store in the age of the postcard was an institution in decline and transition.

The one-room school actually outlasted the country store. As late as 1920, more than seventy percent of the schools in Vermont were one-room schools. How good an education a student got in these schools depended a great deal on the quality of the teacher. Many of those who attended one room schools look back fondly on that experience and argue that they got a good education in part because the older students taught the younger ones. But if one was a slow learner, or had what today would be called a learning disability, one probably got left behind.

The old ways of country stores and one-room schools may not have been better than the supermarkets and consolidated schools of today. But it is instructive to study the images on old postcards, to look at the young students who are staring directly into the camera, to study the old billboards and signs on the stores. It may not have been a better time, but it is a life-style that we have lost.

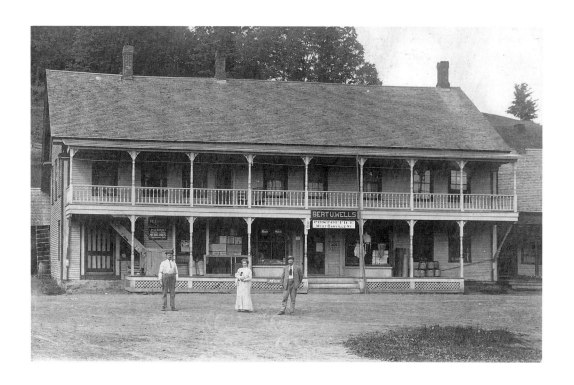

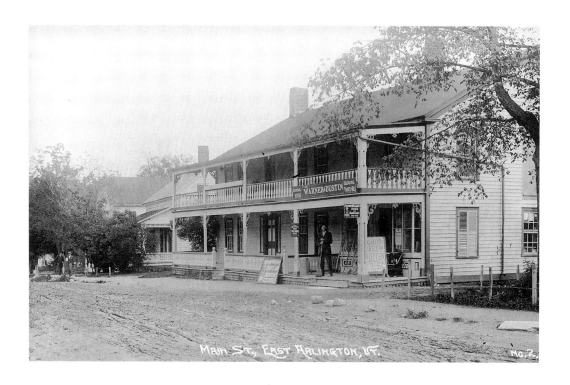

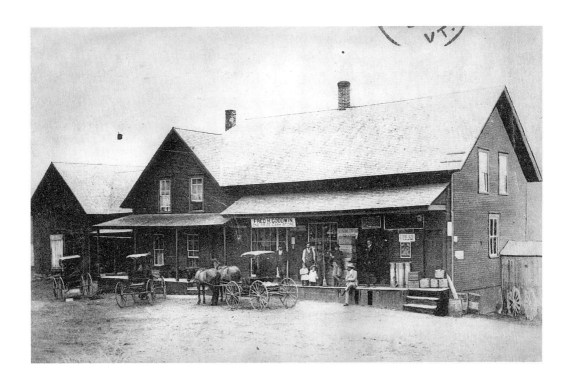

The country store was often also the home of the local post office. The owner of the store was paid a salary, and that sometimes made the difference between failing and staying in business. The Bert U. Wells store in West Danville (*top left*) also housed the post office. In this photo card mailed in 1913, the proud owners pose in front of the store. The signs promote Fels Naphtha Soap and Dr. A. C. Daniel's Horse and Dog Medicine. The sign on the store (*bottom left*) in East Arlington reads: "Warner & Dustin—General Md'se, Gasoline, Paints and Oils." There is no gas pump, but before stores added pumps they sold gasoline in containers to the drivers of autos. The signs advertise Sherwin Williams Paints, Ice Cold Soda, Milk Shakes, and Moxie. The hand-lettered sign reads: "Good Fresh Butter, 25¢." (*Above*) The photo card of the store in Craftsbury was probably made from an earlier photo from about 1900. The sign reads: "Fred H. Goodwin—One Price Cash Store." Most country stores operated, at least in part, on a credit basis, and often took butter and other items in trade. The Goodwin store was part of a new trend toward cash only.

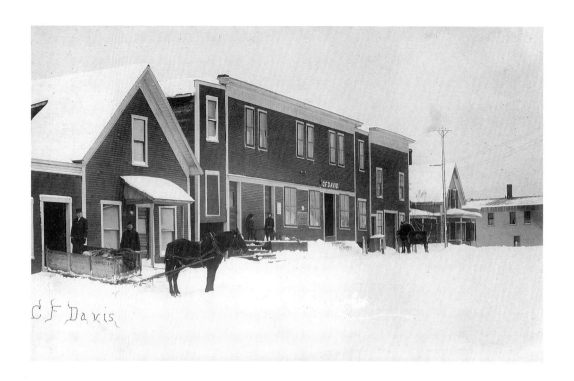

C.F. Davis

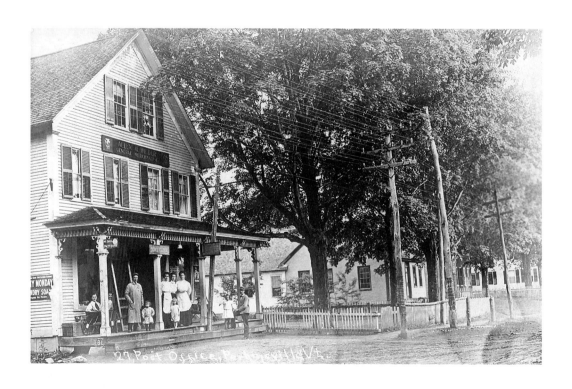

27 Post Office, R. Adamville, Vt.

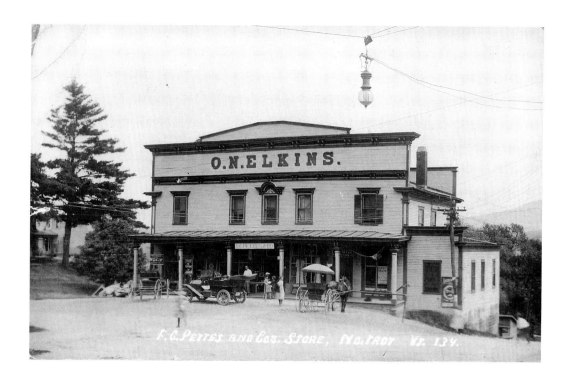

(*Top left*) The store in the granite town of Hardwick was purchased by my grandfather, Charles F. (C. F) Davis (1864–1951) in 1901 and sold to my father, Harold F. Davis (1894–1977), in the 1920s. It was finally sold and converted into apartments in 1968. The family, like most store owners, lived over the store for many years before moving to a separate house. This unusual photo, circa 1906, shows how deliveries were made by sleigh in the winter. Like so many postcards of businesses, this card was used not only for correspondence, but also to advertise the store. (*Bottom left*) This store is the Allen M. Wilder General Merchandise Store in Perkinsville, which was also home of the town clerk's office and the post office. In this photo, circa 1910, the owner, family, and friends pose on the porch. The electric and telephone lines in front of the store indicate a changing technology that would eventually make many country stores obsolete. (*Above*) F. C. Pettes and Co. Store (obviously purchased from O. N. Elkins) in North Troy, circa 1912. A single street light is in the foreground, and both an auto and wagons are parked in front.

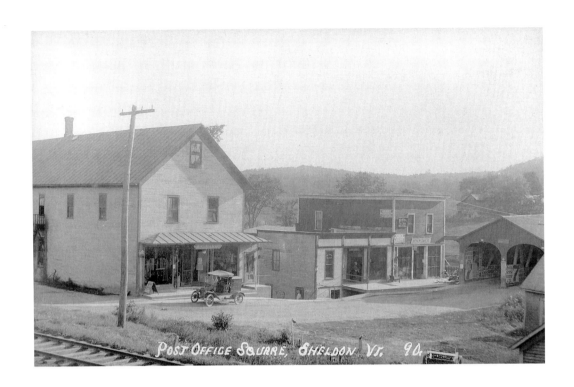

POST OFFICE SQUARE, SHELDON VT. 90.

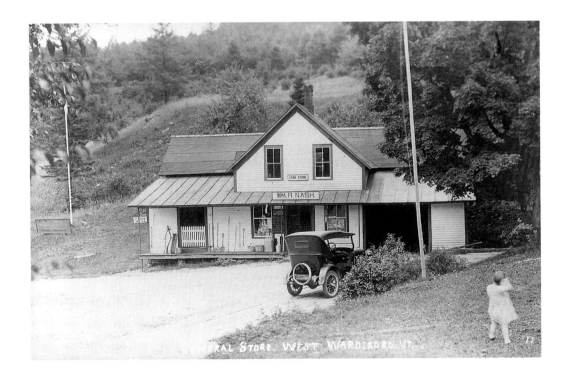

...RAL STORE, WEST WARDSBORO, VT.

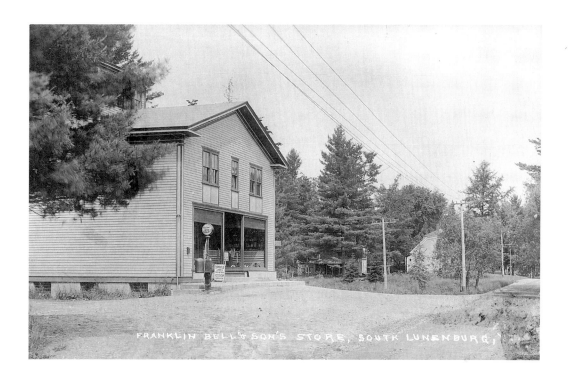

FRANKLIN BELL & SON'S STORE, SOUTH LUNENBURG,

The country store was often the center of the small town's social life, but gradually these stores had to adapt to the auto. (*Top left*) A store in Sheldon with an early Model T truck parked in front. (*Bottom left*) The Nash store in West Wardsboro sold farm tools in addition to other items. It also provided parking spaces for cars, something that most stores had to do after 1910 as the auto became more popular. (*Above*) The store in South Lunenburg has added a gas pump. This card, like many that picture stores, was used as an advertisement. Typed on the back of a card mailed in 1914 is the message: "Big Opportunity Sale. This is the place that is having a House Cleaning of their Shoe Stock. Your Big Opportunity to buy shoes for the whole family and save several $$$$$. Come in soon and be convinced. Sale begins August 12."

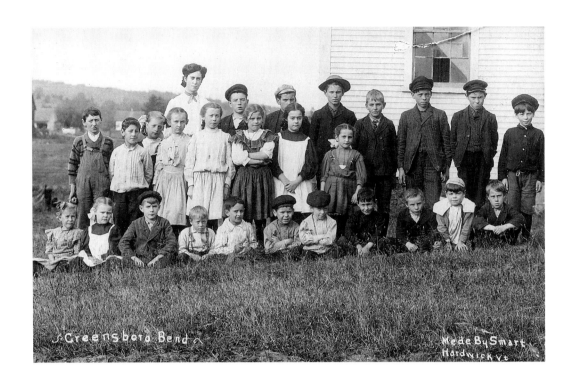

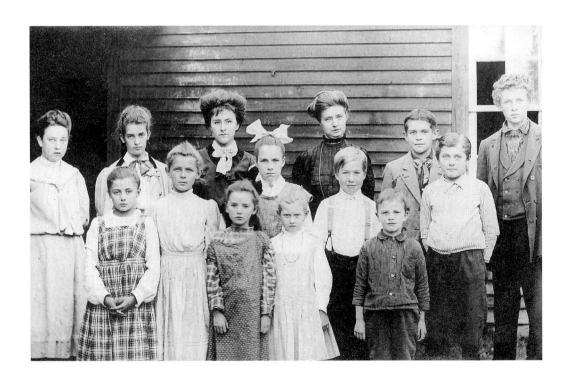

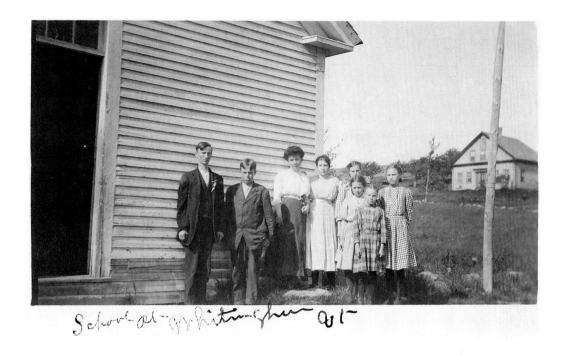

School at Whitingham Vt

When the local professional photographer arrived at the school, usually in the fall, the students and their teacher lined up to have their picture taken. The group portraits are formal, but the students pose, if not naturally, at least with a minimum of tension, for by the first decade of the twentieth century the children are familiar with the camera. Now, more than ninety years later, these children look out at us, their hair carefully combed, dressed in their best clothes (some look homemade.) Even the big boys, some bigger than their teacher, are on their best behavior. The photographer probably made formal pictures for the school and postcards that could be purchased by the children or their parents to send away to friends and family. (*Top left*) In the Greensboro Bend photo, the boys are wearing hats, something not permitted in the school. (*Bottom left*) This photo was postmarked on Christmas Day 1908 from Plymouth Union and was used as a Christmas and New Year's Card. Two girls in the front row, probably sisters, have a dress and a blouse made of the same material. Which young woman in the back is the teacher, and what authority did she have over the big boy on the right? (*Above*) The school at Whitingham is unusually small even for a one-room school.

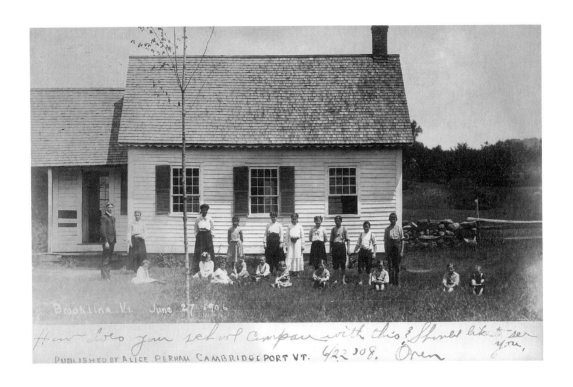

Brookline Vt. June 27 1906

How does your school compare with this? Should like to see you,

6/22 1908. Oren

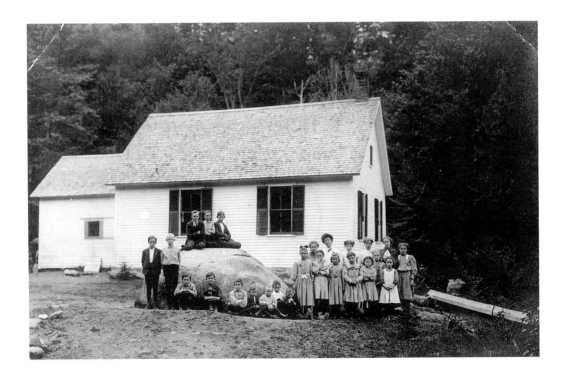

The small schools at Cambridgeport (*top left*), with portrait taken by a woman photographer in 1908, and the school in Bartonville (*bottom left*), a postcard mailed in 1907, contrast remarkably with the more urban school in Poultney, a slate-producing town (*above*), in a photo taken in 1906. The sizes of the schools and even the dress of the children suggest that in Vermont there was a difference between rural and urban, or between the small village and the bigger town.

3

A Horse-Drawn Age

It is hard to imagine a world without automobiles, a world without parking meters, route signs, gas stations, and painted lines down the middle of the hardtop road. But there once was a world of watering troughs, hitching posts, livery stables, and blacksmith shops. The horse dominated the culture, as well as the social and economic life, of Vermont farms, small towns, and cities until about 1910, and then the auto and the truck took over. By 1930 the age of the horse was rapidly ending. But in some places the horse was still used for hauling and delivery until after World War II.

In the pioneer days in Vermont the two-wheel cart pulled by oxen was the preferred means of transportation on poor and rutted roads. But by the end of the nineteenth century the horse was king. There were over 80,000 horses on Vermont farms in 1910, and many more in the cities and small towns. On the farm, horses provided the power to plow and harvest, to haul and carry. Even in the towns and cities the presence of the horse was evident everywhere. The smell of horses and horse manure was hard to escape even in stores, houses, and churches. There were few paved streets, and the manure mixed with the dirt to create a viscous mess after a rain and an irritating dust that penetrated everything when the summer winds blew. Some were allergic to horses (called horse fever in the nineteenth century), and they were constantly wheezing and sneezing.

Every city and many small towns had livery stables where horses could be stabled for a day or longer and where those without horses could rent them, along with a wagon. Traveling salesmen, or drum-

mers, arrived at a railroad station with their cases and trunks filled with samples. They rented a horse and buggy at the local livery stable and then spent several days traveling to the neighboring towns where there were no railroad connections. After they had made their sales they packed up their cases and went on to the next town. Local citizens could also rent a horse and buggy for a wedding, a funeral, or perhaps just to take a ride in the country. Livery stables were male domains, where men gathered to tell stories, to swap gossip, to smoke, even to drink and to swear. Women were not welcome, and mothers warned their sons about such places, almost as dangerous as the saloon or the pool room, but, of course, the sons found the livery stable fascinating and irresistible.

Horse-drawn delivery wagons carried groceries, ice, meat, baked goods, and other products to individual houses. Larger wagons drawn by teams of work horses "freighted" lumber, milk, grain, even granite to the railroad station and to building sites. Harness shops made and repaired the various leather saddles, belts, and straps necessary in the age of the horse. Blacksmith shops repaired broken wagon wheels, shoed horses, and created an endless array of iron tools, hinges, and contraptions. The sound of the blacksmith's hammer striking the anvil was one of the constant sounds of the horse-drawn age.

The pace was slow in the age of the horse. Although some high-spirited horses moved at a fast clip, and there were many accidents caused by runaway horses and overturned wagons, most horses moved at a few miles per hour. The landscape looked different at that speed than it would in the age of the auto. The speed and range of the horse determined the way towns were laid out and the location of schools and churches. The horse even influenced dating customs, and determined the patterns of social relationships.

The golden age of postcards marked the transition from horse to auto. Many early photo cards capture and preserve the world of livery stables, hitching posts, and watering troughs.

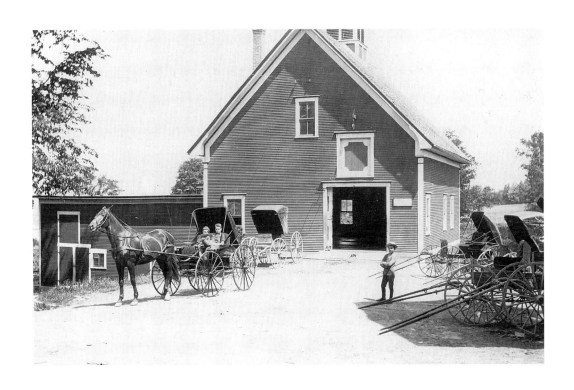

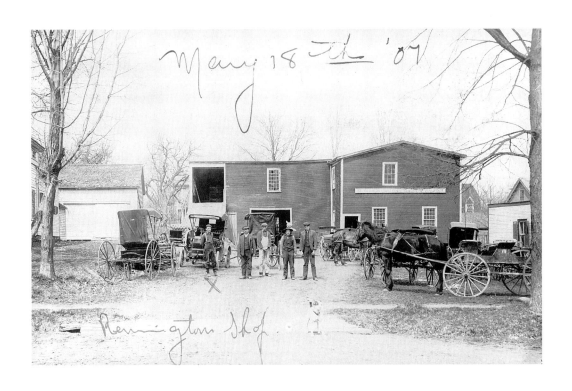

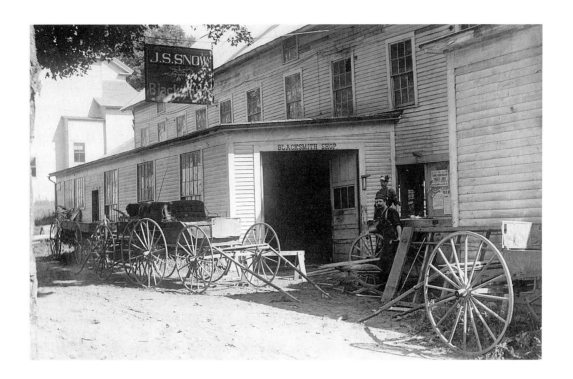

Two carefully posed photo cards—a livery stable in Hartford (*top left*), and a wagon shop in Bennington (*bottom left*). The sign reads "Bennington Carts and Wagons," and the message on the back of the card, mailed in 1907, reads, "Here is a picture of the place where my dear brother spends his time mostly." (*Above*) A blacksmith shop in Saxtons River. The blacksmith shop was an essential place in the age of the horse. The blacksmith was an important citizen and businessman in a small town, looked up to and depended upon. He made horseshoes, shoed horses, and made and repaired wagon wheels, tools, and anything made of iron. Livery stables, blacksmith shops, and wagon shops were especially intriguing for little boys who pose stiffly in one photo (*top left*). All three of these photos provide rather stylized and carefully posed images of commercial institutions.

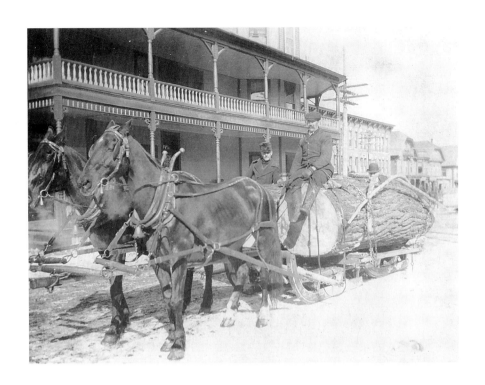

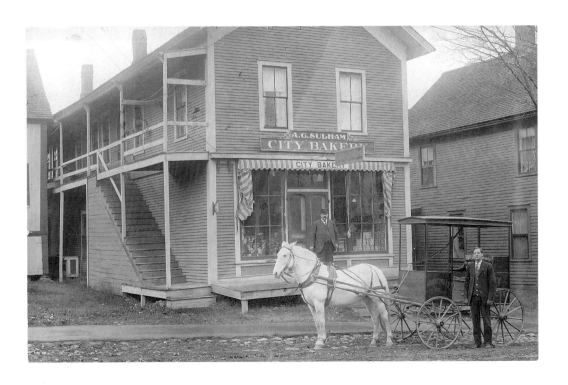

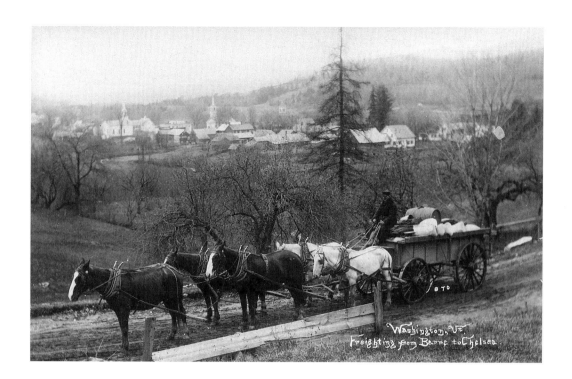

Horses provided the power for long and short hauls. (*Top and bottom left*) Two kinds of hauling in Morrisville show a team of horses dragging an impressively large log through the village on the way to the sawmill, and a well-dressed man standing beside a bakery delivery wagon pulled by an equally elegant white horse. (*Above*) A five-horse team pauses in Washington while hauling freight between Barre and Chelsea. Even after the railroad transformed transportation in Vermont, "freighting" by horse-drawn wagons between towns and to rail centers remained important into the 1920s. Chelsea never did attract a railroad even though it was (and is) a county seat (or "shire town," as they are known in Vermont).

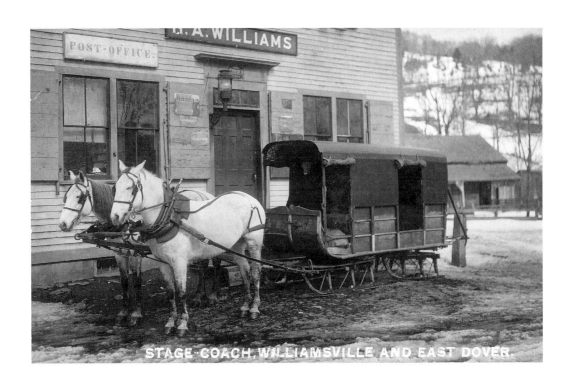

STAGE-COACH, WILLIAMSVILLE AND EAST DOVER.

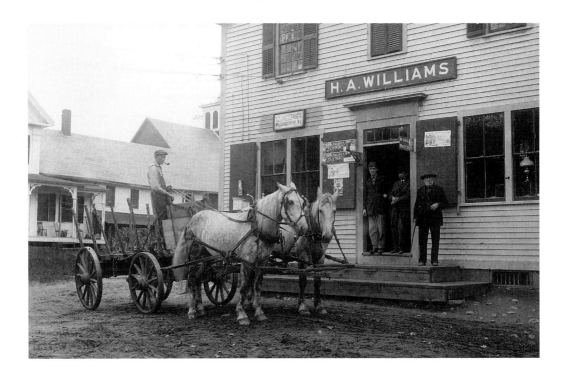

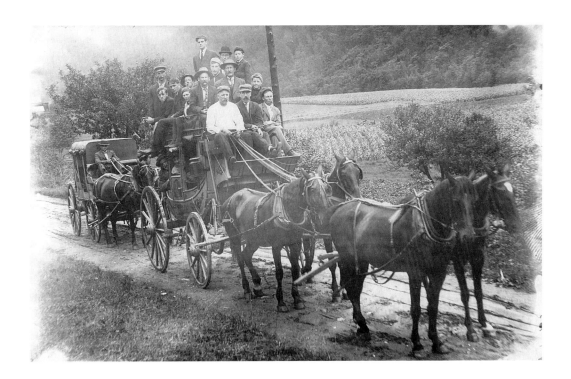

The Hastings Williams Store in Williamsville, circa 1910–1915, was started by Williams' great-grandfather in 1828 as an adjunct to his carding and grist mills. In these two photos, two different matched white horse teams pull two different kinds of vehicles. (*Top left*) This photo, which appears to be earlier (notice the post office sign replaced by the smaller sign in the other photo, *bottom left*) is a wintertime scene with a covered sleigh stage. (*Bottom left*) The other photo shows a utilitarian work wagon in front of the store while three patrons pose in the doorway. The advertisements are for "Salvert—Destroys Worms," "Flash—For Cleaning Hands," and "McCall's Patterns." (*Above*) A Concord Coach and a smaller covered wagon parade in Granville in 1910. By the early twentieth century the era of the Concord Coach was over, but many towns brought them out for fairs and festivals. However, horse-drawn stages, and then auto stages, connected Vermont towns until after World War II.

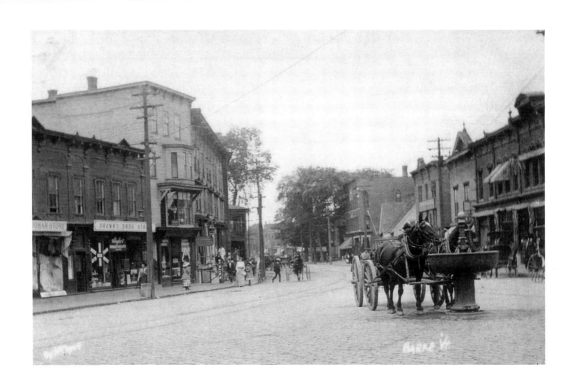

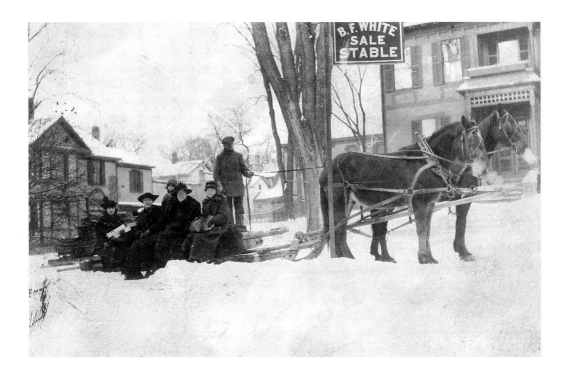

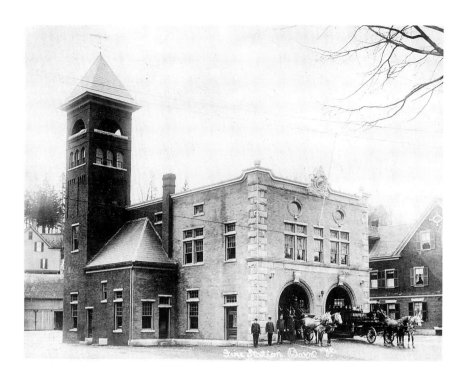

Horse-drawn vehicles were part of the urban scene early in the twentieth century. (*Top left*) Two work horses drink from a watering trough in Barre while in the background a more elegant horse and carriage moves rapidly about town. (*Bottom left*) Well-dressed ladies get a ride on a sleigh past a livery stable in Burlington. (*Above*) Horse-drawn fire engines at the Barre Fire Department.

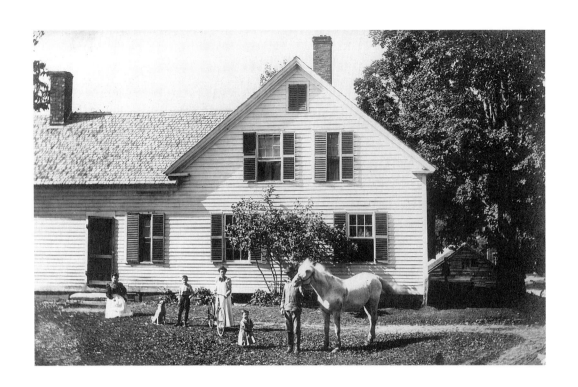

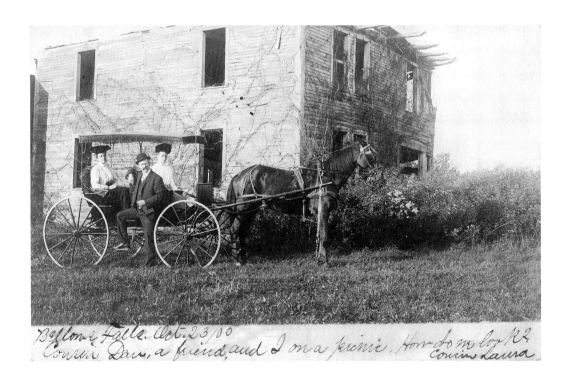

Bellows Falls. Oct. 23/00
Cousin Dan, a friend, and I on a picnic. How do we look? Cousin Laura

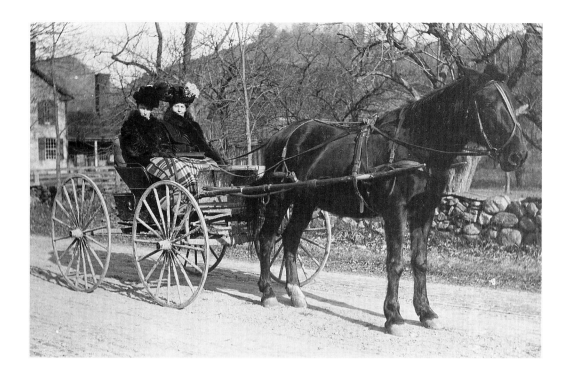

Horses, often treated like members of the family, were sometimes depicted in family groups carefully posed by a local photographer. (*Top left*) This postcard, which was found with a group of Vermont cards, has no location. Do you recognize the building or the family? It is a typical shot taken by a professional photographer who probably arranged the family members in front of the house. Some interpreters of old photographs, however, argue that one can understand family relationships by the body language and the positions taken by the various family members. (*Bottom left*) A well-dressed threesome with an elegant horse and wagon pose beside an abandoned house near Bellows Falls. The message at the bottom of the card, mailed October 23, 1905, reads: "Cousin Dave, a friend and I on a picnic. How do we look?" A fourth passenger probably took the picture. (*Above*) Two austere but elegantly dressed ladies with fashionable hats, fur coats, and a lap robe, ready for a ride in Townshend.

4

Farm and Factory

Vermont seems synonymous with farming, and the images of cows in the pasture and of farmers loading hay, plowing fields, and gathering maple sap are among the enduring symbols of the state. Farming was the predominant occupation of Vermonters until well into the twentieth century, but Vermont also had textile factories and quarries. It produced furniture, farm machinery, platform scales, organs, and many other items. Even though Vermont was one of the most rural states in the nation in 1910, there still were many industrialized centers throughout the state, and many of the small towns had factories.

The nature of agriculture changed over the years. The early setters were largely subsistence farmers, raising most of what they consumed. Their primary cash crop was potash made from hard wood ashes, and perhaps a small amount of maple sugar. Rye, wheat, and corn could be grown on the newly cleared land, but after a few years the wheat production dropped. Most farmers had a cow or two, a few sheep, some poultry, and a pig. Subsistence farming survived in many areas, but by the 1830s many Vermont farmers concentrated on raising sheep. Textile factories in Massachusetts and then in Vermont and New Hampshire increased the demand for wool, especially long-staple wool from the Merino sheep, first introduced into Vermont in 1811. Merino wool was rich in lanolin, and the cold climate increased the thickness and the weight of the fleece. In 1810 there were 580,000 sheep in the state. By 1840 that number had increased to 1,681,000, six sheep for every person in the state. Sheep farming was concentrated in the Lake Champlain

and Connecticut River valleys, with the town of Shoreham alone having more than 41,000 sheep, but farmers in all sections of Vermont raised sheep, and wool became the chief cash crop of the state's farmers.

Sheep farming declined as rapidly as it had risen. The decline in the protective tariff on wool in 1846, and increased wool production in the West and as far away as Australia, together with improved transportation, made it difficult for the Vermont wool to compete in the global market. By 1870 the sheep population in the state had declined by 64%. Some Vermont farmers continued to raise sheep, but by the time of the Civil War most had turned to dairy farming.

The typical Vermont farm in 1880 had eight or ten cows, and the cash crop was butter, not whole milk. The process of making butter on the farm started with placing the milk in shallow pans, skimming off the cream, then churning the cream into butter. The butter had to be worked on a table, then placed in tubs to be transported to the local store or to a railroad station. Butter production was time-consuming and complicated, and the quality of butter determined the price. Most of the work of making butter was done by women on the farm.

Dairy farming was very different from sheep farming. Sheep could forage for themselves on the rocky, thin soil of Vermont hills. They needed to be sheared only twice a year and to be provided with minimal shelter during the winter and a small amount of hay when no grass was available. Cows, on the other hand, had to be milked twice a day, every day. They needed barns for the winter months and for milking, and they ate great quantities of hay. And not just any cow would do. In the early nineteenth century most cows in Vermont were Devons or Durhams, but with milk quantity and butterfat content crucial most farmers raised Ayrshires, Holsteins, and Jerseys, with Jerseys being the most popular during the butter-making era. Holsteins became the favorites when whole milk replaced butter as the primary product.

The shift from sheep farming to dairy farming, which took place gradually over many years, changed the look of the Vermont landscape as well as the vernacular architecture. The hilltops where the sheep once foraged began to grow back to woods, while the hay fields and pasture land in the valleys and partway up the hills gave a checkerboard look to the landscape that became Vermont's signature. The time

when the greatest amount of Vermont was cleared land was probably about 1880, with about 70% cleared land and 30% forested, though some experts would place it as early as 1850. And they disagree about the amount of cleared land. The images of the landscape on postcards from early in the twentieth century show land beginning to return to forest; still, the hills seem bare compared to the way they would look in the later part of the century.

The decline of sheep farming was only one trend that influenced agriculture in Vermont and the look of the landscape. Many farmers abandoned their hill farms because they could not compete with the more fertile and flatter land in the Midwest or even with the valley farms in Vermont where new farm machinery made crop production more efficient. The largest total number of farms in Vermont was 35,000 in 1880. That number declined to 33,000 in 1900 and to 24,000 in 1940, with many farms abandoned during the Depression. Although most Vermont farms remained primarily dairy farms, many produced other crops as well—a pig or two for family consumption or for sale, poultry and eggs, and a large garden that sometimes allowed the farm family to survive. Some farmers, especially in the Champlain Valley, also raised apples, and many farms produced some lumber and pulpwood. But the largest secondary crop was maple sugar. The Vermont Maple Sugar Association was organized in 1893, and it sought to improve the quality of the maple sugar produced, which reached a peak of 12 million pounds in 1930, more than produced in any other state. The 1930 crop was almost entirely maple syrup, while fifty years earlier almost all the production was maple sugar.

Until the mid-nineteenth century, farmers built all-purpose English barns, simple structures to shelter animals, store hay, and do a variety of farm tasks. Near the end of the century they constructed more elaborate high-drive bank barns to allow the wagons loaded with hay to go directly to the hay mow often three or four stories above the floor where the cattle were milked. Farmers had also learned to save the manure to use as fertilizer, but the combination of manure in the barn basement and many cows created a great deal of moisture in the winter. To solve the problem, cupolas were added to the barn roofs to provide ventilation. The transition in farming changed the look of the landscape and led

to the construction of the barns that became an important part of the rural scene in Vermont.

Butter remained the most important cash crop for most Vermont farmers for many years, but the production of butter was improved by the invention of mechanical cream separators and the Babcock tester, which provided an easy way of measuring the butterfat content of milk. One version of the separator was invented by William Cooley of Waterbury. Called the Cooley Creamer, it was patented in 1877 and produced in the 1880s by the Vermont Farm Machine Company of Bellows Falls. Along with other inventions and improvements, it enabled the production of butter to move off the farm into commercial creameries located on railroad sidings. Butter production in creameries increased from 5,000 pounds in 1879 to 22 million pounds in 1899. In 1900, St. Albans was the largest butter center in the world, producing more than 2 million pounds a year, but other smaller creameries were scattered around the state. On the other hand, cheese production in the state declined after 1850, because Vermont had no advantage over Wisconsin or New York. By the 1920s fluid milk, which could be shipped directly to Boston and New York in refrigerated railroad cars, replaced butter as the main crop in Vermont. In 1935 nearly 270 million pounds of milk were shipped from Vermont to Boston.

Although Vermont remained one of the most rural states in the nation and farming the predominant occupation, the state was also the home of many factories, as well as quarries and mines. The first major industry in Vermont, and in the rest of the world, was textile manufacture. Various operations—carding, spinning, and weaving—were combined in one building, first at Lowell, Massachusetts, then elsewhere, including Vermont. In 1850 there were 156 textile mills in Vermont, both cotton and wool, with the largest factories in Bennington, Winooski, Springfield, Middlebury, Bethel, and Northfield. But many of the small mills had gone out of business by the early twentieth century, and Vermont never produced more than 5% of the total New England production. The American Woolen Mill in Winooski was one of the largest woolen mills in the country, but most of the textile mills in Vermont were small and seemed to fit naturally into the environment. Thomas Jefferson and other Americans, early in the nation's history, worried that

the United States would follow Europe's example and build huge industrial cities with all the problems that they created. They hoped to avoid urban problems by placing factories in the countryside and small towns. Vermont factories, even more than those in Massachusetts, seem to be "workshops in the wilderness." Ralph Flanders once described Springfield, Vermont, as a center of manufacturing surrounded entirely by cows. Vermont did not avoid all the problems created by industrialism and urbanism. The factories polluted the streams. Textile mills and granite polishing sheds were unsafe and dangerous places to work. Still, compared to southern New England and New York, Vermont factories did seem like workshops in the wilderness.

The photographs on postcards depicting factories usually presented a monumental and benign view of industrial plants. They usually provide a long-distance view from a hillside or close-up shots of the front of a building with few or no people around. They often appear to have been taken on Sunday mornings when the plants are not operating. Rarely do we see the railroad sidings or the messy storage lots. Some of the photos do show smoke or steam pouring from smokestacks, but early in the twentieth century smoke usually symbolized progress, not pollution.

Lumbering was a major industry in the state, with a peak of 384 million board feet cut in 1890 (a board foot is 12 inches by 12 inches by 1 inch), with that number declining to 91 million in 1925. Early in the nineteenth century, Burlington was a major lumber center, with both logs and lumber being shipped north to Canada, and then later south through the Champlain Canal into the Hudson. There were huge log drives on the Connecticut River in the spring of each year. The last major drive was in 1915, but almost every village in Vermont had at least one sawmill.

Proctor and West Rutland became important marble cutting and polishing centers in the late nineteenth century, making Vermont the leading producer of marble from 1870 to 1930. Barre, Hardwick, and Bethel helped to make Vermont either first or second in granite production from 1870 to 1950. Vermont was second to Pennsylvania in slate production and also produced significant quantities of asbestos and talc.

Vermont also had many specialized manufacturing plants. There

were major furniture factories in Orleans and Beecher Falls. Scales were produced in St. Johnsbury and Rutland, organs in Brattleboro, machine tools in Springfield, and farm machinery in Bellows Falls. Vermont remained predominantly rural, but with railroads, electric lines, and telephone and telegraph connections the state began to share some of the advantages and disadvantages of urban industrialism. Most Vermont postcards depict the beauty of rural scenery, the charm of small towns, but some promote and celebrate manufacturing and industry as well as farms.

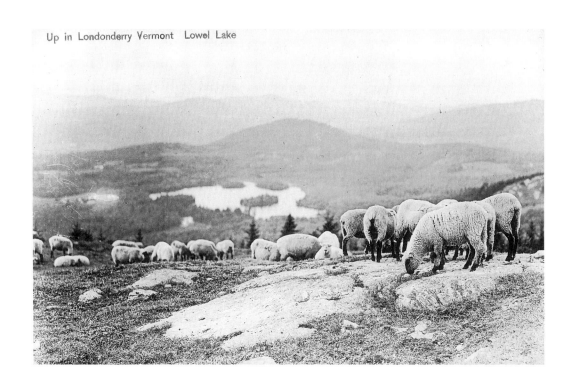

Up in Londonderry Vermont Lowel Lake

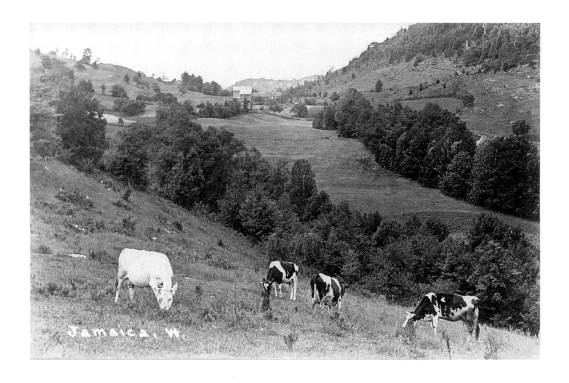

Jamaica, Vt.

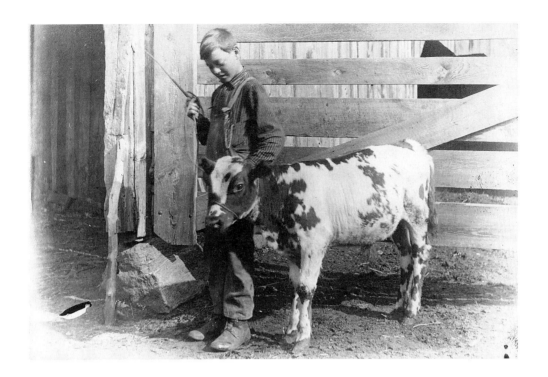

Despite Vermont's reputation of having more cows than people, there are very few postcards depicting cows, and even fewer showing sheep. (*Top left*) Sheep grazing in Londonderry. This photo illustrates how sheep can survive on rough, rocky, high terrain. (*Bottom left*) Cows in a hill pasture in Jamaica. The hills are already filling in with trees in this early twentieth-century view. (*Above*) A young farmer from Springfield getting his calf ready to display at the Vermont State Fair.

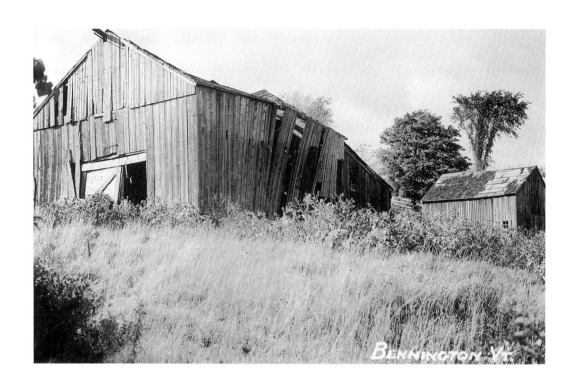

BENNINGTON VT.

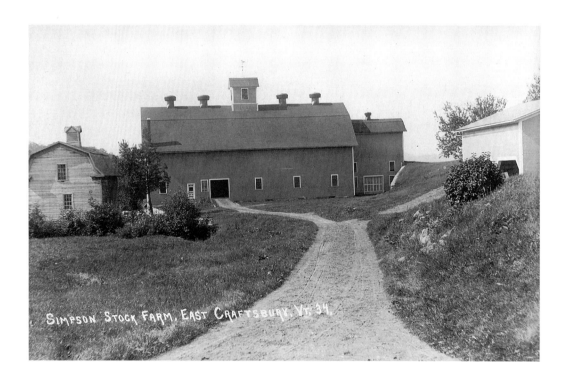

SIMPSON STOCK FARM, EAST CRAFTSBURY, VT. 34.

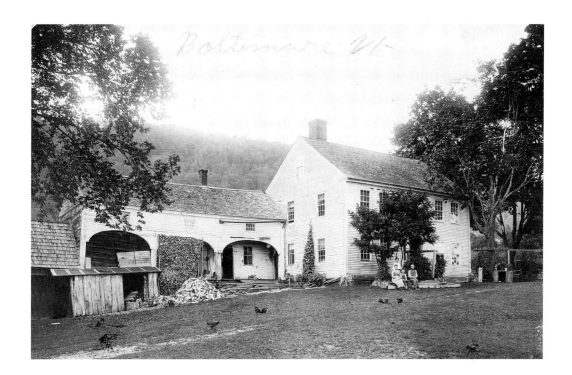

(*Top left*) An abandoned English barn is nearly ready to collapse in the foreground, while an adjacent barn, near Bennington, isn't in much better condition. These barns were probably built about 1850 and are victims of the flight from the hill farms early in the century. This card was mailed March 3, 1910. (*Bottom left*) A high-bank barn built by John Woodruff Simpson in East Craftsbury in 1906. The entrance to the right had a steep incline to allow the wagons filled with hay to go directly to the hay mow, four stories above the ground floor. The cupola lets in air, but the ventilators may have been added later. (*Above*) Members of a family, along with chickens and a dog, pose in front of an impressive farmhouse in Baltimore. In typical Vermont fashion, the shed is connected to the house and perhaps also to the barn, which is out of the picture. The house was probably built in the 1790s, with the shed added later. This family has a good supply of wood split into small pieces for the kitchen stove. Baltimore, situated between Cavendish, Weathersfield, and Chester, is one of the smallest towns in the state, with only 3,190 acres and fewer than a hundred residents in the years since the Civil War. It has never had a post office or a village center, but this postcard, mailed in 1913, pictures what must have been a prosperous farm.

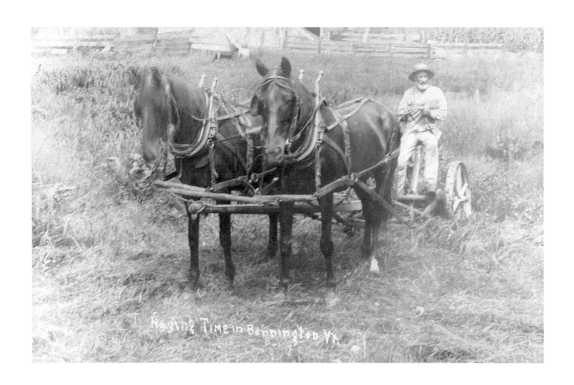

Haying Time in Bennington, Vt.

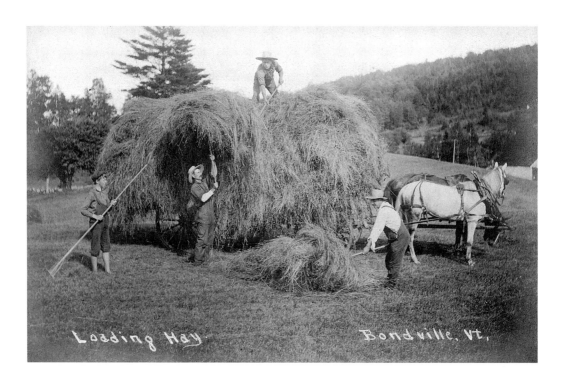

Loading Hay. Bondville, Vt.

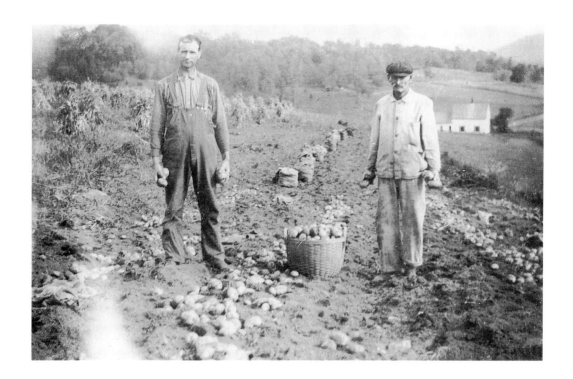

(*Top left*) By the first decade of the twentieth century most dairy farmers had replaced the hand scythe with a mowing machine and the hand rake with a mechanical, horse-drawn rake. The Vermont farmer might dream of using the new combines in common use on Midwestern farms, but they were impractical in the hill farms of Vermont. The mower worked well because the farmer could raise and lower the cutting bar to avoid rocks. This card was mailed in June 1908. (*Bottom left*) A carefully posed photo of a Bondsville farmer, his hired man, and his two sons, loading hay. This was an intricate and skilled job, and it is unlikely that the young boy on top of the wagon would have been trusted with the difficult task of locking in each pitchfork of hay to prevent it from falling off, and assuring it could be removed in reverse order in the barn. Haying was hot and back-breaking work, but it seemed romantic and was often pictured on postcards. (*Above*) Farmers picking potatoes in Concord, another tiring farm task. Behind them are corn stocks cut by hand with a corn sickle and gathered in bundles to dry. This looks like a small farm with the corn and potatoes for family use, with perhaps a few bushels left over to trade.

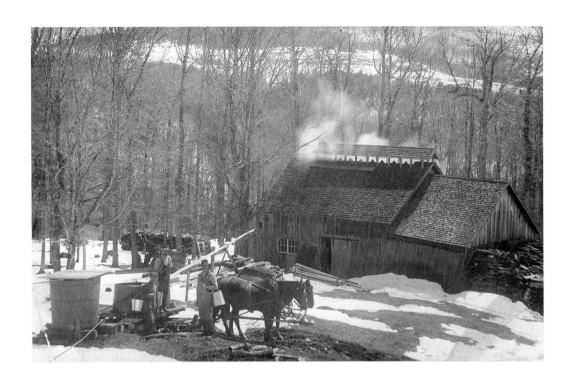

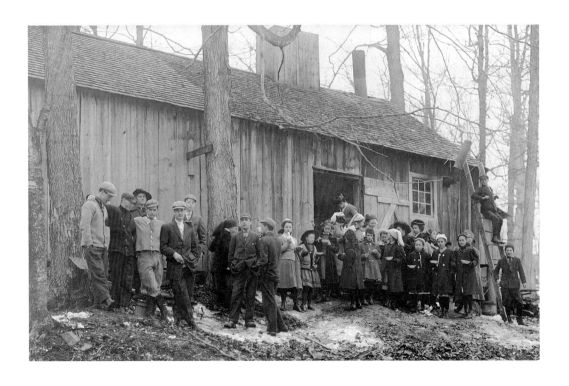

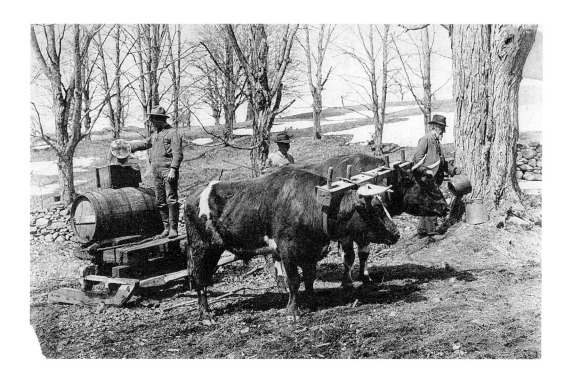

Haying and grazing cows were part of the romantic image of rural Vermont, but so was maple sugaring. (*Top left*) Gathering sap, circa 1910, near Rutland with a horse-drawn wooden gathering tank, but new metal pails. (*Bottom left*) One custom enjoyed even by Vermonters was a sugaring off party. Here quite well-dressed young people gather at a sugar house near Greensboro Bend for sugar on snow. (*Above*) In most cases horses had replaced oxen in Vermont sugar bushes by 1910, but the romantic scene of oxen pulling wooden gathering tanks survived on postcards for many years. This card, part of a series, is entitled "Sap's Runnin' in Weathersfield, Vt."

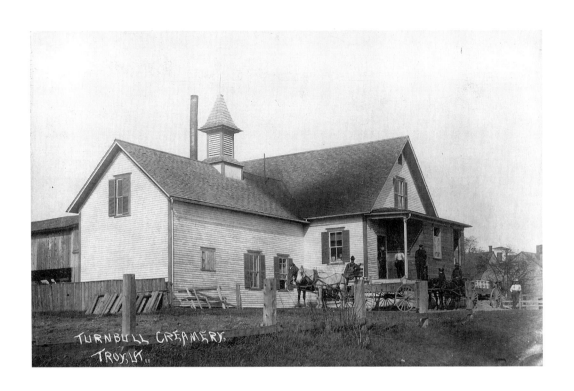

TURNBULL CREAMERY.
TROY, VT.

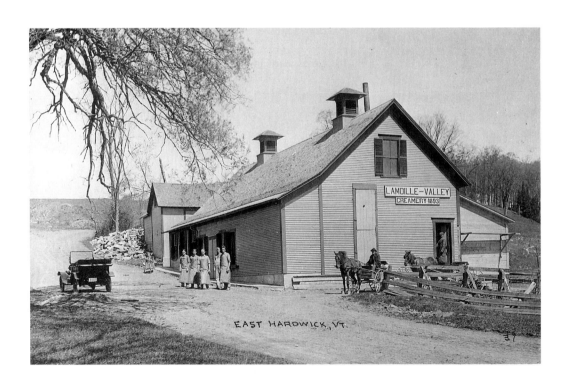

LAMOILLE-VALLEY
CREAMERY 1893

EAST HARDWICK, VT.

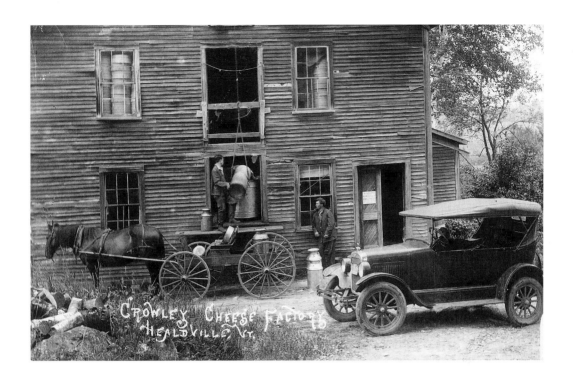

Commercial creameries in (*top left*) Troy, circa 1910, and (*bottom left*) East Hardwick, circa 1915. After the invention of the Cooley Separator and the Babcock Tester, more and more butter was made in creameries such as these, which were located near a rail line. Creameries replaced the home production of butter, just as these small creameries eventually lost out to bigger operations and to the refrigerated railroad car that could transport whole milk to Boston. (*Above*) Pouring milk or cream one can at a time into a container at the Crowley Cheese factory in Healdville, a village in Mt. Holly, sixteen miles south of Rutland, circa 1924. Vermont could not compete with New York or Wisconsin in cheese making, but Crowley Cheese had an excellent reputation. Notice the round boxes of cheese stored upstairs.

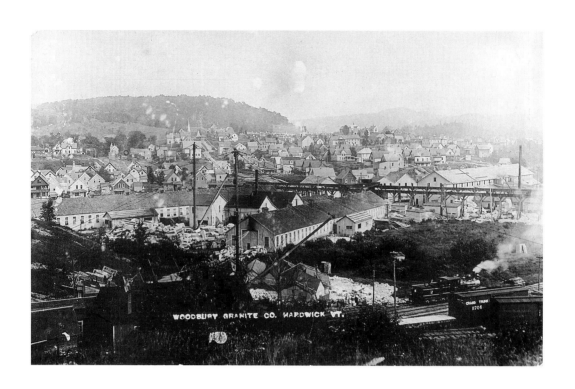

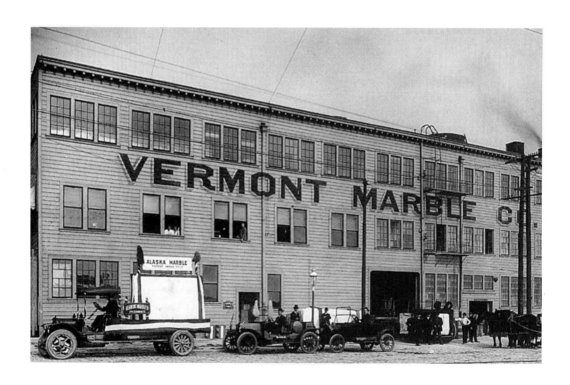

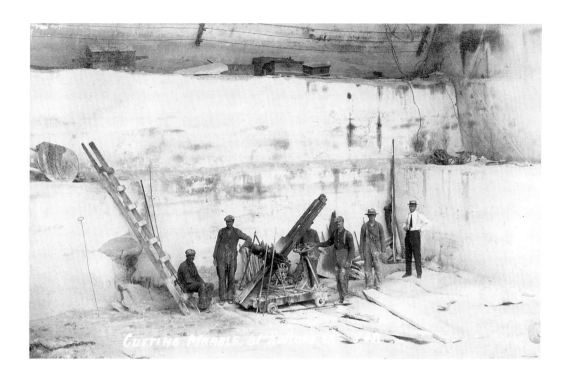

(*Top left*) The Woodbury Granite Company in foreground dominating the village of Hardwick, circa 1910. Specializing in building granite, the Woodbury Granite Company also had sheds and quarries in Bethel. It cut and polished the stone for the Pennsylvania State Capitol, the Wisconsin State Capitol, city halls in Cleveland and Chicago, and many commercial buildings in New York, Chicago, and elsewhere. During peak periods the company employed as many as 600 men. In the right foreground is Engine Number 2 of the Hardwick & Woodbury Railroad, a 10½-mile line that brought the granite from the quarries in Woodbury to the sheds in Hardwick. The grade was so steep that special engines such as this one, which was manufactured in Peru, were used to negotiate the hills. (*Bottom left*) Vermont Marble Company in Proctor, founded in 1880 by Redfield Proctor. In this photo, circa 1910, a special piece of Vermont white marble is being moved by truck, but most of the marble was shipped by rail. The Indiana and Oregon State Capitol buildings and the Supreme Court Building in Washington, D.C., were all built of marble from the Vermont Marble Company. From 1880 to 1930 Vermont was the largest marble producer in the nation, and most of it came from plants such as this in Proctor and West Rutland. (*Above*) Cutting marble underground was both dirty and dangerous. This carefully posed photo postcard depicts marble workers in West Rutland. The supervisor is on the right with white shirt and tie.

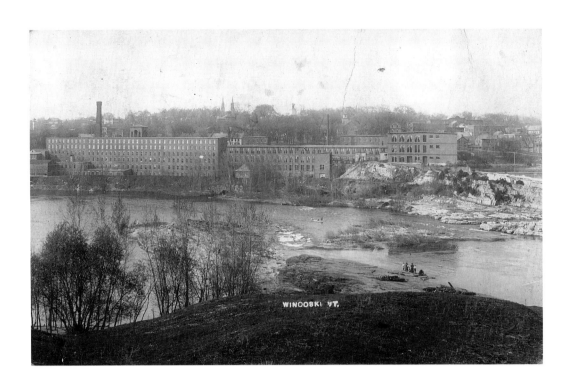

WINOOSKI VT.

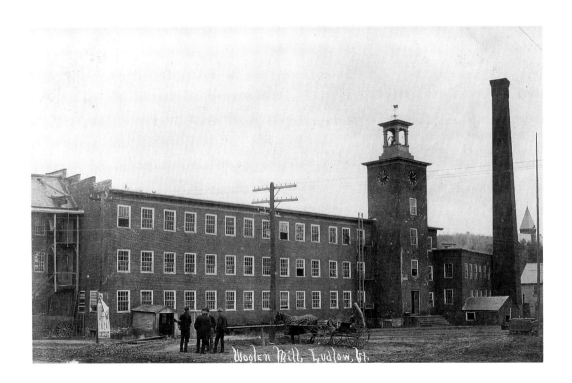

Woolen Mill Ludlow, Vt.

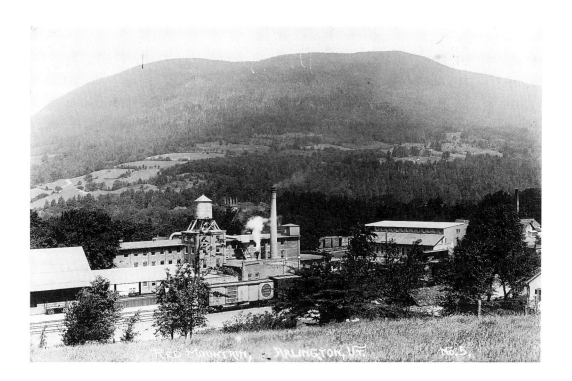

The textile industry was important to Vermont even though the state's production was only about 5% of the total New England output. Textile mills along the rivers gave an industrial look to a rural state. (*Top left*) The American Woolen Mill in Winooski (card mailed 1913), about the time that the mill employed more than 400 people, at least half of them women of French-Canadian background. (*Bottom left*) A smaller woolen mill in Ludlow, circa 1910. (*Above*) The Arlington Refrigerator Company—with water tower, smokestack, and belching steam—sits next to the railroad tracks. This postcard, mailed in 1912, illustrates industrialism and manufacturing in Vermont. But the factory nestled under the mountain gives the pleasing impression of a "workshop in the wilderness."

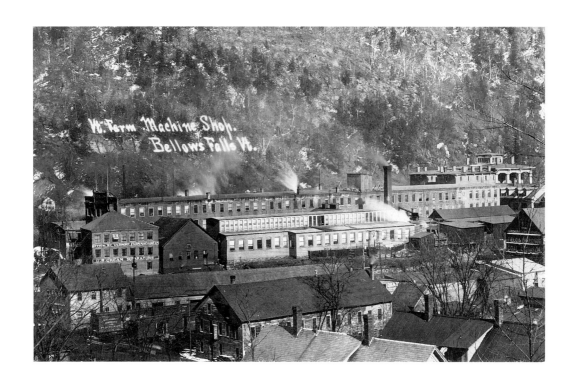

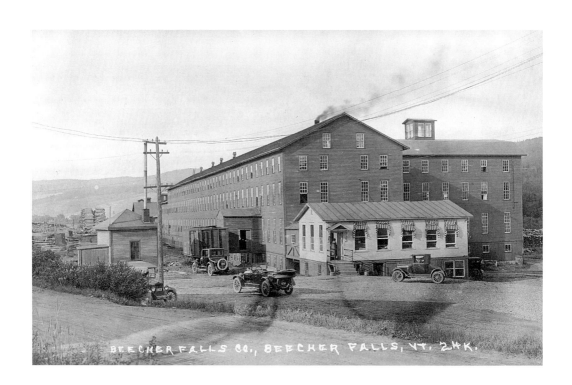

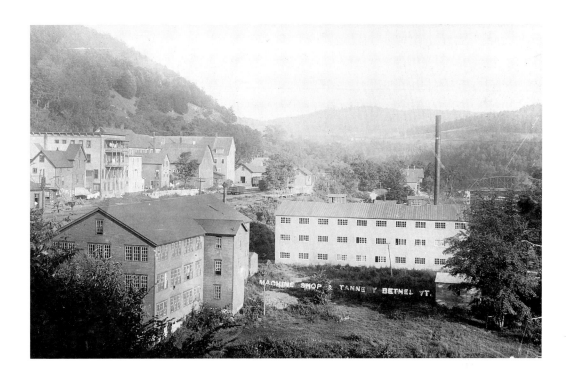

(*Top left*) The Vermont Farm Machine Company dominates this view of Bellows Falls.
The card, mailed in 1912, reports on the work of a young woman employee: "I am in
the general office. My work is comparatively easy, some posting, filing and copying."
The company, organized in 1873, manufactured dairy, creamery, and sugar-making
equipment, including the Cooley Separator, the Babcock Tester, and the Davis Swing
Churn, invented by my great-grandfather, Oliver W. Davis (1834–1913) of Waterbury
Center. (*Bottom left*) Even the small village of Beecher Falls in the town of Canaan in
the far northeast corner of the state had a bustling furniture factory, which employed
more than 150 men when this photo was taken about 1915. (*Above*) This postcard, circa
1910, pictures a machine shop and tannery in Bethel. This Central Vermont village on
the White River also had major granite quarries and sheds as well as textile mills. With
rail connections to White River Junction and Boston, this small town was also an indus-
trial center.

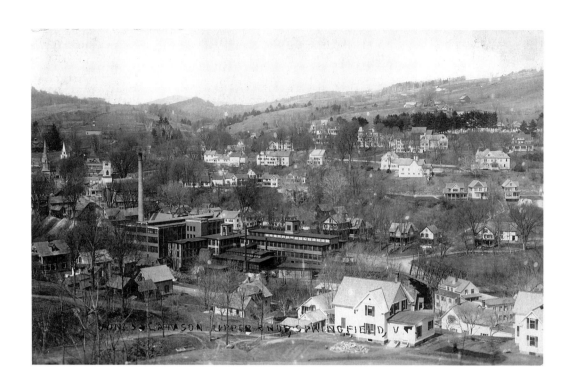

JONES & LAMSON UPPER & NO. SPRINGFIELD, VT.

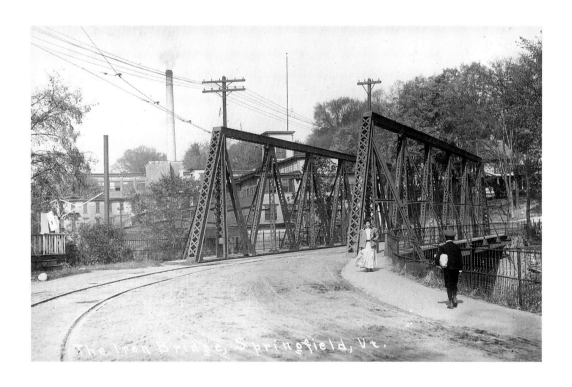

The Iron Bridge, Springfield, Vt.

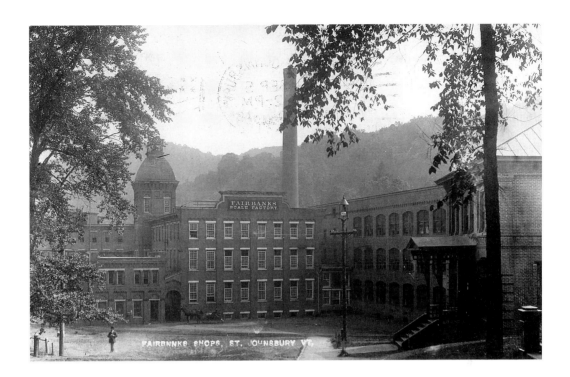

(*Top left*) The Jones and Lamson Company dominates this view of Springfield, circa 1910. The company produced lathes and machine tools and employed more than 700 people, and many more than that during World War I and World War II. (*Bottom left*) A close-up view of industrial Springfield. The iron bridge, trolley tracks, telephone poles, and smoke stacks from the factory in the background, along with the two young pedestrians, could place this scene in any industrial city about 1910, but it is in industrial Vermont. (*Above*) The Fairbanks Scale Factory in St. Johnsbury, circa 1910. In 1830 Thaddeus Fairbanks invented the platform scale, which was used by druggists and gold miners, as well as the local general store. It could weigh a bag of potatoes or, in its larger versions, a railroad box car. The Fairbanks family dominated the town and built an impressive museum and athenaeum. This photo, however, carefully framed and taken when no one was at work, creates a benign and attractive image of a factory where the work was often hard and demanding.

5

Men at Work

There are very few postcards depicting people working. Men and women at play, camping, hunting, fishing, traveling, and relaxing seemed more attractive to photographers, both professional and amateur. But occasionally a photographer recorded men at work, usually carefully posed in front of their machines or with shovels in hand. Women also worked, as did many children, but they are missing from the postcard images.

Lewis Hine, the progressive photographer, traveled in Vermont and took at least forty-six photographs of children, both boys and girls, working in the mills and factories, and in the marble and lumber industries, while he was working for the National Child Labor Committee between 1909 and 1916. He tried to document the worst of child labor abuses all over the country in order to help change the laws and to prevent children from being exploited. None of his photographs, to my knowledge, appear on postcards. The photographs of men at work, or men pausing in the workplace to pose for the photographer, lend a certain dignity to the laboring man. There is a stilted but proud quality to these portraits. They also allow us to study the faces—Italian, Irish, French-Canadian—and to notice the work clothes, hats, suspenders, and overalls, as well as the machines, tractors, and derricks.

Most workers in Vermont did not belong to unions. The exception was the granite industry in Bethel, Hardwick, and Barre, where the Granite Cutter's National Union and the Quarry Workers International were powerful. Barre especially was a strong union town, with 90% of the jobs union jobs at one point. Occasionally there were bitter strikes, such as

the one in 1922 when some companies brought in French-Canadian strike breakers. One postcard, mailed in 1910, showing a hundred or more workers in one of the quarries, has a message written across the face of the card: "Most of these men are now on strike."

The marble industry, unlike granite, was actively anti-union. The American Marble Company established its own company union with a company store and company-sponsored basketball teams and Boy Scout troops. When a strike broke out in 1904, only a very few workers supported it. The American Marble Company remained anti-union and paternalistic well into the 1930s. Most workers in Vermont were hired by the hour, fired when business was slow, and, like all workers before World War I, they had few benefits, no Social Security, unemployment, or disability insurance. Though Vermont was one of the first states to pass a workmen's compensation law in 1915, the state legislature consistently voted against laws designed to prohibit child labor.

Until the end of the nineteenth century, road builders and construction crews relied on teams of horses and on many men with shovels to remove rocks and dirt. Early mills depended on water power, then on steam, to drive the machines. In 1887 Daniel Best, a forty-nine-year-old farmer and inventor, attached wheels to a steam engine for use in logging. He called it a "tractor engine." Others called it a "tractor." A few years later a California farmer named Benjamin Holt replaced the wheels on his tractor with an endless band. He called it a "caterpillar tractor." In 1895 he developed a gasoline engine for his tractor. Early in the twentieth century steam shovels and steam tractors gradually were replaced by machines powered by gasoline engines, but in Vermont the transition took many years. Even with powerful machines, much work was done by men who sold their strength by the hour. These postcards reveal a time when horse power and steam and gasoline engines together with human strength worked together to cut and haul, dig and construct. Nothing took more energy than the hard, relentless work of logging—cutting, dragging, and sawing—and then riding the logs down the rivers in great drives.

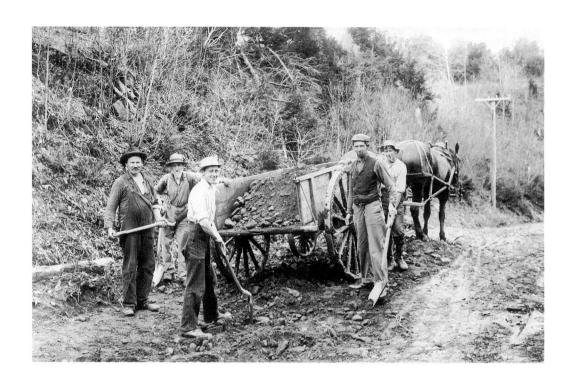

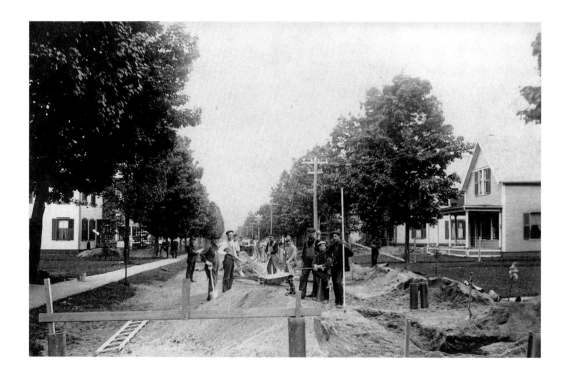

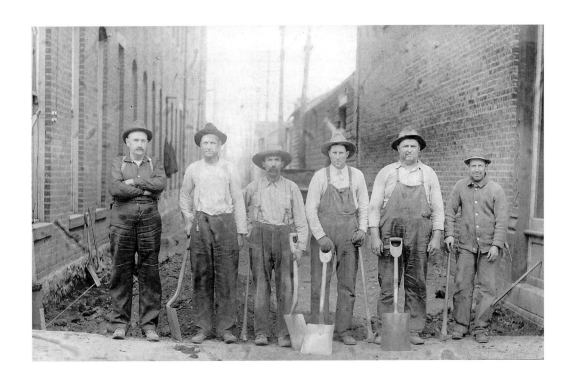

During the early part of the nineteenth century in most Vermont towns all able-bodied men had to work on town roads; later, they could either pay taxes or work. By the turn of the century, most road workers were hired by the town. (*Top left*) A card written May 13, 1908, in Williamsville and mailed the next day to Miss Lena A. Randall, in Newfane, reads: "Arrived home at 5 P. M. sweating to beat the band. Do you recognize the kid on the other side? Tough looking crowd ain't it." (*Bottom left*) Workers prepare for a new asphalt street in Randolph. The card was mailed July 9, 1907. (*Above*) A road construction crew in Rutland, circa 1908. The foreman stands at the left with arms folded, while the workers, of different ages and sizes, pose for the camera with their picks and shovels.

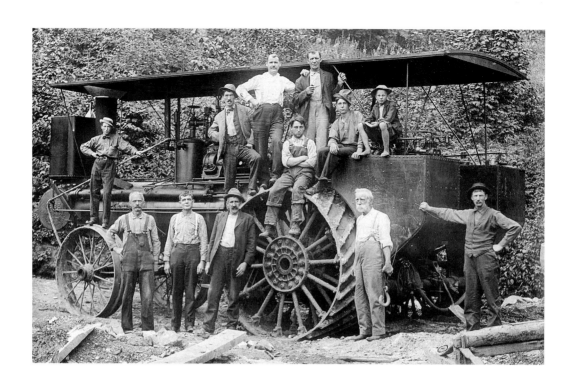

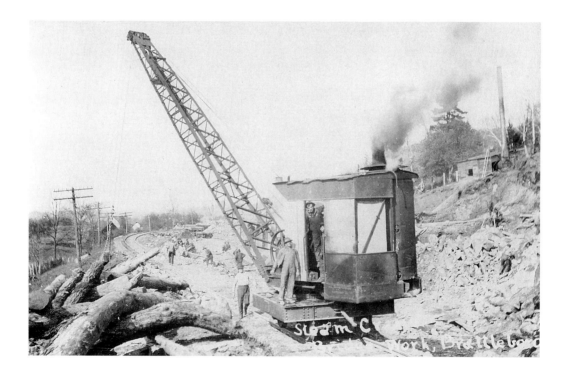

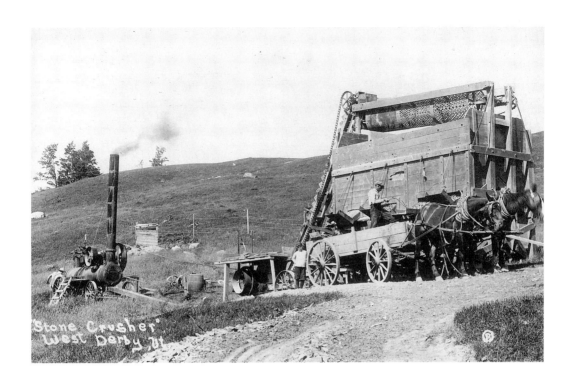

(*Top left*) Construction crew with steam tractor, Eden Mills, circa 1910. Most of the men and boys on top of the tractor seem to be observers rather than workers. (*Bottom left*) Steam crane clearing the railroad track near Brattleboro, circa 1910. (*Above*) A steam-powered stone crusher in West Derby, circa 1912. Crushed stone is loaded into a horse-drawn wagon, probably for road improvement.

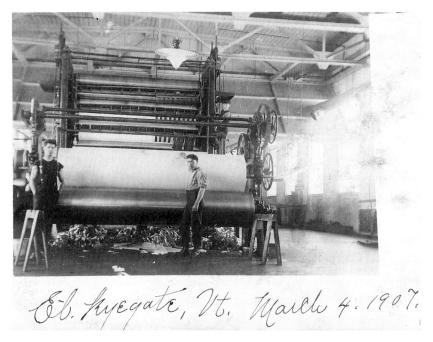

Two workers pose next to a large roll of paper at the paper mill in East Ryegate, March 4, 1907.

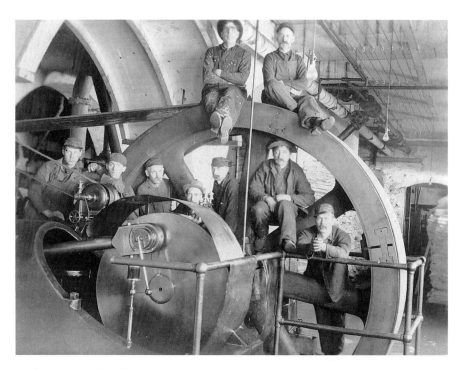

Workers pose inside and around a modern machine, probably at a power plant along the Connecticut River, circa 1910. Almost like Charlie Chaplin's *Modern Times*, this photo symbolizes the age of the machine.

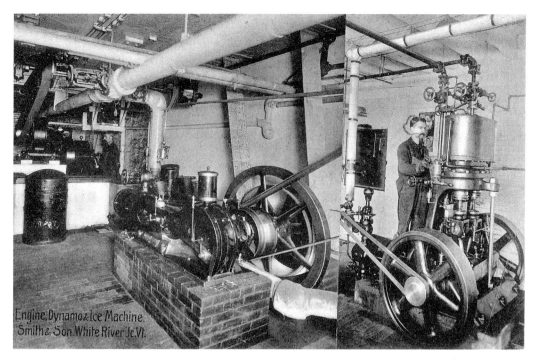

Ice-making machine in White River Junction.

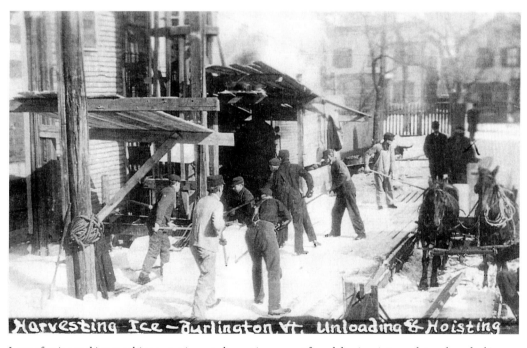

Long after ice-making machines were invented, most ice was cut from lakes in winter and stored, packed in sawdust and hay, in ice houses. Here men unload and hoist ice into an ice house in Burlington, a dangerous and cold job. This is an unusual photo because the photographer caught the men actually working, rather than posing near the workplace. *(Courtesy Vermont Historical Society.)*

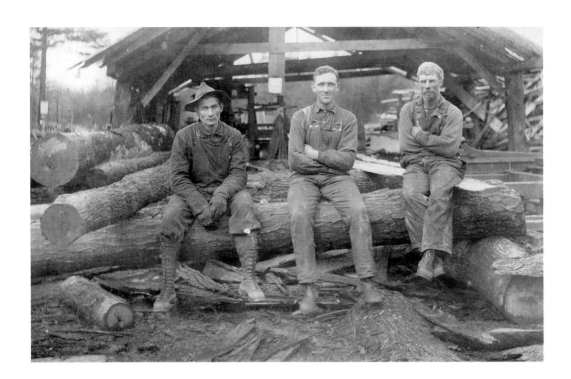

(*Above*) Sawmill workers in Springfield, circa 1910, a tough and perilous way to make a living. (*Top right*) Men at a logging camp near the upper Connecticut River. Teams of horses were used to drag the logs to the river for the spring drive. (*Bottom right*) Lumbermen using peavies (named for its inventor, Joseph Peavy of Stillwater, Maine) to move logs in the Deerfield River valley near Readsboro. The Deerfield Valley company built an 11-mile railroad to move logs to sawmills in Readsboro, but still much of the work had to be done by hand. (*Local History Photograph Collection, Fairbanks Museum and Planetarium Archives.*)

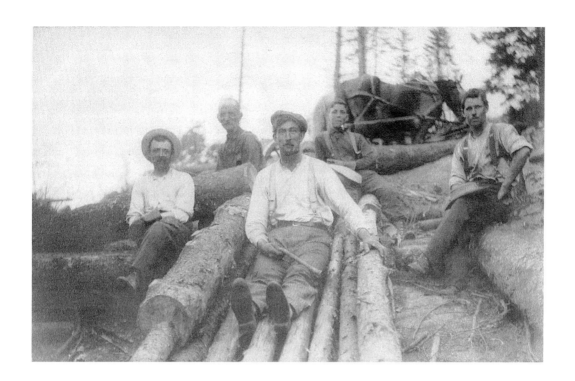

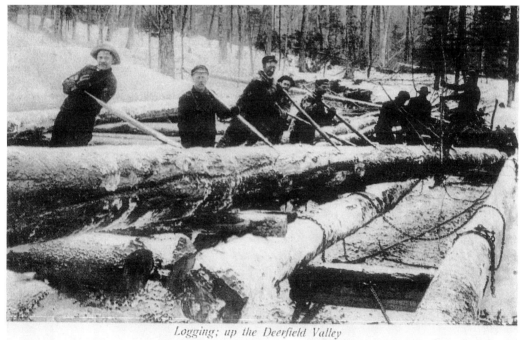

Logging; up the Deerfield Valley

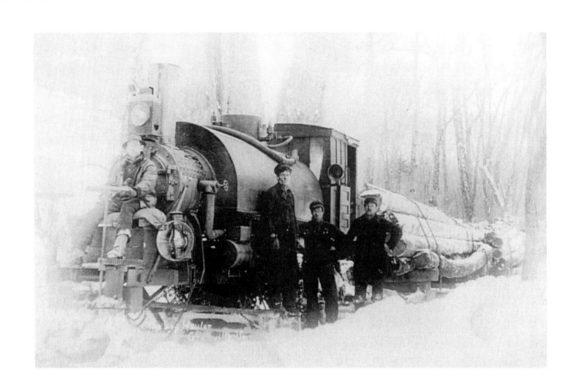

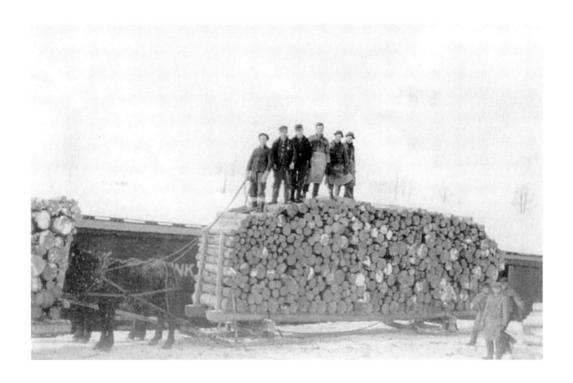

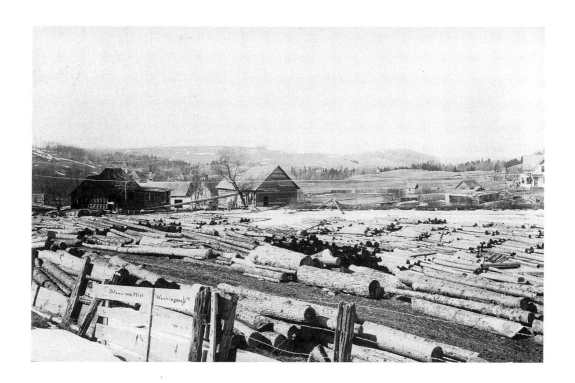

(*Top left*) A logging train in Granville, card mailed 1914. This was one of several short and temporary trains used to speed up the process of getting the logs to the mills or to the river for spring drives. *(Courtesy Vermont Historical Society.)* (*Bottom left*) A large wagon load of pulp being transferred to railroad cars. *(Courtesy Vermont Historical Society.)* (*Above*) A large lumber mill near Washington, circa 1908.

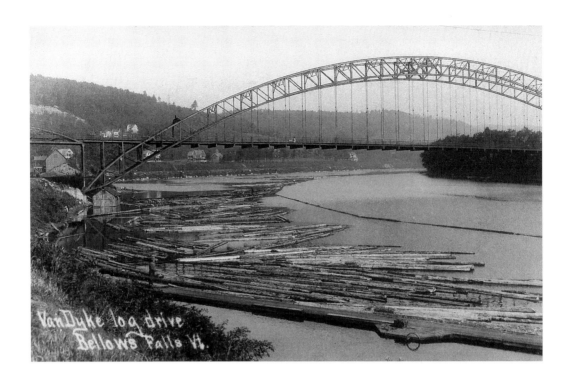

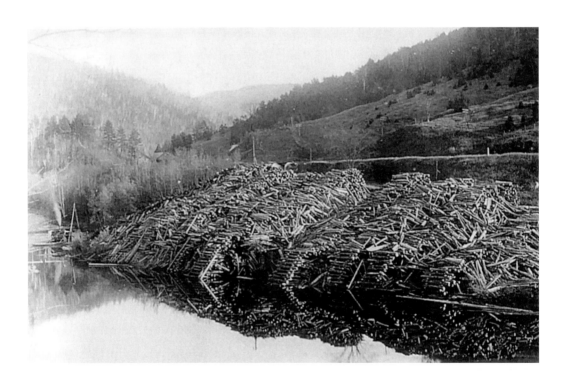

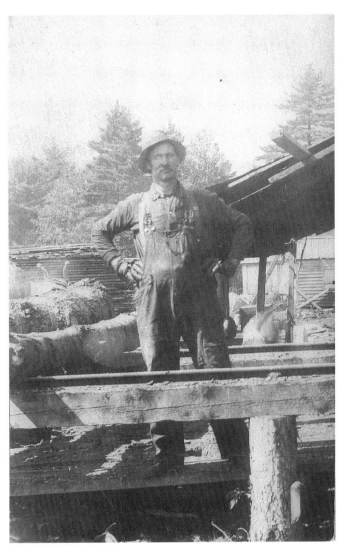

(*Top left*) Part of the Van Dyke spring log drive at Bellows Falls, circa 1908. George Van Dyke was one of the lumber kings of the Connecticut Valley. Born in Stanbridge, Quebec, in 1846, his father came from Highgate, Vermont. Van Dyke got his start as a logger and driver, but eventually he owned sawmills, railroads, and the Connecticut Valley Lumber Company, which organized the great log drives all the way from the Connecticut Lakes to mills in Holyoke, Massachusetts, and Hartford, Connecticut. Some logs made it all the way to Long Island Sound. The drives averaged over 50 million board feet a year. This photo was taken at Bellows Falls about 1908 near the most difficult falls on the river. It sometimes took several weeks for the logs to clear this section. When Van Dyke died in 1909 his fortune was estimated at more than 10 million dollars. The last great drive on the Connecticut was in 1915. (*Local History Photograph Collection, Fairbanks Museum and Planetarium Archives.*) (*Bottom left*) Logs stacked up waiting for the log drive on the White River in Sharon. The logs would go down the White River until it joined the Connecticut and then down the Connecticut. Hundreds of men were employed in the drives, some in bateaus or rafts who tried to guide the logs, and others who actually walked on the logs and used their peavies to prevent jams. It was risky work, where one misstep could mean instant death. (*Courtesy Vermont Historical Society.*) (*Above*) A proud sawmill worker in the upper Connecticut Valley. (*Local History Photograph Collection, Fairbanks Museum and Planetarium Archives.*)

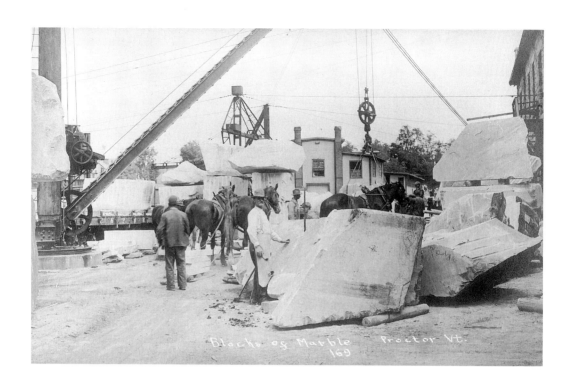

Blocks of Marble — Proctor Vt.
169

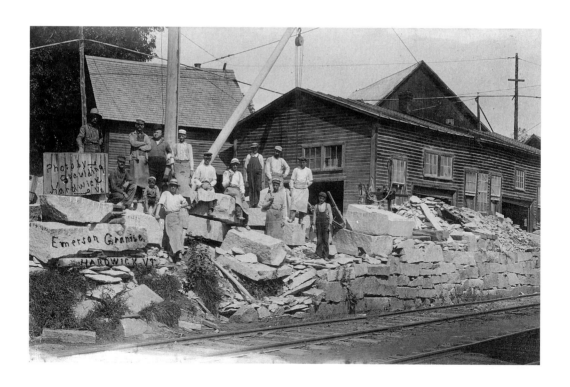

Photo by Gravlding Hardwick Vt.

Emerson Granite HARDWICK VT.

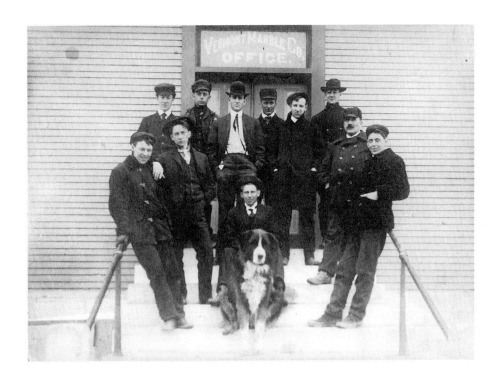

(*Top left*) Marble workers in Proctor. (*Bottom left*) Granite workers in Hardwick. Working in the stone quarries was hard and hazardous work, but the granite sheds were more dangerous than the marble sheds. Granite is a harder stone, which meant that cutting and polishing it released tiny particles into the air. Breathing these particles over a period of years caused lung disease, which often led to early death. (*Above*) Not everyone who worked for the stone companies worked in the quarries or sheds. These are clerks and bookkeepers posing outside the Vermont Marble Company office in Proctor, circa 1910.

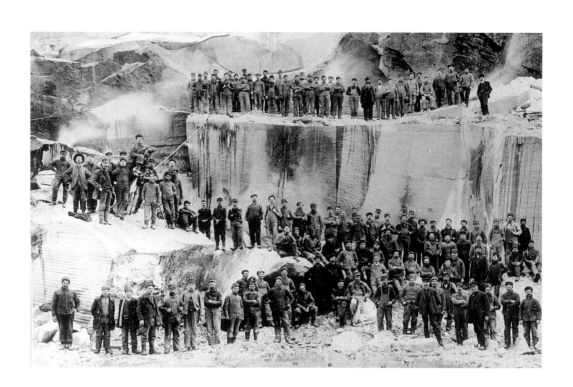

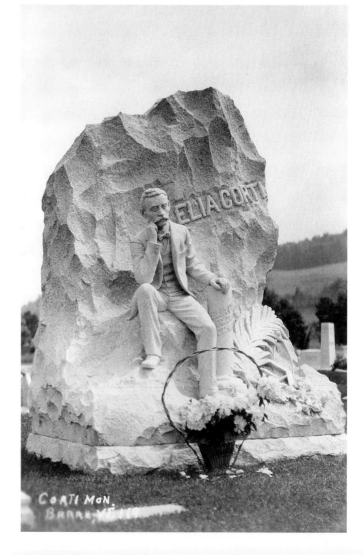

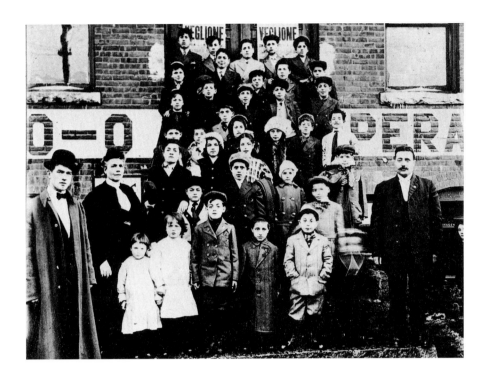

Barre was a major granite center with sixty-five firms employing more than 1,200 men in 1891. In 1902 the granite companies cut and polished more than 1½ million tons of granite. Most of the early granite workers were Scots from Aberdeenshire, but Italians came in great numbers after 1890, many of them skilled stone carvers from northern Italy. (*Top left*) More than a hundred granite workers gather for a photo opportunity at one of the large quarries near Barre. (*Courtesy of the Aldrich Public Library, Barre, Vermont.*) Not only was Barre a strong union town, but it also was a hotbed of radical political activity. Emma Goldman, Eugene Debs, Big Bill Haywood, and Mother Jones were among those who spoke there early in the century. The Socialist Party of America, the Socialist Labor Party, and the Industrial Workers of the World all gained support in the city, as did anarchists. A scuffle between socialists and anarchists in 1903 at Labor Hall led to the accidental shooting and death of Elia Corti, a skilled stone carver and anarchist. His brother William and brother-in-law John Comi carved a monument in his honor that was designed by sculptor Abramo Ghigli (*bottom left*). A photo of the monument in Barre's Hope cemetery was made into a postcard that was widely collected. (*Above*) In 1912, during the IWW textile strike in Lawrence, Massachusetts, the workingmen and their families in Barre invited the children of the strikers to Barre where they would be safe. Thirty-five children came. In this photo, they pose in front of Labor Hall in Barre on February 15, 1912. This photograph was made into postcards, which were sent back to the families in Lawrence to let them know that their children had arrived safely and were doing well. (*Courtesy of the Aldrich Public Library, Barre, Vermont.*)

6

Main Street

Main Street in the larger towns and small cities of Vermont was where the action was in the first decades of the twentieth century. In the days before shopping malls and giant chain stores, everyone shopped on Main Street. When Vermonters said they were going "downstreet" or "overstreet" they usually meant to Main Street or one of the adjacent commercial streets. Hardware stores and banks were crowded together next to dry-goods stores, specialty shops, poolrooms, livery stables, hotels, restaurants, and boardinghouses. There were few bars and taverns in Vermont towns. The state was dry until 1902, when a local option law was passed. In 1910 only twenty-nine towns allowed liquor to be served by the drink, down from ninety-two towns in 1903, but in most towns it was still possible to buy a drink if you knew where to go or whom to ask. Main Street was not only a place to shop, it was also a place to meet friends. Young men walked up and down the street looking for young women. Young women gathered in groups to talk and to look for young men. Older women came to shop but stayed to talk with other women. Men congregated in the barbershops, the poolrooms, and the livery stables.

Traveling salesmen tried to sell their wares to the store owners, and businessmen conducted their affairs at the bank or post office or in a lawyer's office, which was often on the second floor down the hall from the dentist and the doctor. Farmers came to town to market their eggs or butter but also to shop. Often they came on Saturday night when most of the stores stayed open until 9 P.M. They could usually be identified as farmers by the way they dressed and even by the way they smelled.

Most Vermont cities and town centers had been wired for electricity by the first decade of the twentieth century. Most farms and many rural areas, however, did not get electric lines until the Rural Electrification Administration of the New Deal years, and some farms did not get plugged into the twentieth century until after World War II. There was a wide gulf early in the century between the world of the farms and the world of Main Street. Farm families could admire washing machines, telephones, and eventually radios on display in the stores. They could even go to a motion picture. With bright lights in the stores and on the streets, Main Street must have seemed like the Great White Way.

Vermont was one of the most rural states in the nation in 1910. Burlington, the largest city, had only a few more than 20,000 people, and Rutland, the second largest, had 13,000, hardly more than medium-sized towns by national standards. Yet with railroads, an expanding telegraph and telephone network, and the market economy, these cities and much smaller places shared some of the urban advantages and disadvantages. Main Street had an urban look and feel to it, especially if one lived on a farm.

Horses and wagons were everywhere on Main Street early in the century, while hitching posts, watering troughs, livery stables, and blacksmith shops marked their presence. But gradually the auto took over, the streets were paved, and the gasoline station replaced the livery stable. Postcards record that transition. They also capture the excitement and the vitality of Main Street, before it was destroyed by the shopping mall and urban sprawl.

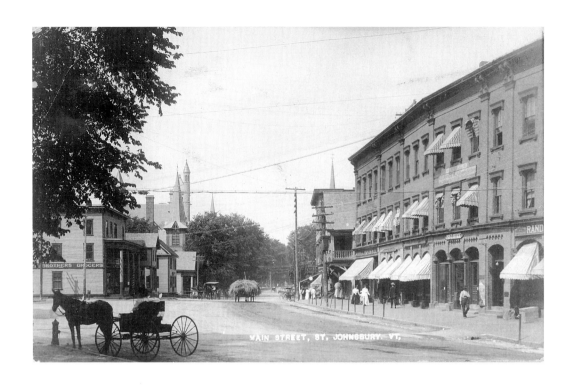

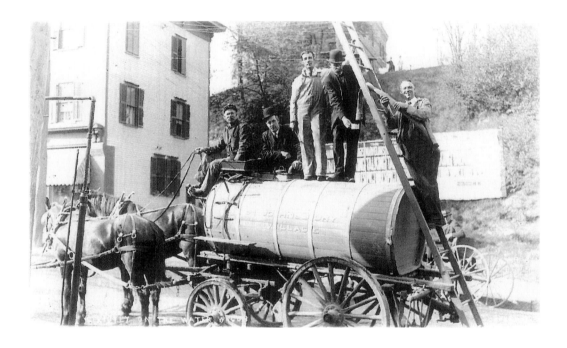

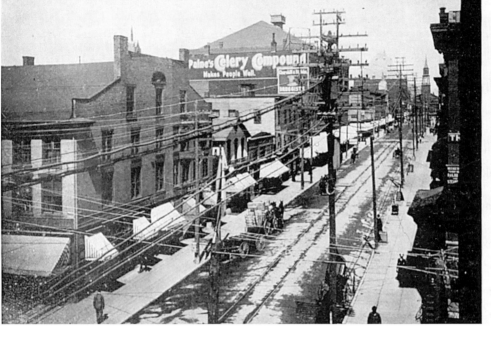

Vermont cities and towns were not far from the farms. (*Top left*) This photo card, mailed in 1910, records a horse-drawn wagon loaded with hay proceeding down Main Street in St. Johnsbury, probably on its way to fill one of the many barns or carriage houses within the village where horses were stabled. Well-dressed men and women and an occasional farmer in overalls do not even glance at what must have been an ordinary sight on a summer day. (*Bottom left*) A sprinkler wagon used in St. Johnsbury (and other towns) to keep the dust under control in the summer on the unpaved streets, though some questioned whether the sprinkler made matters better or worse. Here town officials perform for the camera on top of the wagon. The sign on the wagon reads "St. Johnsbury Village." (*Local History Photograph Collection, Fairbanks Museum and Planetarium Archives.*) (*Above*) A jumble of electric lines, streetcar tracks, and horse-drawn wagons forms this winter urban scene on Church Street in Burlington about 1905. The advertising sign on the drug store building on the left is for "Paine's Celery Compound," one of many patent medicines or tonics, often heavily laced with alcohol, that were consumed in great quantities by Americans early in the twentieth century.

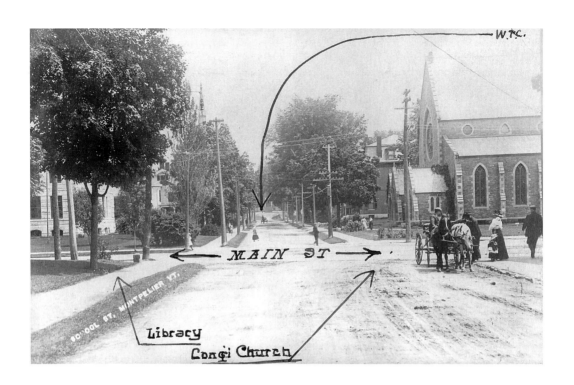

MAIN ST

Library

Congl Church

SCHOOL ST. MONTPELIER VT.

W.T.C.

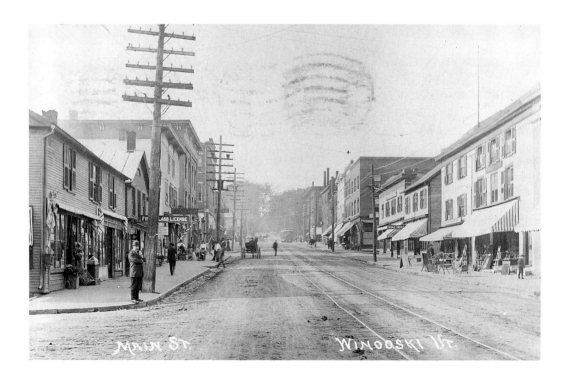

MAIN ST. WINOOSKI VT.

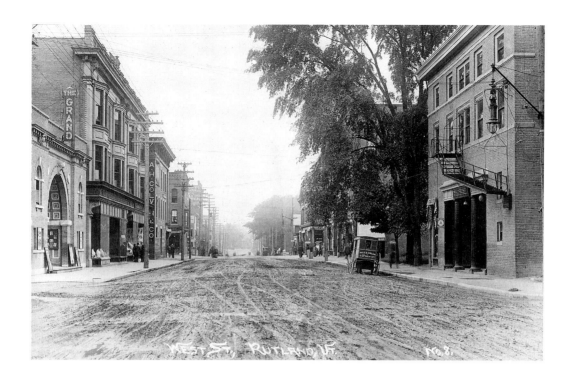

(*Top left*) The man who mailed this card on September 26, 1910, from Montpelier to a woman in Underhill provided helpful labels including identifying himself in the distant horse and buggy. He wrote, "You probably recognize this street all right. Hoping to see you walking up it soon. It is pretty up here now—come and see for yourself. And they are getting new fall hats too." (*Bottom left*) Winooski, home of the American Woolen Company, was a village in Colchester of nearly 4,000 people in 1910. It was connected to Burlington by Electric Railroad "with cars every 20 minutes" (notice the tracks). The signs, "First Class License" and "Wine House," suggest that it was not a dry town, but the message on the card mailed in September 1910 reads: "How do you like the looks of this place? Can you see the signs? This place is dry." Winooski had just voted dry for the first time in 1910. (*Above*) A Rutland street, clearly showing the wagon tracks in the dirt. The dirt turned to mud in the spring and after a rain. There is a new movie theater on the left, "The Grand." The sign on the delivery wagon on the right reads: "Milk and Cream—650 Main Street."

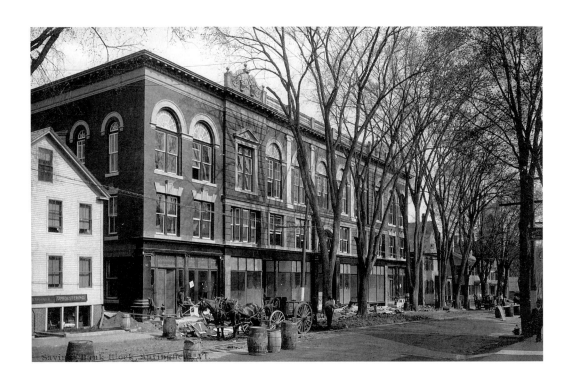

Saving's Bank Block, Springfield, Vt.

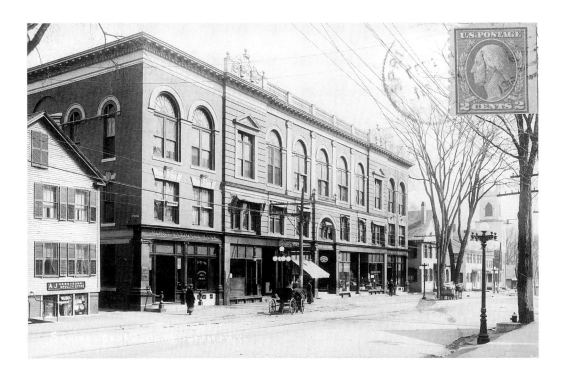

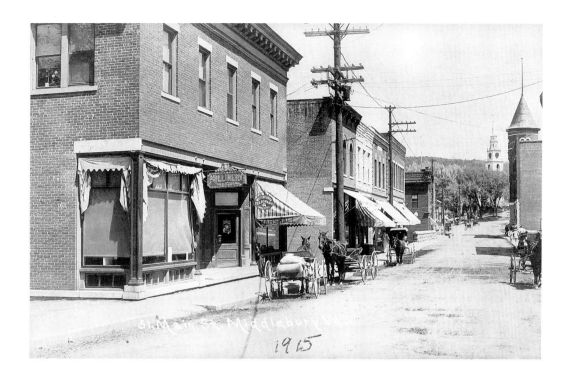

Two views of Springfield, Vermont: (*Top left*) One card was mailed in 1908, and (*bottom left*) the other in 1915. Notice the changes in just 7 years. Barrels and trash have been removed, the building on the left now contains a novelty store, and the one in the middle houses a bank. Trees have been cut and new streetlights installed. The railroad tracks in both photos are for the electric trolley between Springfield and Charlestown, New Hampshire. The message on the card on the right, mailed to Paris, France, February 24, 1915, reads, "We are anxious about the war, but hope our country can keep out of it." (*Above*) Horses and wagons tied to hitching posts on a Middlebury street with a millinery store and a telegraph office in the foreground. Someone has labeled the card "1915," but the photo is probably earlier.

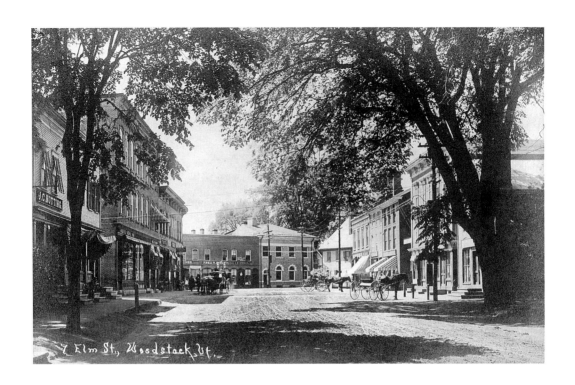

Elm St., Woodstock, Vt.

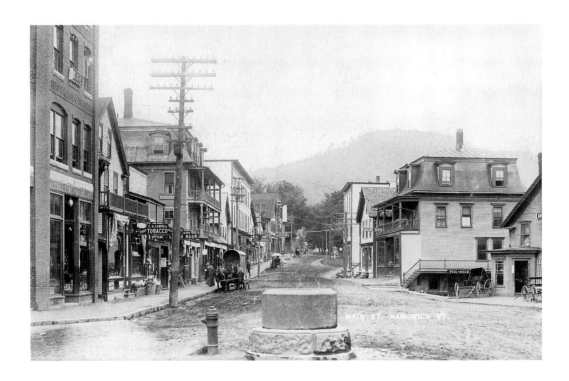

MAIN ST., HARDWICK VT.

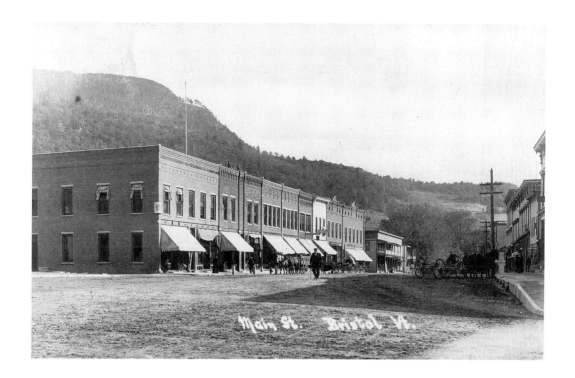

(*Top left*) Horses wait patiently on Elm Street in Woodstock, shaded by a majestic elm tree. (*Bottom left*) Hardwick was a granite boom town early in the twentieth century, and its main street shows the haste with which it was constructed. Unlike Woodstock, the Hardwick main street is jammed between the Lamoille River and a steep hill; there is no room for trees. Visible in the photo are a livery stable, a poolroom, a lodging house, a tobacco shop, and a lunchroom advertising oysters. Notice the fire hydrant and the watering trough in the middle of the street. Within a few years, when the auto replaced the horse, they will have to be removed. (*Above*) Bristol, a shopping and lumber center in Addison County with a few more than 1,000 residents in 1910, has the look of a Western mining town.

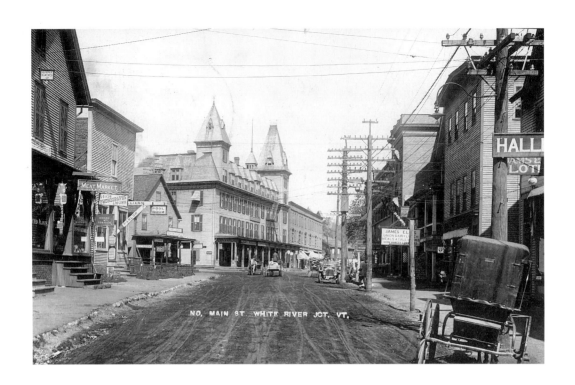

NO, MAIN ST. WHITE RIVER JCT. VT.

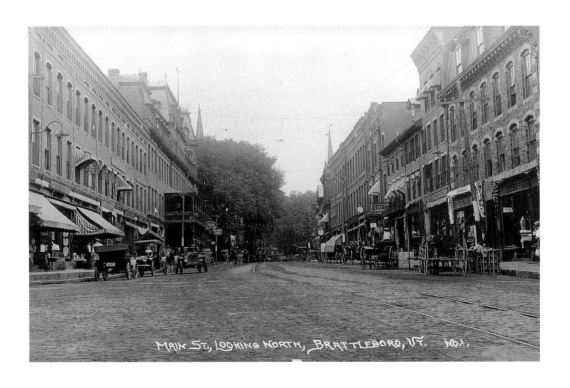

MAIN ST., LOOKING NORTH, BRATTLEBORO, VT. NO.1.

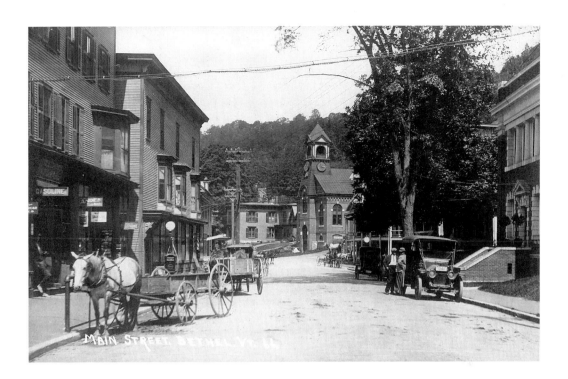

(*Top left*) Automobiles and horses mix on North Main Street in White River Junction, circa 1915. The signs indicate a meat market, a shop selling phonographs and records, a billiard parlor–poolroom, a store selling meats and groceries, and a barber shop. The sign at right reads: "James Ellis Union Dairy Lunch, Meals at All Hours, Home Bakery." (*Bottom left*) A busy street in Brattleboro from a card mailed in 1918. Three phases in the evolution of transportation are shown in this scene, with horses on one side of the street, cars on the other, and the street railway tracks in the middle. Notice that the street has been paved with brick, which proved very expensive. Within a few years, cities and towns were using asphalt or concrete. (*Above*) Horses and automobiles mix in Bethel about 1915. The sign on the store to the left reads "Gasoline." Before gas pumps one could purchase gas by the gallon in stores and pour it into the gas tank.

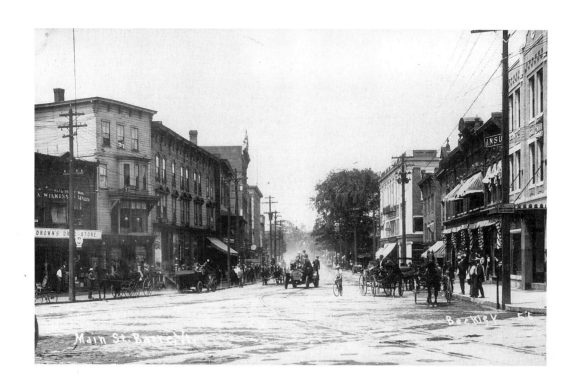

Main St. Barre, Vt.

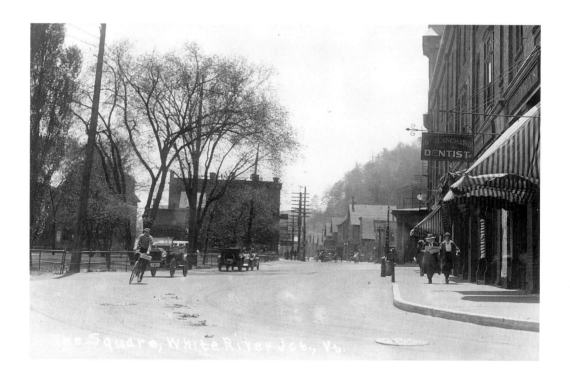

The Square, White River Jct., Vt.

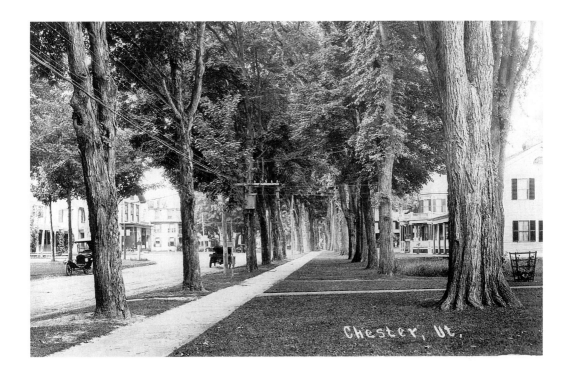

Boys on bicycles add to the transportation mix in Barre (*top left*) and White River Junction (*bottom left*). (*Above*) Most Vermont towns did not have the impressive trees that graced the streets of Chester in this circa 1915 photo, but the need to widen and pave the streets to accommodate the auto, and the encroaching telephone and electric lines, eventually led to cutting most of the trees.

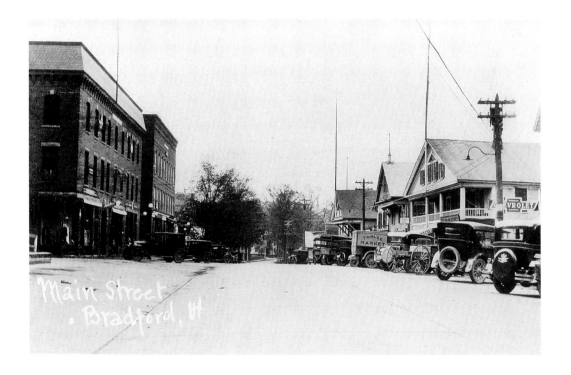

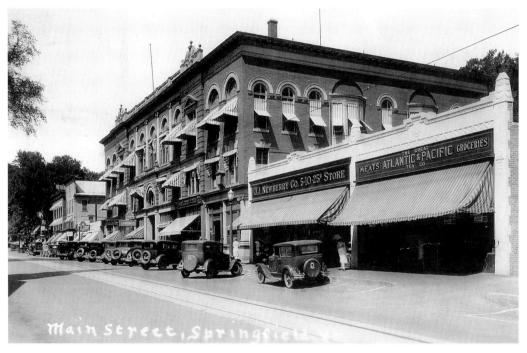

Main Streets remained vital in Vermont towns during the 1920s and the 1930, and even into the 1940s and early 1950s. (*Top*) In Bradford in the late 1920s there still was at least one wagon parked among the cars, but the delivery truck had replaced the horse-drawn wagon and a Chevrolet dealer had replaced the livery stable. (*Bottom*) In Springfield, circa 1928, the A&P and a J. J. Newberry Store dominate the shopping street, where parking spaces are already marked in white paint.

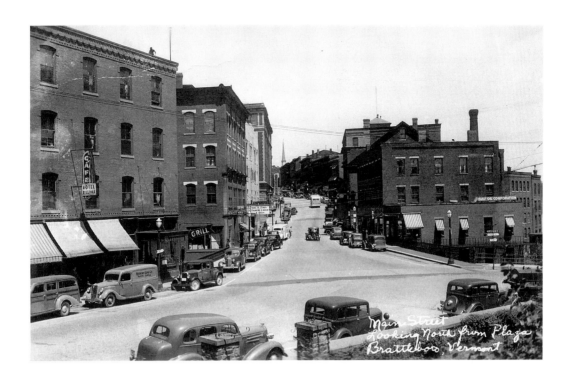

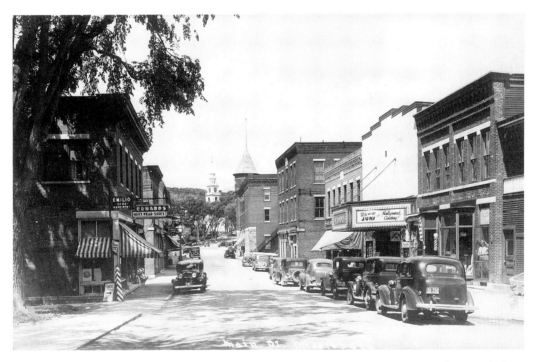

In Brattleboro (*top*) and Middlebury (*bottom*), circa 1940, movie theaters occupy prominent places on the busy streets.

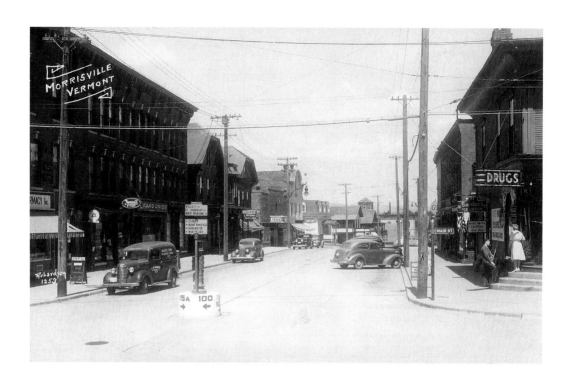

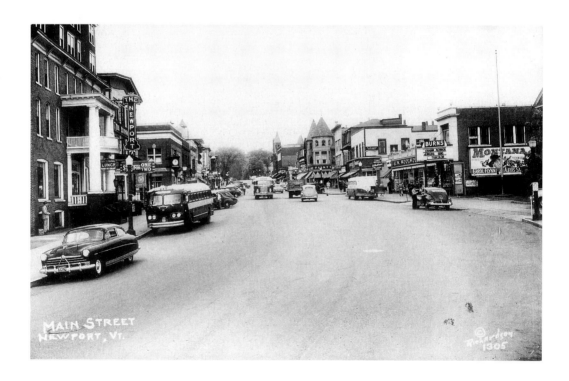

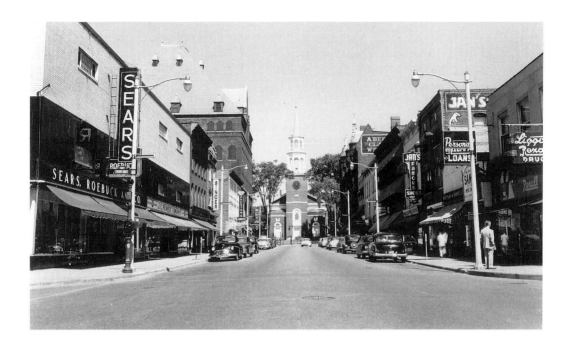

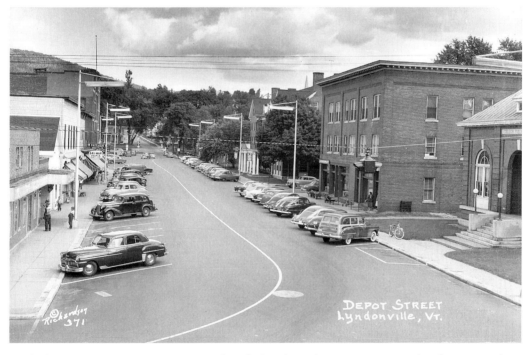

By the late 1930s and 1940s, route signs and marked parking places are routine, and parking meters have sprouted along the streets. The larger towns have put electric and telephone lines underground and improved the street lights. Buses have replaced trolleys, and hotels still operate in town centers, but they are under pressure from the motels on the highways outside of town. In fact, the main streets of (*top left*) Morrisville, (*bottom left*) Newport, (*top right*) Burlington, and (*bottom right*) Lyndonville, which seem busy and thriving in these photos, are already under attack by various market forces that will transform them once again in the half century after 1950.

7

A Color Portfolio

We live today in a technicolor world. We are confronted everywhere by colorful displays, from television and film, to photographs, magazines, billboards, newspapers, and computer screens. We are so attuned to color that it is difficult for us to imagine the world of 1910, even the world of 1930. The early twentieth century was an age of black and white, or of dull reds and browns, which the camera turned into shades of grey. Newspapers and magazines, movies and photos were all black and white. Colored film was used experimentally in the 1930s, but it was not until after World War II that most people took color snapshots. The public was introduced to movies in color only in the late 1930s with *Gone with the Wind* and *The Wizard of Oz*.

As we look at old photographs and film, we are impressed with the black and white, and often we nostalgically assume that black and white means authenticity, and that color is perhaps artificial. But in the early twentieth century color was unusual and startling, and the color lithograph postcard seemed truly remarkable. Along with the covers of the new mass-circulation magazines, and some advertising, the postcard introduced color in dramatic ways. There had been tinted and hand-painted photographs for many years, as well as colorful stereograph views, but compared to postcards made with the halftone process, they seemed artificial. Amateur photographers usually made black and white, real photo postcards, but sometimes they experimented with blue cyanotype cards. Sometimes called ferroprussiate prints because they were sensitized with iron salts, cyanotype cards were relatively easy to produce, and gave the impression that the photo was taken at night. But in

a world of black and white, or even blue, the color postcard stood out. It seemed so realistic, it made a drab world come alive. Part of the attraction of the color view cards, and the reason so many people collected them, was that they seemed so real. These were the postcards that fascinated Walker Evans. He thought they were direct, unsophisticated, and an important part of American realism.

The colors on the early view cards were not always accurate. Before World War I the best cards were made in Germany, and the various manufacturing companies gave specific directions for ordering and suggested a detailed color scheme to go with the black-and-white photograph, but often the buildings, the clothes, and even the streetscapes took on different hues. The Detroit Publishing Company, which published the best cards produced in the United States, often republished the same scene every few years, and each time there was a slightly different color scheme. But even if the color cards were not quite accurate, they seemed amazing to a generation accustomed to a world of black and white. They remain amazing, not so much for their color, although we can imagine the excitement that aroused, but because they capture the main streets, the rural landscape, the factories and railroad stations, at particular moments in time.

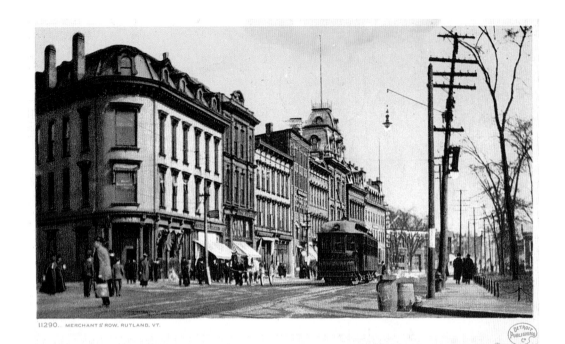

11290. MERCHANTS' ROW, RUTLAND, VT.

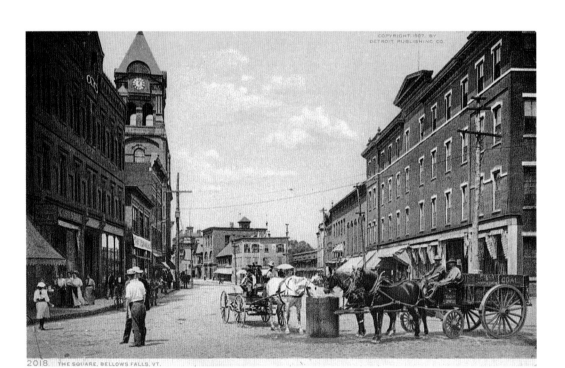

COPYRIGHT, 1907, BY
DETROIT PUBLISHING CO.

2018. THE SQUARE, BELLOWS FALLS, VT.

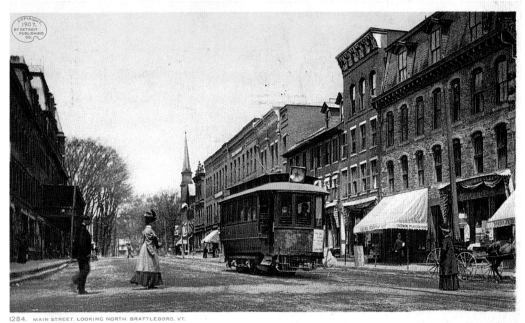

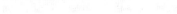

1284. MAIN STREET, LOOKING NORTH, BRATTLEBORO, VT.

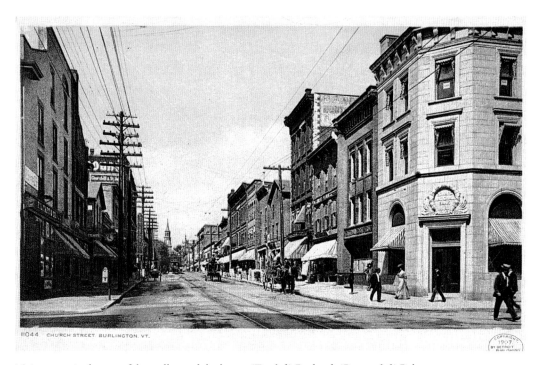

11044 CHURCH STREET, BURLINGTON, VT.

Main streets in the age of the trolley and the horse. (*Top left*) Rutland. (*Bottom left*) Bellows Falls. (*Top right*) Brattleboro. (*Bottom right*) Burlington. These cards, all printed in 1908, were produced by the Detroit Publishing Company, which always numbered its cards in the lower left corner.

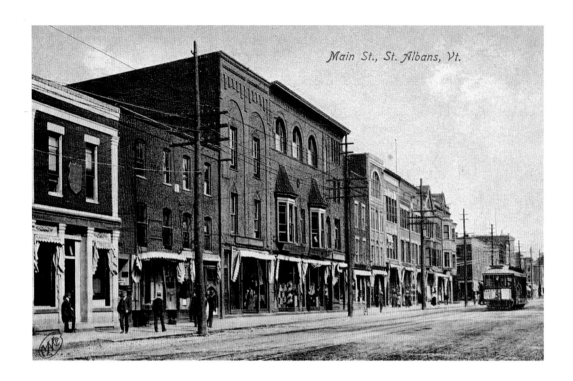

Main St., St. Albans, Vt.

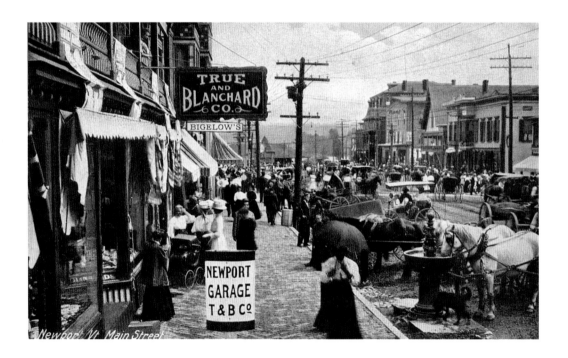

TRUE
AND
BLANCHARD
CO.

BIGELOW'S

NEWPORT
GARAGE
T & B Co.

Newport Vt. Main Street

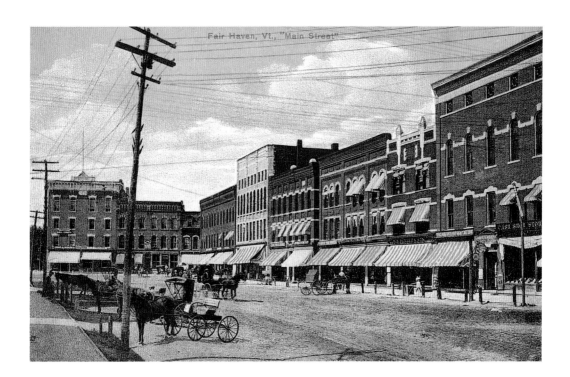

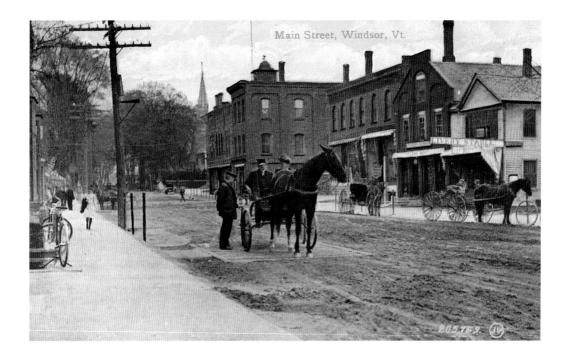

Busy main streets, with telephone and electric lines everywhere. All of these cards were printed in Germany with the exception of the Windsor card, which was printed in Great Britain.

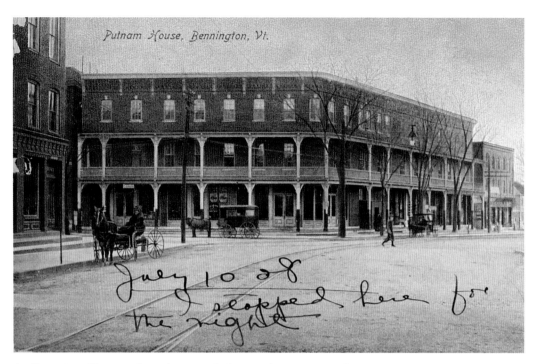

An illustration of how people made postcards their own by writing over the picture.

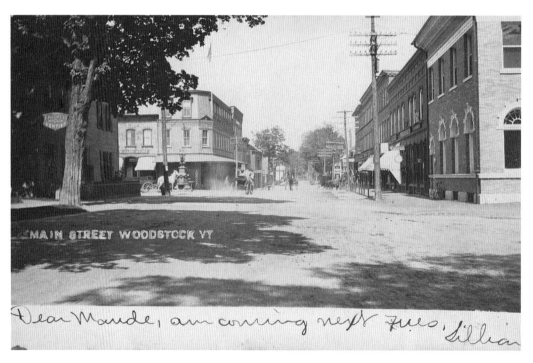

This card of Woodstock in blue is a cyanotype print, sometimes called a ferroprussiate print, because it was sensitized with iron salts. It was popular for several years among amateur real photo card makers because it was a relatively easy process. It worked better for landscape photos than for street scenes, but this 1908 portrait of Woodstock came out well.

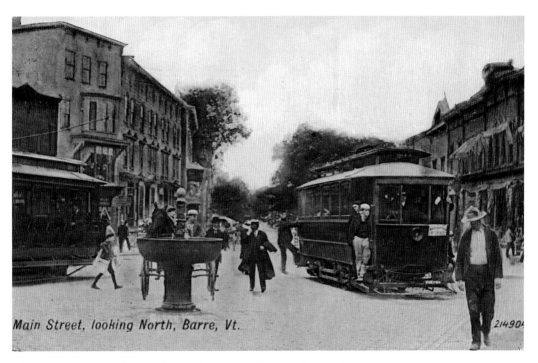

Main Street, looking North, Barre, Vt. 214904

A busy scene in Barre where trolleys, pedestrians, and horses all share the street.

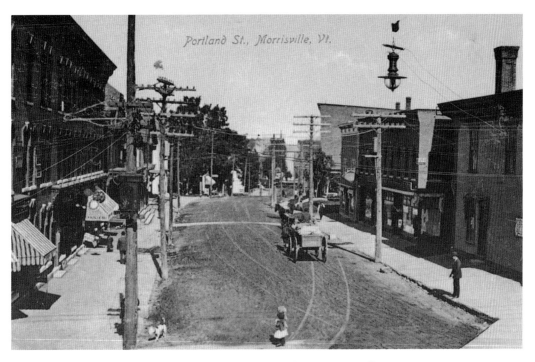

Portland St., Morrisville, Vt.

A tangle of electric and telephone wires creates a chaotic tableau in Morrisville, circa 1907.

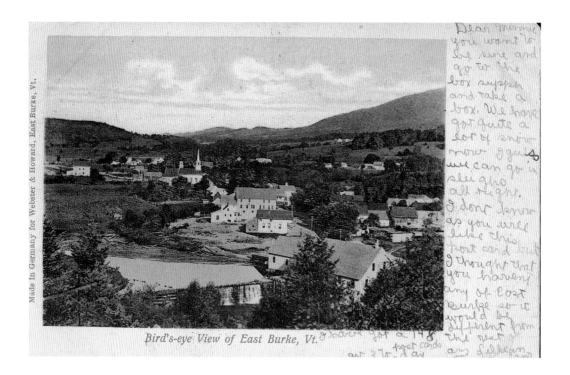

Bird's-eye View of East Burke, Vt.

Dear Minnie you want to be sure and go to the box supper and take a box. We have got quite a lot of snow now. I guess we can go in sleighs all right. I dont know as you will like this post card but I thought that you haven't any of East Burke so it would be different from the rest as Lillian. I have got a 148 post cards got 3 to day.

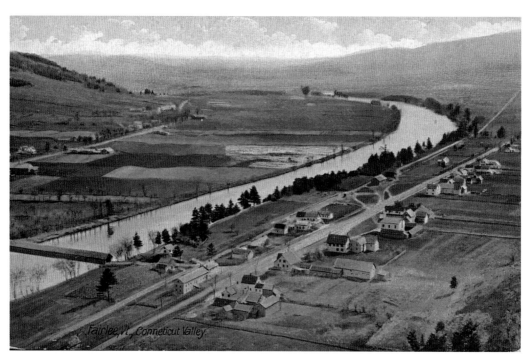

Fairlee, Vt. Connecticut Valley.

Small towns also had their color postcards, which were often produced in Germany. (*Top*) The message on the 1906 card of East Burke reads: "Dear Minnie, you want to be sure to go to the box supper and take a box. We have got quite a lot of snow now. I guess we can go in sleighs all right. I don't know as you will like this post card but I thought that you haven't any of East Burke so it would be different from the rest. I have got 148 post cards, got 3 today." (*Bottom*) A view of the Connecticut valley near Fairlee, circa 1905, showing cleared land and few trees.

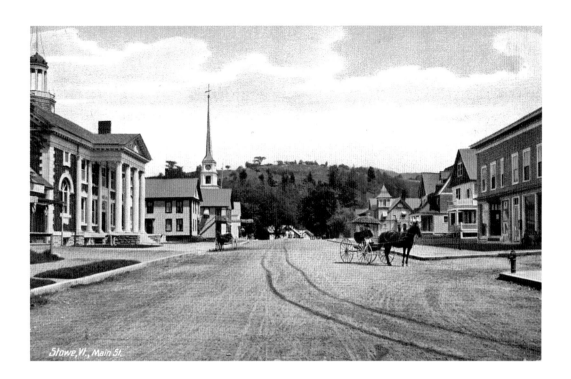

Stowe, Vt., Main St.

Main St., Plainfield, Vt.

This is "Broadway."

(*Top*) Stowe and (*bottom*) Plainfield. The message on the back of the Plainfield card, circa 1910, reads: "This is Plainfield on a busy day."

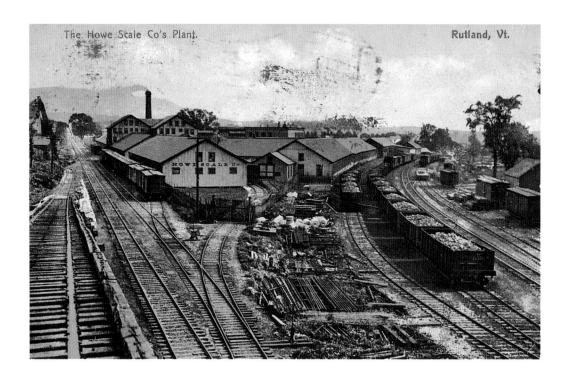

The Howe Scale Co's Plant. Rutland, Vt.

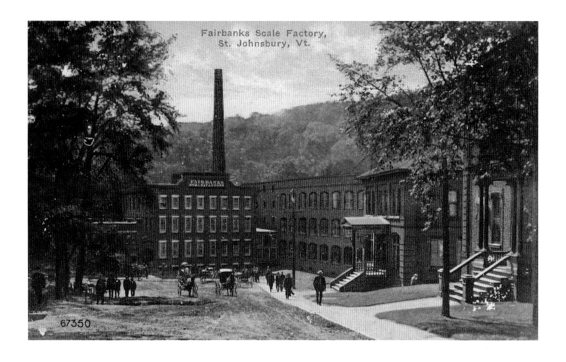

Fairbanks Scale Factory,
St. Johnsbury, Vt.

67350

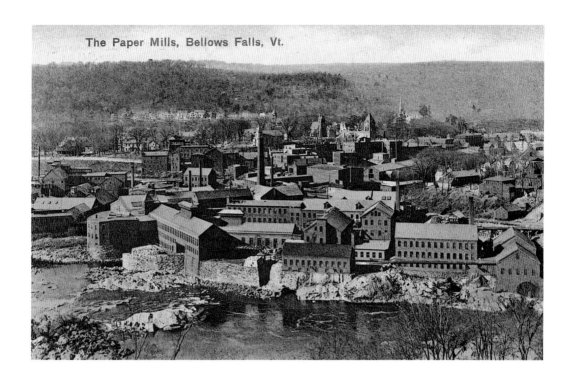

The Paper Mills, Bellows Falls, Vt.

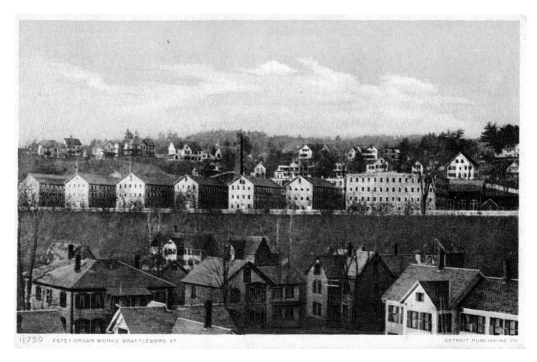

11759 ESTEY ORGAN WORKS. BRATTLEBORO VT DETROIT PUBLISHING CO.

Workshops in the wilderness: Vermont factories that produced scales (*top and bottom left*), paper (*top right*), and Estey organs (*bottom right*).

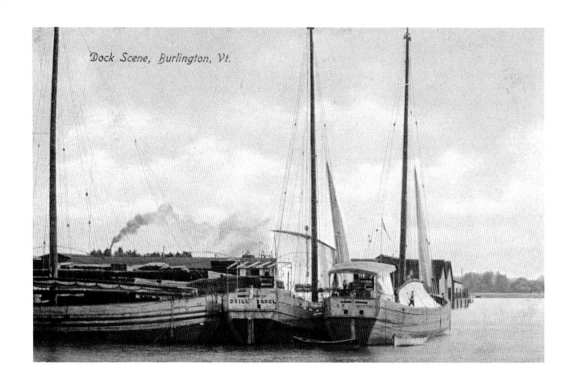

Dock Scene, Burlington, Vt.

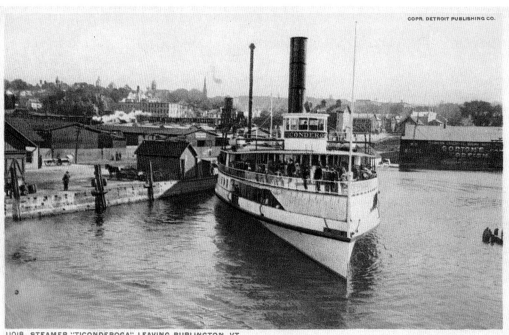

11018 STEAMER "TICONDEROGA" LEAVING BURLINGTON, VT.

Boating scenes on Lake Champlain (*top left, and bottom left and right*) and Lake Bomoseen (*top right*).

C. V. R. R. STATION. ST. ALBANS, VT.

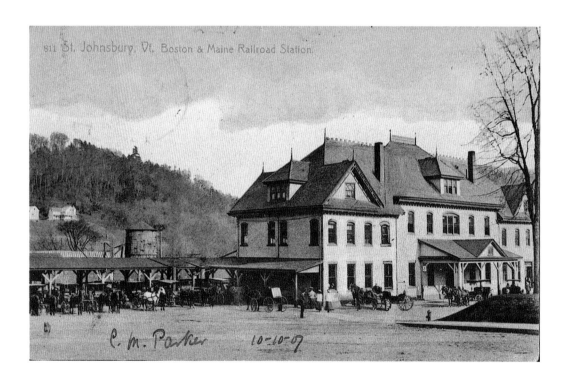

811 St. Johnsbury, Vt. Boston & Maine Railroad Station.

C. M. Parker 10-10-07

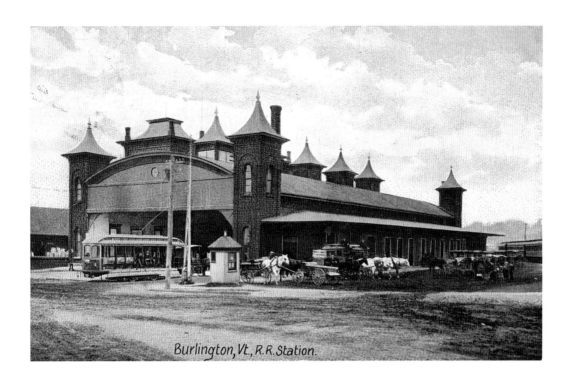

Burlington, Vt., R.R. Station.

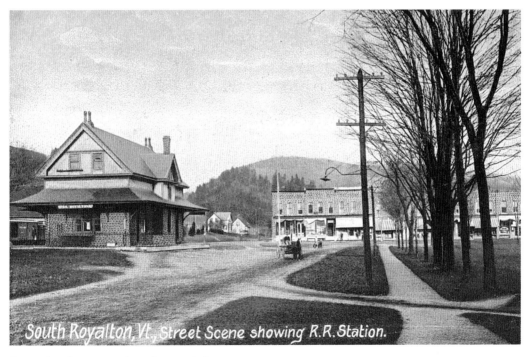

South Royalton, Vt., Street Scene showing R.R. Station.

Busy railroad stations early in the twentieth century.

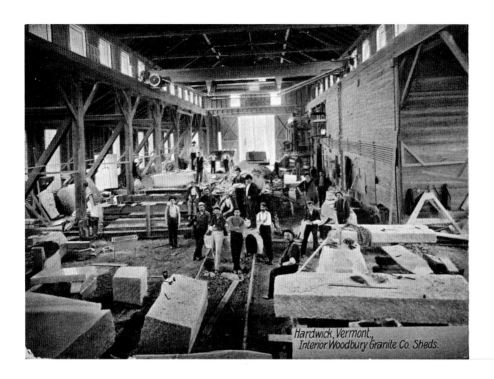

Hardwick, Vermont.,
Interior Woodbury Granite Co. Sheds.

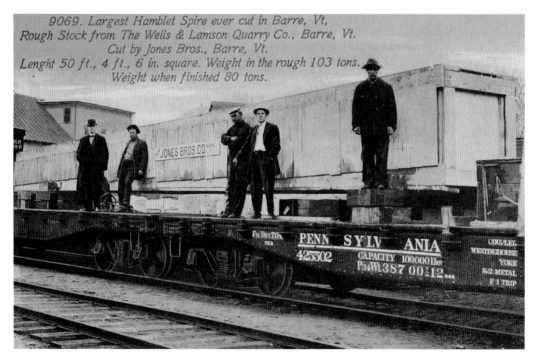

9069. Largest Hamblet Spire ever cut in Barre, Vt,
Rough Stock from The Wells & Lamson Quarry Co., Barre, Vt.
Cut by Jones Bros., Barre, Vt.
Lenght 50 ft., 4 ft., 6 in. square. Weight in the rough 103 tons.
Weight when finished 80 tons.

Granite workers in Barre and Hardwick. The granite and marble industries were among the largest in the state, and the railroad train made industrial production possible in Vermont. Trains and industrial plants were important subjects for postcards, as were main streets and rural landscapes.

8

Railroads and Trolleys

The railroad transformed Vermont as it transformed the nation. The first train in Vermont, a decade later than in southern New England, began operation in June 1848 on twenty-six miles of track between White River Junction and Bethel. The next year the Rutland and Burlington and the Vermont Central completed the connection between Burlington and Boston. Within the next few years a line opened to Albany, New York, and the Grand Trunk Railroad connected Portland, Maine, and Montreal, crossing a section of northeastern Vermont through Island Pond. Railroad building ceased during the Civil War, but in the 1870s the Portland and Ogdensburg created a link between Portland, Maine, St. Johnsbury, and Burlington (via Essex Junction).

When the railroad—or "the cars," as they were known—first steamed into a Vermont town there were elaborate ceremonies, complete with golden spikes and promises that the good citizens would soon be drinking tea from China and purchasing other exotic products transported by rail. Most people believed that the railroad would lead to a new era of prosperity for all. By 1900 there were more than a thousand miles of track in the state.

The coming of the railroad altered life in many ways. It caused the displacement of farms and divided towns. "The other side of the track" was a phrase that had real meaning in many communities. The railroad brought trade and riches to some towns. St. Johnsbury, St. Albans, Rutland, Springfield, and other towns became rail and industrial centers, while White River Junction, Essex Junction, Island Pond, and

Greensboro Bend were literally created by the railroad. But many towns bypassed by the railroad declined and lost population. Craftsbury Common, Peacham, Grafton, Belmont, Weston, Wardsboro, Dover, and many other hill towns suffered because the railroad missed them. Ironically, today it is those isolated hill towns that we most admire. They lost out on the industry and the prosperity of the railroad age, but today they seem pristine and beautiful. To many tourists they are the essence of the Vermont way of life.

The railroad changed the landscape. Cuts and fills, trestles, bridges, and depots, signals, and crossings signs, as well as water and coal stations, coal and ash piles, and advertising and telephone lines along the right of way, altered the look of the land. Traveling at the speed of a train also made the land appear different; the fence posts and the buildings seemed closer together than they did when riding behind a horse. The railroad itself, as it cut through the land, left its mark and created a new path. The rails were difficult to walk on, with the ties set an awkward width for a comfortable stride, but they did provide a convenient, if dangerous, shortcut.

There was something exciting and appealing about the railroad. The locomotive belching smoke as it came into a station almost seemed to be alive. In fact, the early observers called it an "iron horse." The train was romantic, but it could also be dangerous, and thousands were killed in accidents as trains left the tracks and as locomotives hit autos and horses. The train was also exciting for the sense of promise it offered. It connected small towns with the city. Young men and women dreamed of boarding the train and leaving town for a distant place. The train brought mail (including postcards); it brought salesmen, and tramps, the circus, and people and products from distant lands. Exotic fruits and new manufactured products became commonplace, and Vermonters began to eat oysters from Chesapeake Bay and Long Island Sound.

The railroad changed the nature of farming. It allowed farmers to market their butter, and eventually their milk, in Boston, but it also made them part of a market economy and sometimes the victim of price fluctuations beyond their control. It stimulated industry along the rail lines. Without the railroad, the granite, marble, and logging industries

would have been very different, and without the ability to ship manufactured products, machine tools, platform scales, and parlor organs would not have been made in Vermont.

The railroad station (usually called the depot) in a Vermont town was an exciting place. It competed with the livery stable, the barbershop, and the country store as a place to gather and to learn the latest news. The larger depots had a separate ladies' waiting room to protect women and children from the pipe and tobacco smoke and the chewing tobacco and spittoons of the men's waiting room. The depot also had a telegraph operator who got instant news from around the world. When a Vermont soldier was killed or wounded during the Civil War, it was usually through the telegraph that the family learned of the tragedy. The railroad changed the nature of time. In rural America the rhythms of the day and the seasons were important, but no one needed to know the exact time. The train, however, ran on a schedule, and the exact time became crucial. In the cities there were often several times, and time varied from town to town. It was very confusing until 1883 when the whole nation adopted railroad time, and within a few years the world was divided into time zones. The railroad made precise time important, and even the Vermont farmer had to adjust.

The railroad reached its peak influence in the early decades of the twentieth century. In many ways it made the age of the postcard possible. The messages scrawled on the backs of postcards, or written around the edges of the picture on the front, remind us of just how closely the postcard and the railroad were connected. "Arrived all O.K. in Proctor at 1:50. Have just time to mail a few cards before the train leaves," a woman wrote a friend in 1909. "Be sure to meet the 8:30 train on Friday," a young man wrote his father in 1910. "Am in Brattleboro, Vermont. Dead tired, been on the go all day, have ridden over 150 miles in trains today," a salesman wrote a friend in Cambridge, Massachusetts, on June 11, 1906. "Business dull, have plenty of hard work. A good night's sleep and I will be O.K. in the morning."

The golden age of the railroad is long past, but trains still operate in Vermont. By contrast, there have been no trolleys in the state for nearly seventy years. One thinks of streetcars as a form of urban transportation, but early in the twentieth century Vermont could boast of ten streetcar

lines, more than 100 miles of track, 137 cars, and a capital investment of more than 4½ million dollars. In 1902 the Vermont streetcar lines carried a total of nearly 5½ million people. In contrast, New York City in the same year had 1,300 miles of track and more than 943 million passengers. Still, for a brief time, streetcars were an important form of transportation in Vermont.

Most of Vermont's electric railways were really interurban trolleys. Like their counterparts in other parts of the country, they rattled through the countryside and connected one town to another. Streetcars in Vermont were run by private companies, but unlike the traction magnates in the big cites who made fortunes, most Vermont investors not only made little money, but also frequently went bankrupt.

In Vermont, as in the nation as a whole, horse-drawn streetcars preceded the electric variety. The Burlington to Winooski line opened in November of 1885 with fireworks and a band celebrating the event. This line served the railroad station, the fair grounds, and the opera house, and it also would run special cars for the theater or a baseball game. The line was converted to electricity in 1893. Vermont's other horse-drawn streetcar ran between Rutland and Fair Haven, a line that was electrified in 1894. Brattleboro started an electric streetcar line in 1895. Other lines connected Barre and Montpelier, Bellows Falls and Saxtons River, Bennington and the New York border, Winooski and Essex Junction, St. Albans and Swanton, and Springfield with Charlestown, New Hampshire.

One of the most interesting trolley lines was the Mt. Mansfield Electric Railroad Company. Incorporated in 1894, it began service in 1897, covering 10½ miles from Stowe to Waterbury. The company had ambitious plans to extend the line to Morrisville, Eden, Craftsbury, Albany, Lowell, and Newport. The extension was never built, but one wonders how many people would have boarded the trolley in Eden or Lowell. Even the line from Stowe to Waterbury, which ran four round trips a day, went into receivership after the financial panic of 1907. The Mt. Mansfield Company was not only plagued by heavy snowfalls, mud slides, and derailments, but it also was troubled by an uncertain electric supply and some very steep grades. When the lights dimmed

in Stowe, everyone knew that the trolley was climbing the hills in Shutesville. The trolley stayed in business until 1932, longer than most lines in the state, but when it went out of business in the depths of the Depression, the age of trolleys and streetcars was over in Vermont.

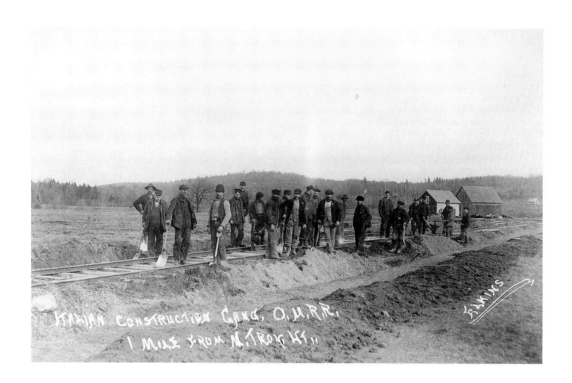

Italian Construction Gang, O.M.R.R.,
1 Mile From N. Troy, VT.

Building a portion of the Odgdensburg and Missisquoi, part of the Canadian Pacific system, near North Troy. The railroad was constructed in the 1880s and several photographs made into a postcard series about 1910. (*Above*) This card, labeled "Italian Construction Gang," recognizes that the hard labor involved in building the railroads was often provided by recent immigrants, Irish in the pre–Civil War period, and Italian on the later railroads. Both groups aroused some concern and prejudice along the line of the railroad. (*Right*) A primitive pile driver used to built a trestle. Many of the trestles were gradually filled in with stone after a few years.

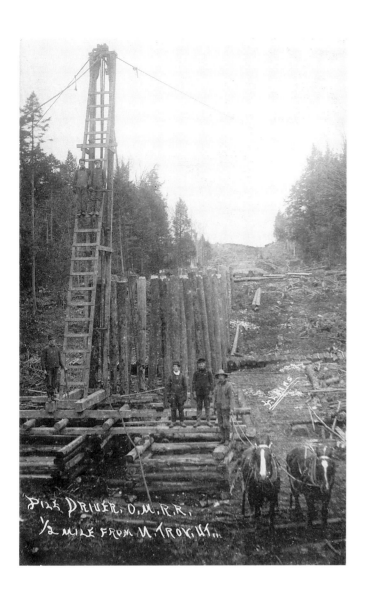

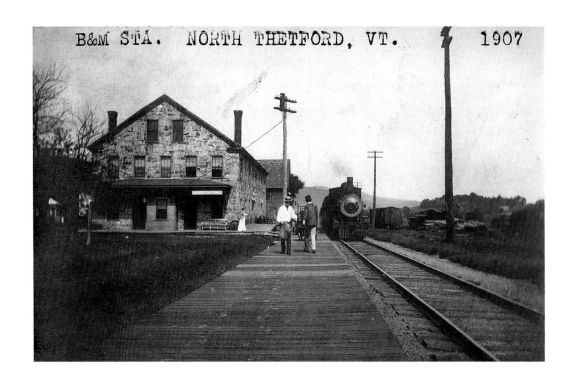

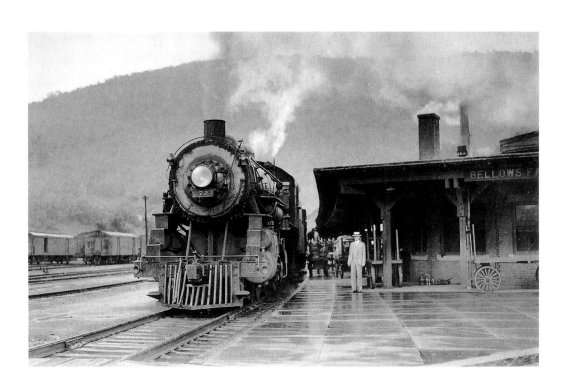

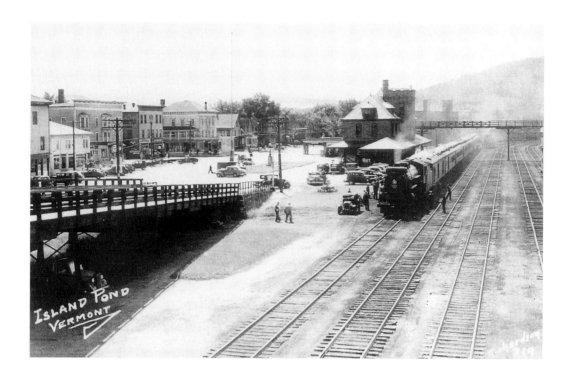

There was something exciting about standing on the platform and watching the train, pulled by a locomotive belching smoke and steam, pull into the station. (*Top left*) North Thetford on the Boston and Maine. This card was mailed on September 5, 1907, and has an RPO (Railroad Post Office) cancel, indicating that it was sorted and stamped in a railroad post office car while en route. (*Bottom left*) The Bellows Falls station on a wet day. Notice the baggage carts and the well-dressed man with his summer straw hat. (*Above*) A Canadian Pacific train, circa 1935, stops in Island Pond, a town created by the railroad. Island Pond had many more tracks than most Vermont towns. This photo shows only a portion of the nineteen tracks that made Island Pond a major rail center.

Returning from Quebec. Aug. 1906.

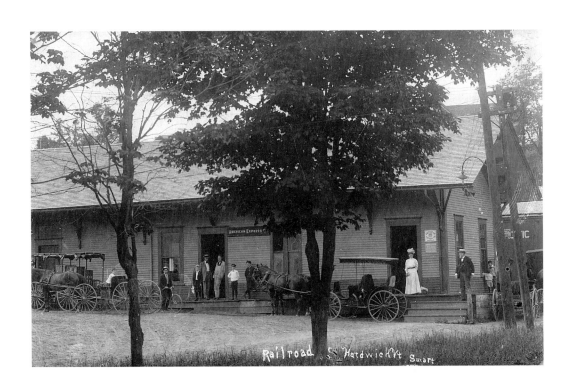

Railroad St. Hardwick Vt. Smart

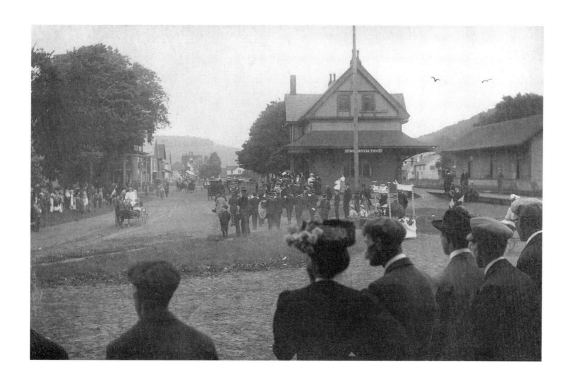

(*Top left*) A group of well-dressed, but tired-looking, travelers at the St. Albans station after returning from a trip to Quebec City. The card was mailed at Barre to Greencastle, Indiana, November 3, 1906. (*Bottom left*) The busy station in Hardwick on the St. Johnsbury and Lake Champlain Railroad, circa 1910. Horses and wagons wait to meet the train, while men and boys linger near the station. The well-dressed man at right with the straw hat is probably a businessman returning to town or a salesman preparing to sell his wares. The woman dressed in white with the elegant hat is emerging from the ladies' waiting room. (*Above*) A celebration or fair at the South Royalton station. The depot was often the site for festive occasions and the place where politicians and other celebrities expected a welcoming crowd.

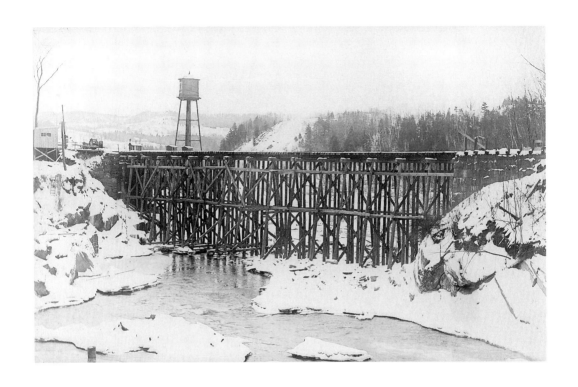

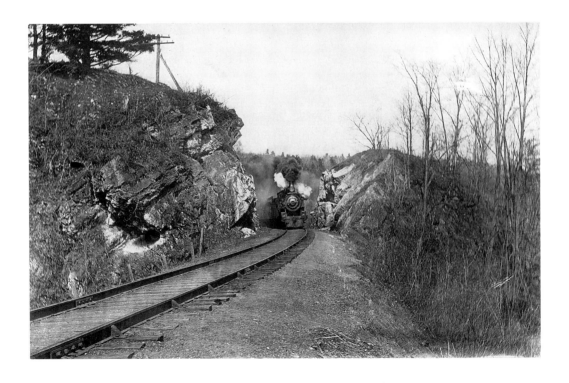

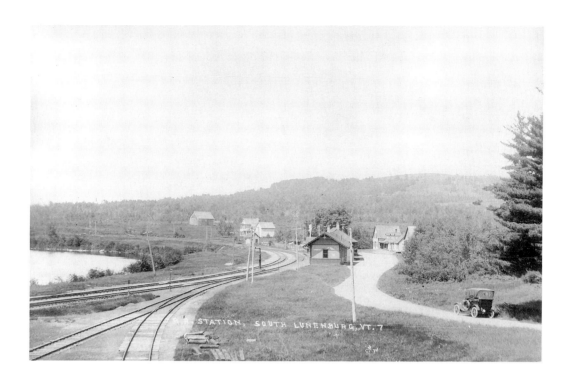

The railroad altered the landscape. (*Top left*) A trestle and water tower on the Central Vermont Railroad in Bethel. (*Bottom left*) A locomotive steaming through a cut on the Rutland Railroad. This was a favorite way for a photographer to depict the railroad as it intruded on the landscape. The presence of this powerful "machine in the garden" inspired contemporary observers and later writers to speculate on the influence of the railroad for better or worse. (*Above*) The railroad changed even the smallest towns it came through, including South Lunenburg, shown in this circa 1915 photo.

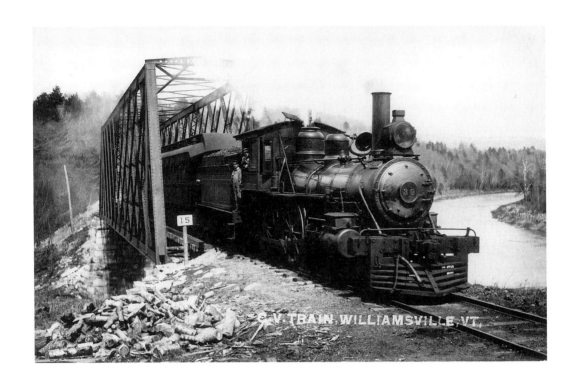

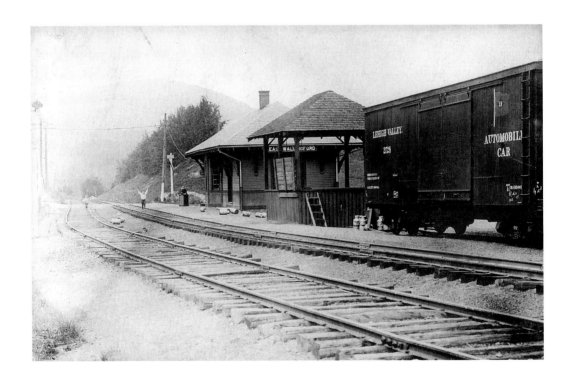

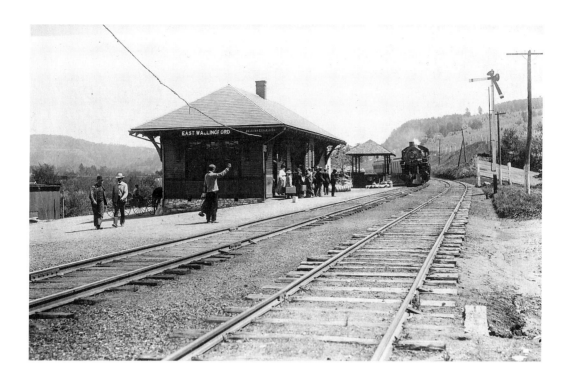

(*Top left*) Central Vermont train stopped at an iron bridge near Williamsville. Wood in the left foreground may have come from the days when the locomotive burned wood. Most trains switched to coal in the 1880s. (*Bottom left*) Boys playing on the tracks near the East Wallingford Station. The card was mailed in 1911 to Roxbury, Massachusetts. The writer identifies the scene as "our little two by once station." Notice the Lehigh Valley Automobile railroad car on the siding. Model T Fords were shipped by rail in pieces and had to be assembled at the station. The auto shipped by rail ironically led to the eventual demise of many Vermont railroads. (*Above*) The same station from another angle. Passengers wait for the train on the Rutland Division of the Central Vermont Railroad in East Wallingford about 1910.

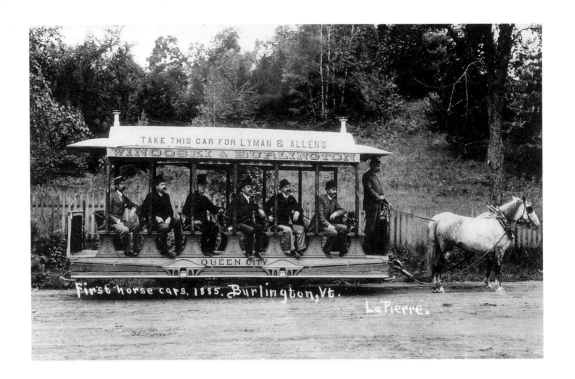

First horse cars. 1885. Burlington, Vt.

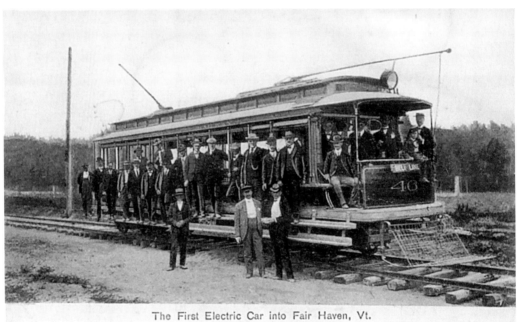

The First Electric Car into Fair Haven, Vt.

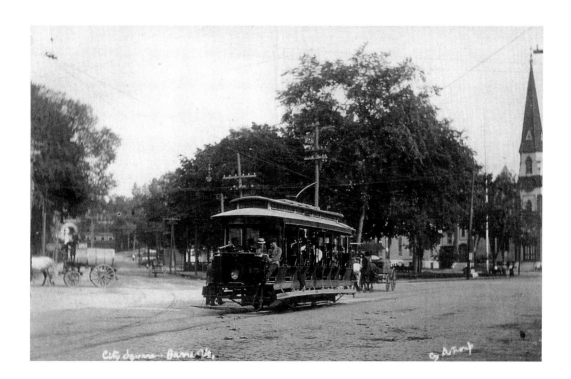

(*Top left*) The first horse-drawn streetcar in Vermont, the Winooski and Burlington line. This photo, taken in 1885, was made into a postcard about 1905. Notice that the streetcar is used for advertising. Lyman & Allen's was a Burlington dry goods store. (*Bottom left*) The first electric car into Fair Haven, 1894, on the Rutland, West Rutland, Hydeville, Castleton, Fair Haven line. (*Above*) The streetcar became part of the urban scene even in Vermont. Here an open streetcar moves through the streets of Barre. In the winter the traction company replaced the open cars with closed cars. Notice the horse-drawn watering tank to the left, used in the summer in many cities and towns to control the dust on the dirt streets.

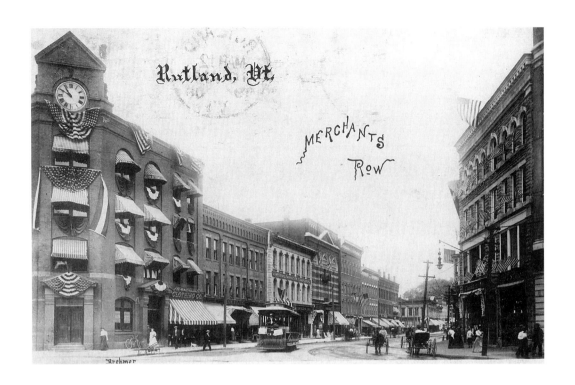

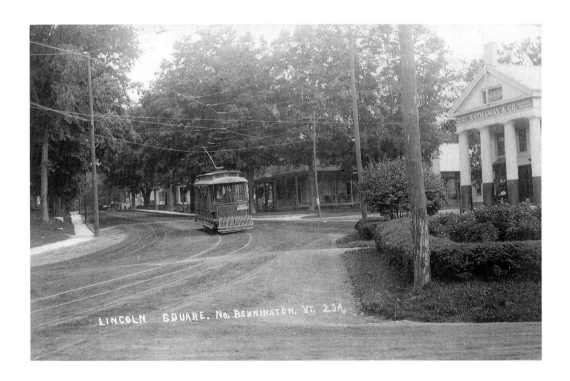

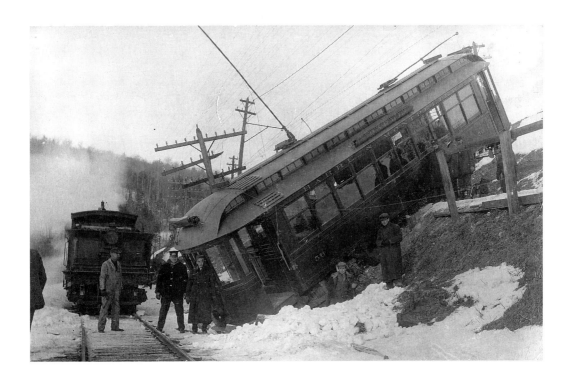

(*Top left*) Merchants' Row, Rutland, with streetcar along with horses and wagons. The card was mailed in 1908, but the photograph is probably earlier. (*Bottom left*) A streetcar comes around a bend in North Bennington. (*Above*) An accident on the Barre and Montpelier line in 1911. It is not clear how the car landed in this position or how the men intend to get it back on the tracks.

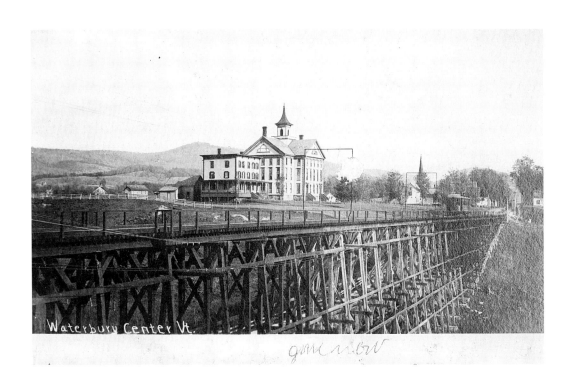

Waterbury Center Vt.

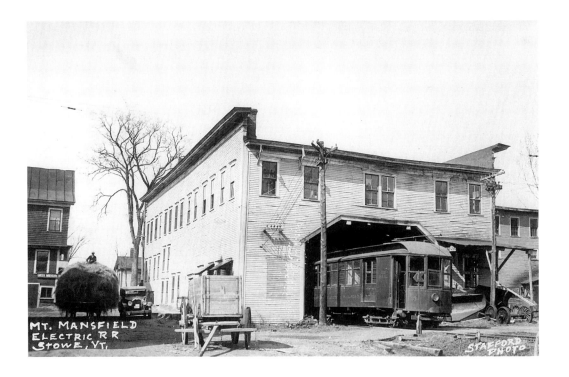

MT. MANSFIELD
ELECTRIC R R
STOWE, VT.

STAFFORD
PHOTO

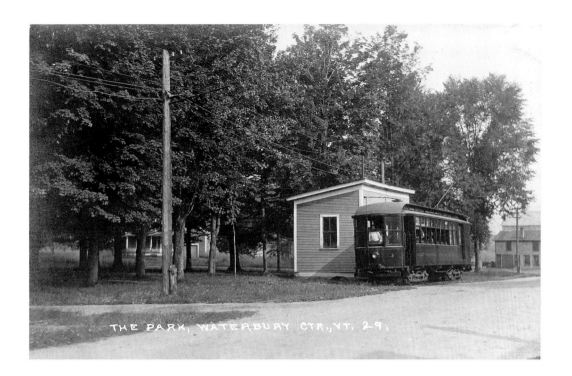

THE PARK, WATERBURY CTR., VT. 29,

(*Top left*) The long trestle at Waterbury Center on the Stowe to Waterbury line with the Waterbury Center School in the background. (*Bottom left*) The Mt. Mansfield Electric Railroad terminal in Stowe about the time the line closed in 1932. Note the load of hay next to the circa 1930 car. If the line could have survived into the 1940s, it would have been a great way to transport skiers to Stowe from the ski trains that stopped in Waterbury. (*Above*) The trolley stops at the park in Waterbury Center, circa 1910.

9

The Automobile Comes to Vermont

In 1906 there were 860 autos registered in Vermont. By 1920 there were 30,000, and that number tripled to 90,000 in 1930. In 1909 Vermont passed a law requiring that all motor vehicles be registered annually. In that year it was one of only twelve states that required drivers to be licensed. Before World War I, and to a certain extent in the 1920s and 1930s, the horse and car occupied streets and roads together. Photographic postcards show horses and wagons tied up next to parked autos, and the two kinds of vehicles passing each other on the roads. Early in the twentieth century, horse owners complained that the noisy autos scared their horses, and they often insisted that the car owners stop their vehicles when approaching a horse. In the early years, horses were certainly superior in winter and especially in mud season. One of the most embarrassing plights for the early car owner was to have to ask a farmer to pull his car out of the mud with a horse. The way the two forms of transportation coexisted in the early part of the century is illustrated by a 1910 advertisement for the Excelsior Carriage Company of White River Junction, which announced itself as "manufacturers of carriages and sleighs," but also "dealers in automobiles and auto supplies." Within a few years, most of the carriage shops and livery stables went out of business, and the culture of the horse was replaced by the culture of the auto.

Early in the twentieth century there were steam cars and electric cars, and dozens of different car manufacturers, including a shop in Bennington where Karl Martin produced the Wasp (he built only eighteen), a well-designed car capable of going 70 miles per hour. But it was

Henry Ford's Model T, introduced in 1908, that brought Vermont and the rest of the nation into the auto age. The first Model T, which came only in black, cost about $850, at a time when the average working man made about $600 a year. But in 1913 when Ford perfected the assembly line the price was cut in half, and suddenly an auto was affordable for most middle-class Vermonters.

The Model T Ford was shipped in railroad box cars in pieces and had to be assembled. Other models were shipped ready to drive. The early autos were uncomfortable and broke down frequently. "He'd Have to Get Under, Get Out and Get Under," a popular song went, "To Fix His Automobile." But within a few years the cars became more dependable. The electric self-starter was invented in 1912, but in the beginning it was only on the expensive models; many still had to crank the car before it would start. Then within a few years the windshield wiper, shock absorbers, and other features were added. The closed car made driving more comfortable, and soon a powerful engine made it possible to go 35 miles an hour.

In the early days of the auto, the car was not used for shopping or commuting to work; it was used for touring and vacationing. Car owners went on Sunday drives, or even on overnight camping trips. Auto touring seemed to many like a romantic adventure. By the mid-1920s, half the cars driving on Vermont roads came from out of state. Railroads brought passengers to a specific place at a fixed time; autos, on the other hand, allowed flexibility and promoted wandering. At first the available maps were not very accurate or reliable and there were no route signs. Most motorists depended on maps prepared during the bicycle craze of the 1890s, but by the mid-1920s gasoline companies provided free maps. Still, auto touring was often difficult and filled with pitfalls. One traveler in 1910 proudly wrote on a postcard that he had driven 30 miles and he considered that a good day's work. Sending a postcard to a friend during an auto trip seemed like a natural thing to do. "Motored up to this lake today and motored along the shore," a woman wrote from Lake Bomoseen. "Roads are dreadfully muddy," another reported.

With the arrival of the automobile, some method had to be devised to fill the gas tank with the messy and combustible fuel that made the internal combustion engine work. At first motorists went to a wholesale

outlet, or perhaps to a country store where they filled a bucket with gasoline, which they poured into the gas tank using a funnel. This was both wasteful and dangerous, and was soon replaced by a gravity-feed system devised in 1905 by C. H. Lasesig of St. Louis. Lasesig took an old water heater, stood it on end, added a glass gauge and a faucet, and was the first to invent a way to move the gasoline directly from the storage tank to the car's gas tank. A short time later, Sylvanis F. Bowser of Fort Wayne, Indiana, invented the first gas pump, used first for kerosene. Bowser's invention, which could be locked at night, was quickly labeled a "filling station."

Gas pumps of various design spread rapidly. At first the pumps were supplied by barrels or drums that were stored on the ground; then, for safety reasons, gasoline storage tanks were buried underground. Owners of country stores, city hardware stores, and other commercial establishments quickly learned that they could make extra money by selling gas. Gas pumps suddenly appeared near the curb on busy streets in cities and towns. They were certainly convenient, although a car out of control could easily hit them and cause disastrous explosions. By 1920, many states banned curbside gas pumps, but in Vermont the gas pump in front of the country store remained a part of the vernacular architecture. Gradually the separate gasoline station replaced the random pumps, but many Vermont country stores have retained their gas pumps (with storage tanks safely underground).

In the early days of the auto, all gasoline was alike. But with the breakup of the Standard Oil Company in 1911, brand names like Texaco, Socony, Gulf, Sunoco, and others, with their special logos, symbols, and stylized pumps and stations, emerged to compete for the motorist's business. Gasoline brands, however, could not be distinguished by smell or appearance, so the various companies started to dye the gasoline pink, purple, or some other color to make it seem different from their competitors. Soon "visible" gas pumps were developed so the customer could see the colorful gasoline in the pump. By the late 1920s and the 1930s the various companies began to market "colonial," "Spanish," or "modern" gas stations, and even in Vermont they became a familiar sight along the highway.

The railroad helped to create the postcard boom early in the twenti-

eth century, but the automobile also contributed to the popularity of the postcard. An auto trip to a neighboring town in 1907 almost required the purchase of a postcard or two to let friends know that you were adventurous and had survived the trip in the new contraption. As cars improved longer trips transformed the way middle-class families spent their leisure time. In the 1920s many large companies introduced paid vacations for the first time and the auto trip to a distant spot became more common. The auto created its own vernacular architecture along the highway, and the owners of overnight cabins, roadside restaurants, and gasoline stations all sold postcards to advertise their establishments, and to enable the traveler to stay in touch with those back home. Those who went on auto trips also bought postcards as souvenirs. Some of them were humorous and featured pictures of cars. "You auto be in Underhill, Vt," one card announced. "Believe me this town of Essex Junction is some speed town," another asserted. Postcards served as proof that one had traveled to an exotic place or even to a place a few miles away that was not very exotic.

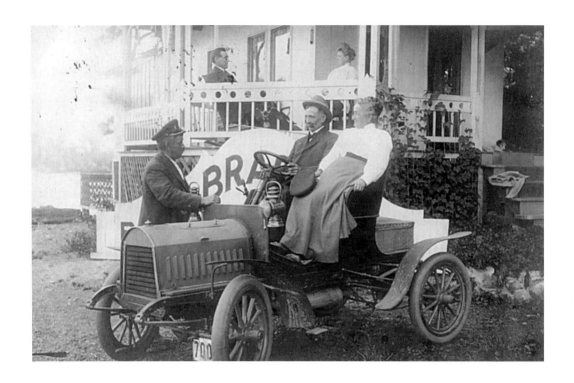

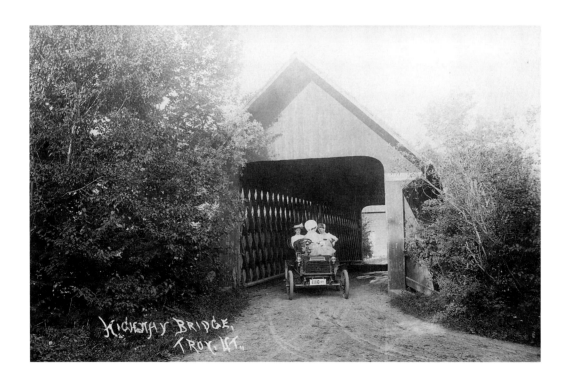

HIGHWAY BRIDGE,
TROY, VT.

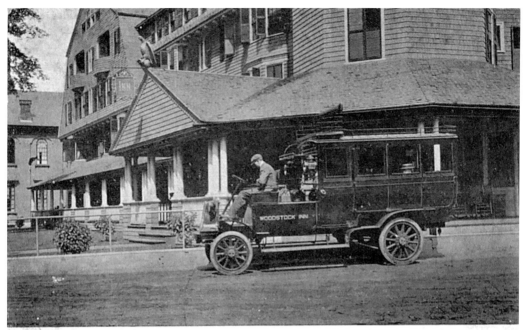

The Electric Bus of the Woodstock Inn, Woodstock, Vt.

(*Top left*) Proud owners of an early auto in Fairlee. The vehicle has a lantern rather than headlights. (*Bottom left*) Three well-dressed women pose in car under a covered bridge in Troy. The postcard was mailed July 2, 1908. Very few women drove cars before World War I. (*Above*) An early electric bus at the Woodstock Inn. Notice that all the cars have the steering wheel on the right and none has a windshield. After 1908 the steering wheel was generally installed on the left side.

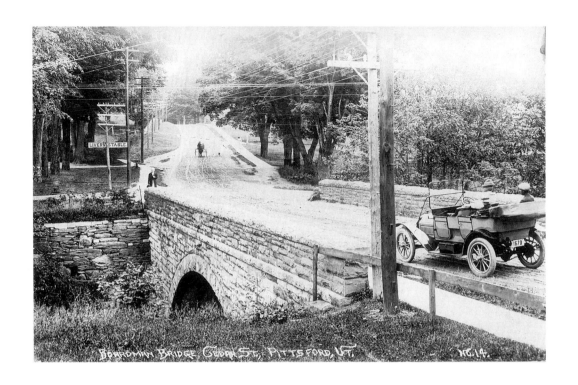

BOARDMAN BRIDGE, CEDAR ST., PITTSFORD, VT. NO. 14.

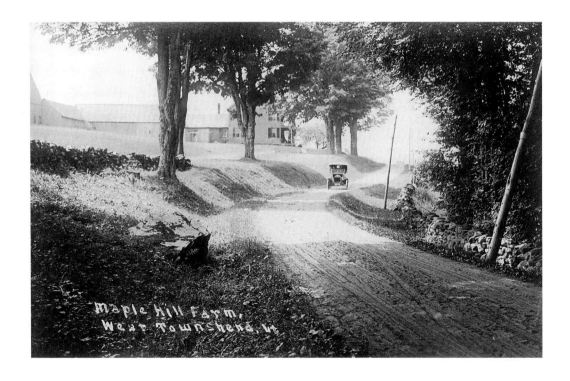

Maple Hill Farm, West Townshend, Vt.

(*Top left*) Horse meets car in Pittsford, circa 1910. Notice the livery stable sign to the left. Within a few years, the car made the livery stable obsolete. (*Bottom left*) Car photographed along a rural road in West Townshend, much the way a horse and wagon would have been photographed a few years earlier. A superb example of continuous architecture is in the background, with the house connected to the shed, which is connected to the barn. This form of connected architecture was popular at the turn of the century and more common in the eastern part of the state. The message on this card, mailed in 1910, reads: "Very quiet up here. Have only seen one of these machines up here." (*Above*) The car replaced the horse in many ways. This proud car owner from Calais photographed his car instead of his horse or family in front of his house. Improvements are evident, for all three cars have headlights and windshields.

JOHN P. MORRIS CAMP GROUND, EAST THETFORD, VT.

BATHING BEACH, HARVEY'S LAKE, W. BARNET, VT.

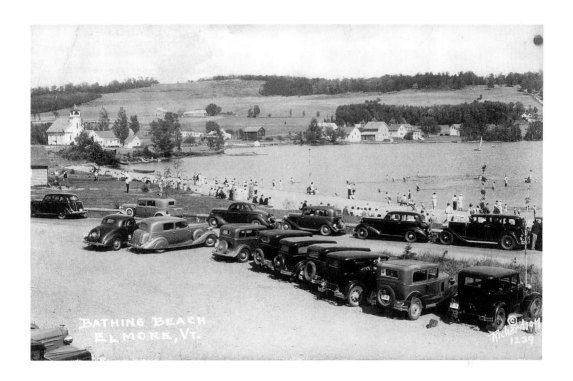

One favorite weekend activity in Vermont during the auto age was to go for a drive and meet for a picnic or to stop at a lake for a swim. (*Top left*) Car owners and their families gather at the John P. Morris campground in East Thetford, circa 1915. (*Bottom left*) An impressive array of autos at the bathing beach at Harvey's Lake, West Barnet, circa 1928. (*Above*) Another bathing beach, this one at Lake Elmore, circa 1936. Even during the Depression, many Vermonters owned cars and used them to relax on weekends. By the mid-1930s some of the cars are getting a streamlined look.

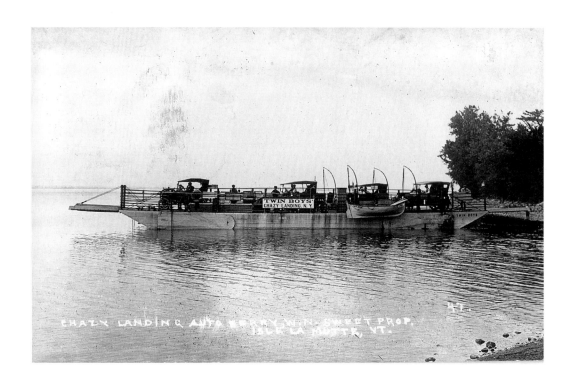

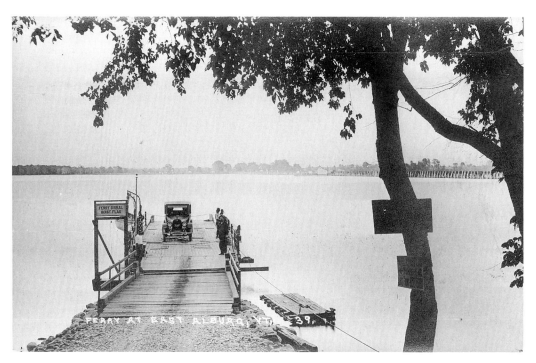

Crossing Lake Champlain by ferry. (*Top*) Isle La Motte. (*Bottom*) East Alburg.

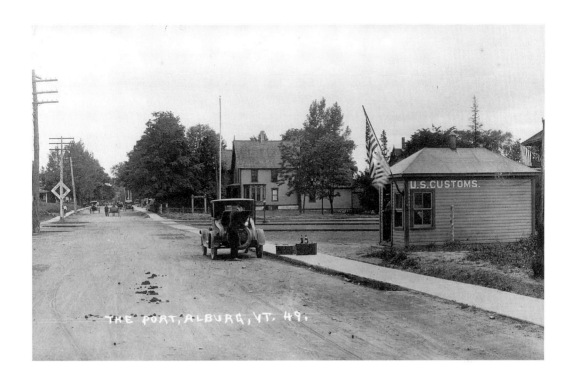

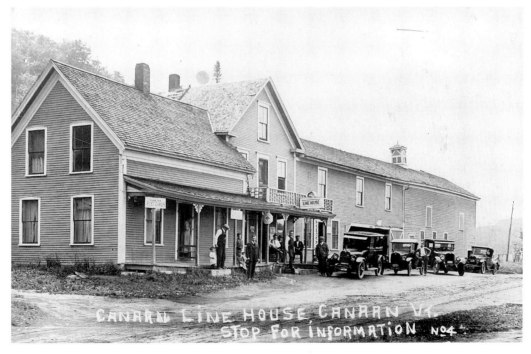

One favorite auto trip was to cross into Canada. (*Top*) A Customs officer checks luggage at Alburg circa 1925. During Prohibition, many drivers tried to bring liquor across the line from Canada into Vermont. (*Bottom*) The Line House at Canaan, circa 1925. One sign on the porch reads: "Post Cards." To mail a few cards home to friends became almost a required part of any auto trip.

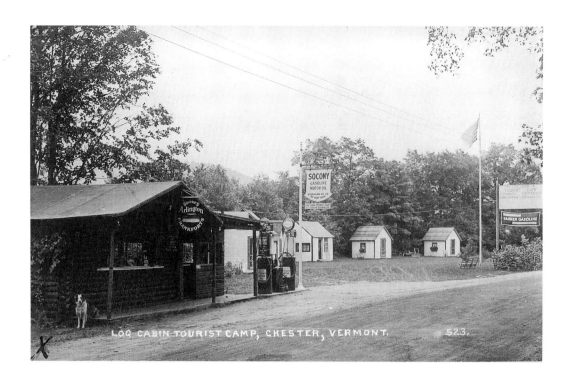

LOG CABIN TOURIST CAMP, CHESTER, VERMONT. 523.

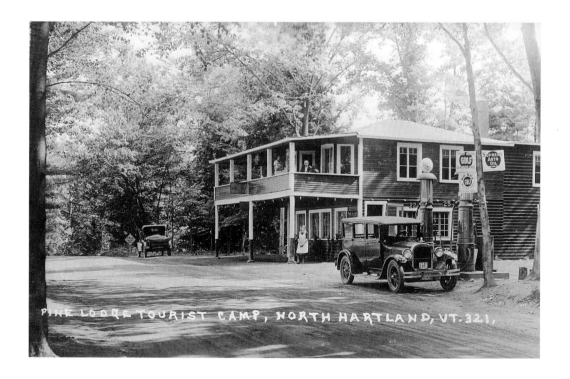

PINE LODGE TOURIST CAMP, NORTH HARTLAND, VT. 321,

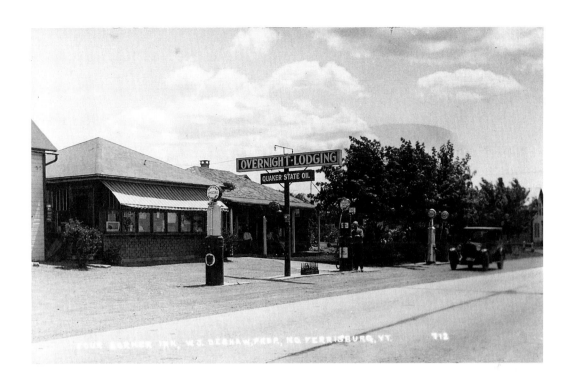

Tourist camps and gasoline pumps went together, and the brand names Socony, Gulf, Quaker State, and Supreme Auto Oil took their place alongside signs for frankfurters and soft drinks. (*Top left*) Socony gas pumps in Chester. Gas is for sale in two varieties at 21.8 cents and 24.8 cents per gallon. (*Bottom left*) Gulf gasoline for sale, circa 1925, at the Pine Lodge Tourist Camp in North Hartland for 22 cents and 25 cents. Both sets of gasoline pumps have a glass section so the customer can watch the gas being pumped and check on the color. (*Above*) Quaker State Oil is featured along with Overnight Lodging and two brands of gasoline at the Four Corner Inn in North Ferrisburg about 1930.

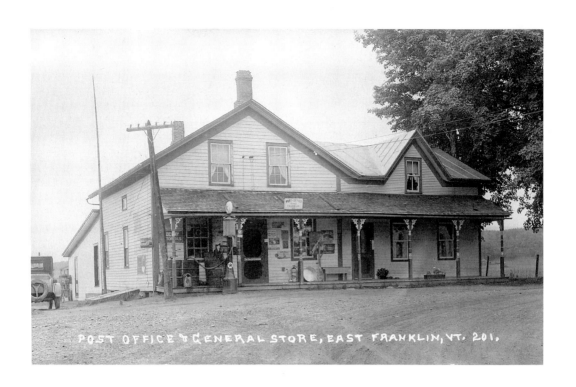

POST OFFICE & GENERAL STORE, EAST FRANKLIN, VT. 201.

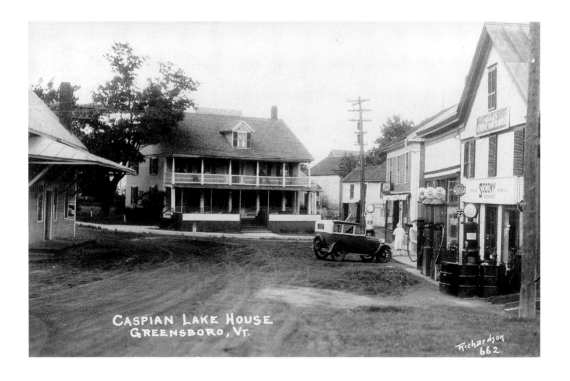

CASPIAN LAKE HOUSE
GREENSBORO, VT.

Richardson
662

Gasoline pumps seemed to sprout everywhere as the auto became more and more pop-
ular. Country store owners added gas pumps hoping that they would bring in enough
profit to keep the store open. However, the gasoline they pumped was often used by the
owners of autos to drive to the larger stores in the bigger towns. The most convenient
place for the gas pumps was on the sidewalk in front of the store, but that could also be
dangerous. (*Top left*) The gasoline pump at the general store in East Franklin is almost
on the porch and seems to be supplied from barrels of gasoline on the porch. (*Bottom
left*) That was also the case in Greensboro, a summer resort community, where as late as
this photo, circa 1925, at least some of the five gas pumps are supplied from barrels on
the sidewalk. This was very dangerous and almost invited an out-of-control car to crash
into the flammable mixture. (*Above*) In Readsboro, circa 1935, Texaco and Moxie (a
beverage) were advertised side by side, and one could shop at the Nationwide store and
read about the circus coming to town on August 15. The gas pumps, one old and one
new, are apparently supplied from an underground tank, but there is still danger of a car
crashing into them.

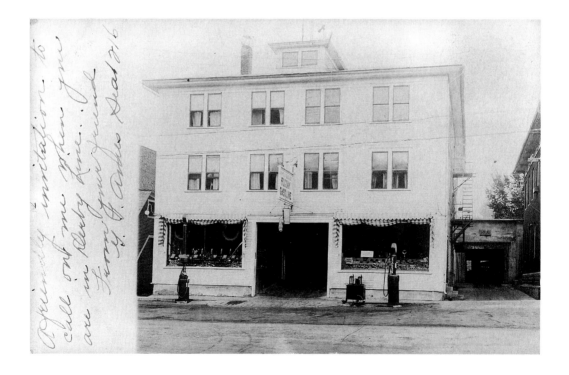

(*Top left*) This photograph in Lincoln, circa 1915, captures an early version of the gasoline truck delivering Socony to an underground tank. The general store has wooden boxes and barrels along with milk cans on the porch, material culture from a past age, but the gasoline truck represents the future. (*Bottom left*) The Ames garage in Derby Line illustrates how the modern garage evolved. One could purchase gas and oil and also drive in for repairs. This card also represents another use of the postcard, as calling card. It is addressed to Mrs. Buck Seat 141 and apparently was passed to her on a train by G. T. Ames (the owner of the garage) seated at 216. The message reads: "A friendly invitation to call on me when you are in Derby Line." Gradually roadside architecture became more specialized, and separate gasoline stations like the one in Milton (*above*) began to appear.

Hotels and Motels

There were inns, taverns, and boardinghouses in Vermont as soon as there were roads, and it was difficult to tell one from the other. They all offered rather primitive accommodations, and they usually served food and drink as well. The temperance movement that began in the 1830s eliminated drink from many establishments, but a few more comfortable inns were built in the larger towns and near mineral springs or lakes. It was the coming of the railroad in the 1850s that spurred the building of hotels, both near the railroad stations and in the center of town. Most nineteenth- and early twentieth-century hotels had livery stables where a traveling salesman could rent a horse and carriage, and where a traveler could board his horse and keep his wagon. Hotels varied in price and amenities, but it was not thought proper for a woman traveling alone to stay in a hotel. Hotels, well into the twentieth century, usually remained male gathering places. Another kind of hotel began to develop in the middle of the nineteenth century and expanded near the end of the century. This was the summer resort located near a mineral spring, or a lake, or in the mountains. These resorts catered to people who wanted to get away from the heat of the city, and who believed that the fresh air, clean water, and high elevation would improve their health. These resorts depended in the beginning on the railroad transporting their guests, but eventually they had to adjust to the automobile.

The first proud owners of automobiles often stopped by the side of the road to have a picnic, but soon the more adventurous began to take overnight trips. Many stayed at hotels, and gradually the hotels were

forced to add garages in addition to the livery stables. But those early auto travelers who had spent all day in an open car arrived dirty and disheveled, and they felt conspicuous and uncomfortable walking across the lobby or sitting in the dining room of a first-class hotel. They felt even more out of place in a cheaper hotel near the depot, where the clientele could be unsavory and the food notoriously bad.

Rather than search for a hotel, some travelers began to carry tents that they set up by the side of the road. They would build a fire, cook dinner, and spend the night. It was a little uncomfortable, but it added to the adventure of early auto travel. Some of these auto pioneers called themselves "gypsies." But soon the roads became crowded with auto campers. "Motor car camping grows more popular each year," a 1920 article announced. As more and more auto gypsies camped along the roads, farmers complained that they were knocking down fences, letting cows out, and doing other damage. Near cities the auto campers posed a serious health hazard. By the early 1920s, more and more cities, and even some small towns, established municipal campgrounds. Some even offered privies, and later flush toilets, as well as picnic tables. It wasn't long before local entrepreneurs started private campgrounds. They charged fifty cents for a tent platform, and $1.50 for a primitive cabin. Sometimes they opened a grocery store and added a gas pump. Eventually the auto camps added a restaurant as well, so the travelers did not even have to cook their own meals.

Meanwhile, many people who lived near a major highway or in a town decided to get in on the auto touring boom by putting up a sign that announced: "tourist home." Others built overnight cabins that eventually evolved into the motel. The first cabins in the mid-1920s were primitive, with only a bed, a table, a chair, and perhaps a wash basin. One had to walk to a central building to use the privy. But gradually the tourist cabin became more elaborate, and by the early 1930s several cabins were often grouped together to form a "tourist court." Some of these courts developed from campgrounds, but increasingly the owners of restaurants, gasoline stations, and other property along the highway built tourist cabins and rented them for a dollar or two a night. "The auto courts have created a new travel etiquette," an article in *Business Week* in 1940 pointed out. "In hotels the husband and father

registers for his party, which is assigned a room sight unseen. In the auto court, it is more likely to be the woman who makes the arrangements going from cabin to cabin, feeling mattresses and investigating plumbing." The tourist court had another advantage as well. Unlike a hotel, where one walked across the lobby (and could be observed by all) in order to register, at a tourist court one could register dressed in old clothes, and, if one chose, without revealing one's companion. Most tourist courts eventually required a car license as identification, but still they were more informal than hotels. They had free parking, needed no reservations, and required no tipping. Some courts became favorite places for clandestine, brief visits by unmarried couples. These auto courts that preferred to rent to families often posted a sign that read: "No locals—strictly tourist."

By the 1930s and 1940s the tourist court was a familiar landmark along the nation's highways, and Vermont kept pace with the rest of the country. Tourist courts came in a great many variations. Some cabins were designed to look like a New England village; some had a Spanish theme. Others were done in English Tudor style or looked like log cabins or wigwams. A few of the larger motor courts began to call themselves motor hotels. But World War II with its gas rationing and restrictions on travel temporarily ended the motor-court boom. After the war, as car ownership and travel increased dramatically, many more motor courts were constructed. Gradually the larger establishments took the name "motel," which was short for motor hotel. The first motel is usually credited to an establishment in San Luis Obispo, California, but nationally and in Vermont the motel was a post–World War II phenomena. Some of the overnight cabins survived for a time, some owners connected the cabins and called them a motel, but soon the overnight cabin, along with the diner and the old-fashioned filling station, became rare.

Postcards from the pre–World War I period document the heyday of the resort and the downtown hotel, while postcards from the 1920s, 1930s, and 1940s help us recall the early auto courts and overnight cabins. When one stayed overnight in one of these tourist courts, it was almost a requirement that one buy a few postcards (easily available in the office) and send them to friends. Many people could not resist

marking their cabin with an X. "Our cabin is 3rd from your right. We are enjoying ourselves," one traveler wrote. "Cold up here. Stay at these cabins last night," another scrawled on the back of a card. "Having nice trip, but crooked roads. Staying here tonight," a third reported.

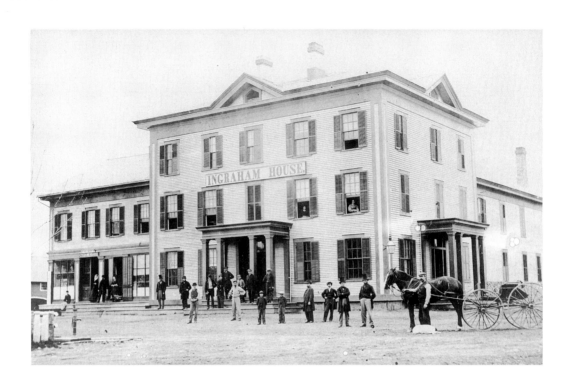

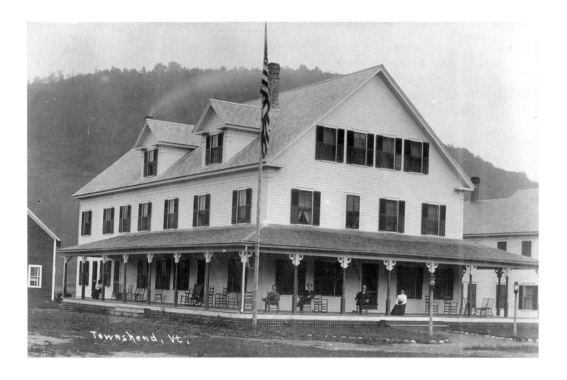

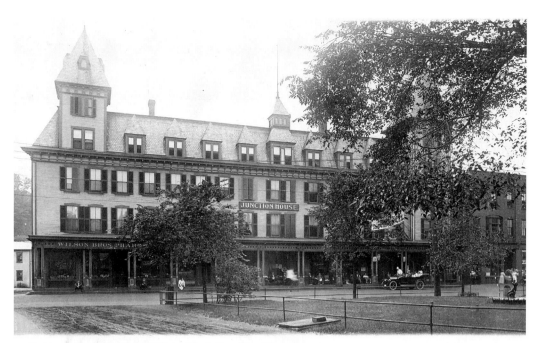

P8589 Junction House, White River Junction, Vt.

(*Top left*) This carefully posed photo was probably taken shortly after the Ingraham House in Chester opened in 1872. Notice the water pump in the street in front of the hotel. The Ingraham House, like most early hotels, probably had no running water or toilets in the hotel. The clothes and the hats of both men and women posed in front of the hotel indicate that this photo dates from the 1870s or 1880s. Probably a local photographer searched through his negatives and selected the best ones to be turned into postcards during the era of postcard mania. (*Bottom left*) The Townshend House, built in 1894, was destroyed by fire in 1921 (the fate of many hotels). This photo from about 1906 captures a number of men and women sitting on the wide porch, about the only recreational activity that these early hotels provided. (*Above*) The Junction House, White River Junction, circa 1912. The best hotel in town often was close to the railroad station.

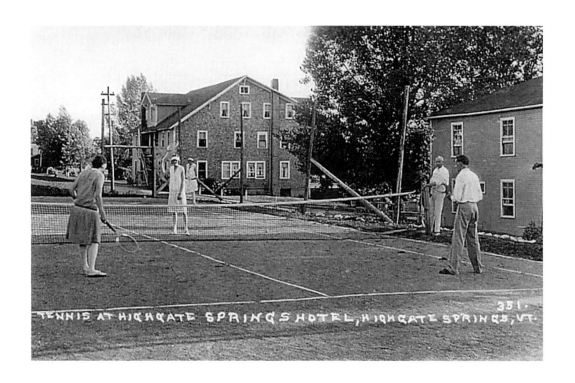

TENNIS AT HIGHGATE SPRINGS HOTEL, HIGHGATE SPRINGS, VT. 351.

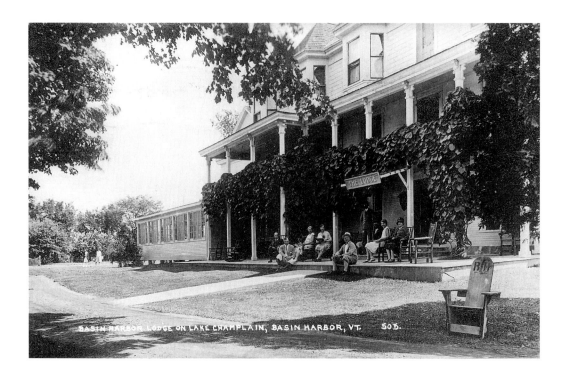

BASIN HARBOR LODGE ON LAKE CHAMPLAIN, BASIN HARBOR, VT. 505.

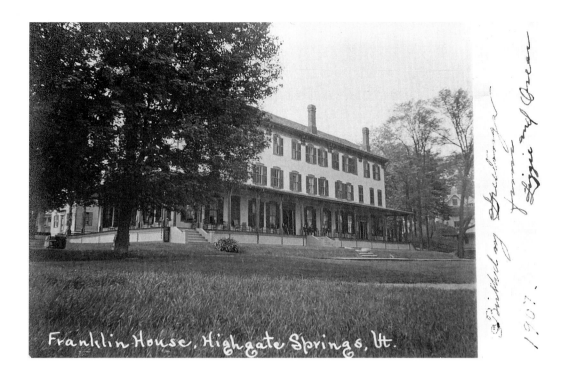

Franklin House, Highgate Springs, Vt.

(*Top left*) Mixed doubles at the Highgate Springs Hotel, circa 1925. Highgate Springs was one of the early summer resorts in Vermont, built around the mineral springs, which attracted guests because the mineral water reportedly cured all kinds of ailments and restored health. There were more than 100 mineral springs in the state, and successful resorts developed near many of them, including Clarendon Springs, Alburg, Manchester, and Brattleboro. (*Courtesy Vermont Historical Society.*) (*Bottom left*) The Lodge at Basin Harbor on Lake Champlain developed from a farmhouse. It was acquired by the Beach family in 1882 and became the largest club resort on the lake, with cottages and a golf course. Despite all the possible activities, these guests seem content to sit on the porch. The message on the card, mailed August 1, 1930, revealed another major reason for the success of Vermont resorts: "Will soon be back to old NY & heat. Down to 59 this A.M." (*Above*) A postcard mailed in 1907 pictures the Franklin House in Highgate Springs.

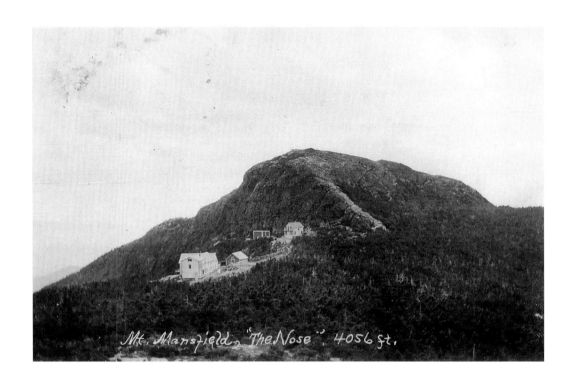

Mt. Mansfield, "The Nose" 4056 ft.

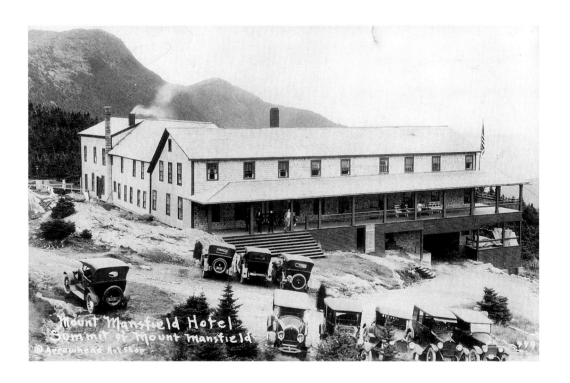

Mount Mansfield Hotel
Summit of Mount Mansfield
© Arrowhead Art Shop

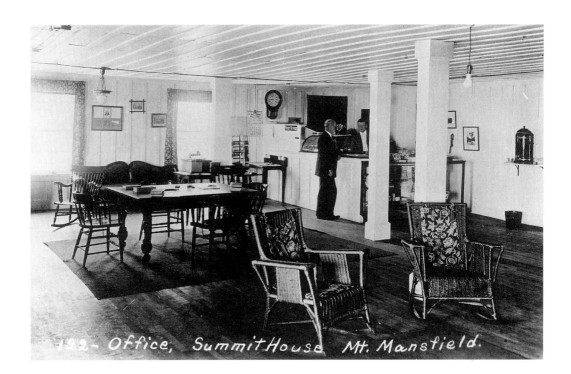

122 - Office, SummitHouse Mt. Mansfield.

The Mt. Mansfield Hotel was built under the Nose on the highest mountain in Vermont in 1858 by William Henry Harrison Bingham, an enterprising lawyer. The impulse to build hotels on top of mountains was inspired in part by the fresh-air and exercise craze. If fresh air was good for you and helped to restore health, then air at the top of a mountain must be even better. The hotel was enlarged from time to time, and it became known as the most comfortable high-altitude hotel in New England. Other Vermont mountains had "inns" on top, including Ascutney and Killington, but none could compare to the Mt. Mansfield Hotel for comfort and longevity. At first a bridle path connected the hotel to the valley below, and that became a carriage road in 1870 and eventually an auto road. The hotel finally closed in 1957 and was torn down a short time later. (*Top left*) A photo of the hotel and outbuildings taken, circa 1915, from the path to the Chin. (*Bottom left*) A close-up of the hotel and the parking lot. The card, mailed September 26, 1924, has a Mt. Mansfield postmark. The message reads: "It is some climb up here, 3000' in 4½ miles, but the Dodge made it without any trouble." (*Above*) The rather spartan lobby and office, circa 1925. A display of postcards is in the corner.

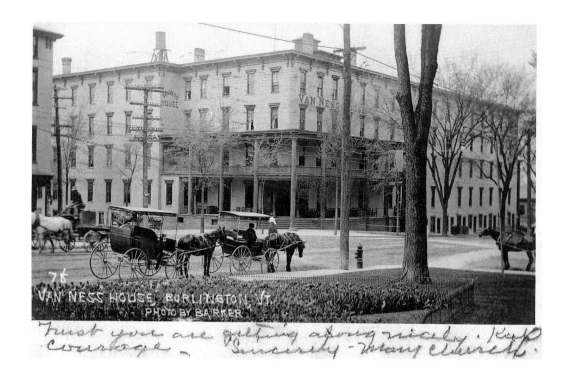

VAN NESS HOUSE, BURLINGTON, VT.
PHOTO BY BARKER

Trust you are getting along nicely. Keep courage — Sincerely — Mary Aldrich

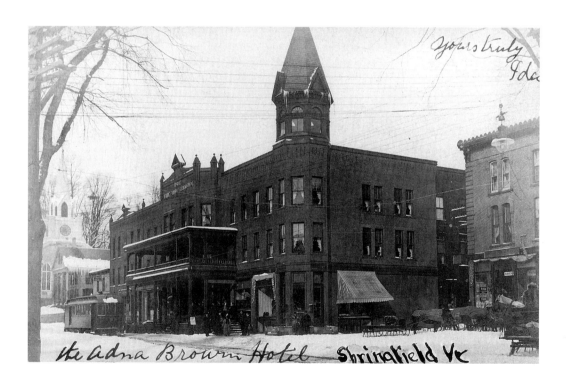

*Yours truly
Ida*

the Adna Brown Hotel Springfield Vt

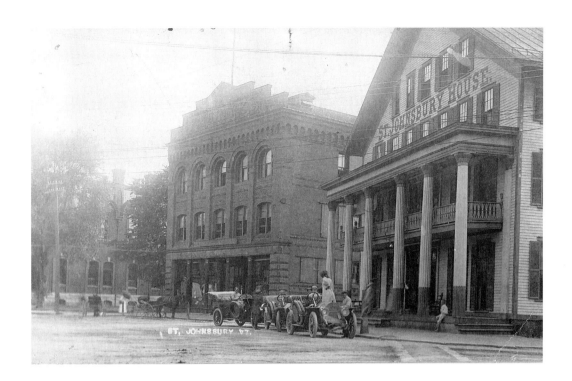

Three rather different city hotels. (*Top left*) The Van Ness Hotel in Burlington was built in 1870 and named in honor of Governor Cornelius Van Ness. This photo, from a postcard mailed in 1906, shows the hotel with various horse-drawn vehicles in front. The two wagons in the foreground may be taxis. A 1910 advertisement announced: "The Van Ness House on Lake Champlain, Burlington Vermont. The largest hotel in the state. Long distance telephone and running hot and cold water in every room. Sixty rooms en suite with bath. The only hotel in Burlington with verandas and shade trees. Fireproof automobile garage." (*Bottom left*) The Adnabrown Hotel in Springfield was built in 1892 on the site of another hotel that had been destroyed by fire. This winter photo, circa 1905, shows several sleighs, a trolley, and a number of guests bundled up against the cold. Ida, who sent this card to a man in Newark, New Jersey, could only write a brief greeting on the front of the card, because there was no room for a message on the back. (*Above*) The St. Johnsbury House, built in the early 1850s after the railroad came to town, was later modified to create a flat roof. Henry Ford was one of the famous people to stay at the hotel, and William Howard Taft gave a campaign speech from the porch in 1912. This postcard, circa 1910, shows three early cars, as well as several horse-drawn vehicles.

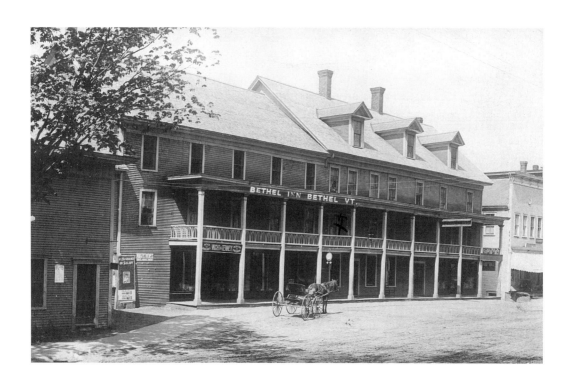

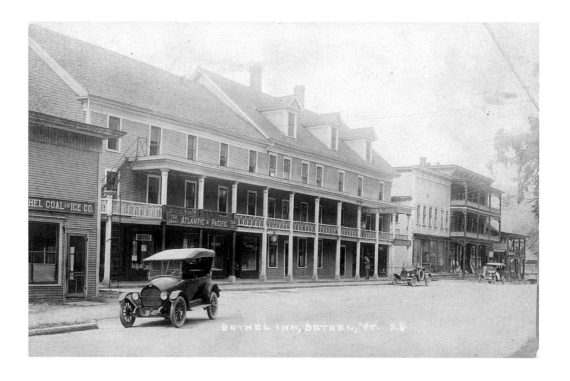

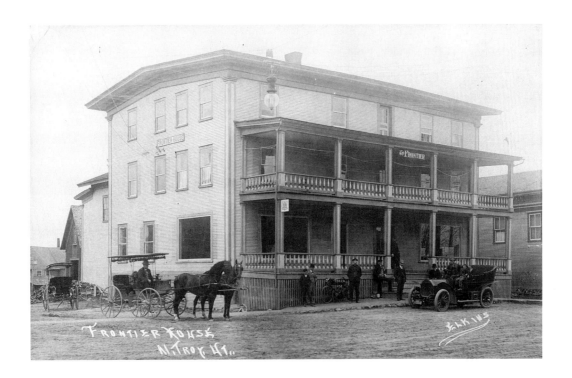

Two photos of the Bethel Inn (*top left*), circa 1906 and (*bottom left*) about 1920, show the change in the use and appearance of a building that can occur in only a few years. In the first photo a general store, "Wright & Jenny," shares a portion of the inn and advertises "Meats and Groceries, Fish and Provisions." The sign to the left advertises a play, "A Husband on Salary," and a lone horse and buggy wait patiently in front of the inn. In the later photo, the street has been paved and cars replace the horse and buggy. The Great Atlantic and Pacific Tea Co. (A&P) has replaced the independent general store, a trend that forced many general stores to close across the state. A coal and ice company now occupies the building to the left. This combination of products was quite common, but after World War II coal was replaced by oil and ice by electric refrigerators, and coal and ice companies went out of business. (*Above*) The Frontier House in North Troy, built sometime before 1878, had a dance hall and a large assembly hall. The photo, circa 1910, reveals the transition between the age of the horse and the auto age, but also includes a motorcycle posing with the young men in front of the hotel. The Bell Telephone sign suggests that the inn had a telephone. Often hotels and stores were the first in town to install telephones, and local citizens came there to make calls.

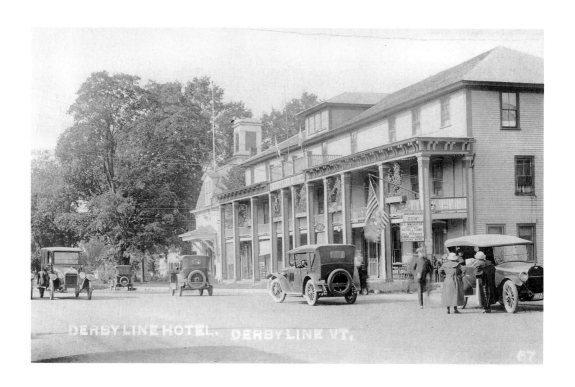

DERBY LINE HOTEL. DERBY LINE VT.

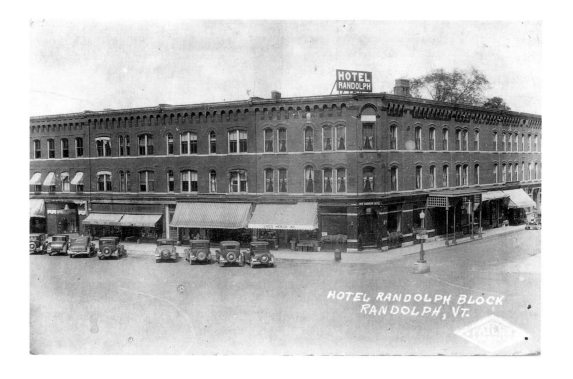

HOTEL RANDOLPH BLOCK
RANDOLPH, VT.

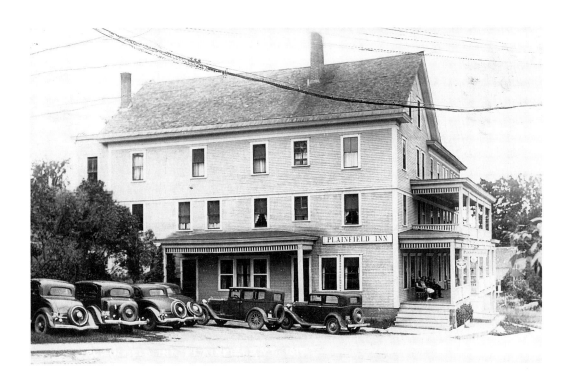

Two hotels from the 1920s that fit into the townscape have adjusted to the auto and serve multiple purposes. (*Top left*) The Derby Line Hotel also functions as a customs and immigration checkpoint. The sign reads: "Stop. U.S. Immigration Office. Autos and Teams, and all persons coming from Canada report here." (*Bottom left*) The Hotel Randolph occupies the top two floors of a commercial block, while the ground floor has stores. Hotels such as this one would soon face competition from the tourist courts outside of town. (*Above*) Even small town hotels, like the Plainfield Inn (circa 1930), faced competition from the tourist cabins. Most did not survive after World War II.

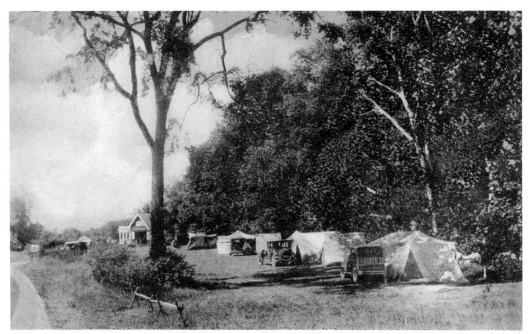

22 MUNICIPAL TOURIST CAMP BURLINGTON, VT.

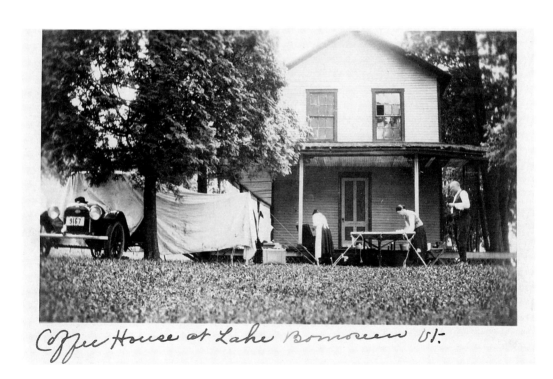

Coffee House at Lake Bomoseen Vt.

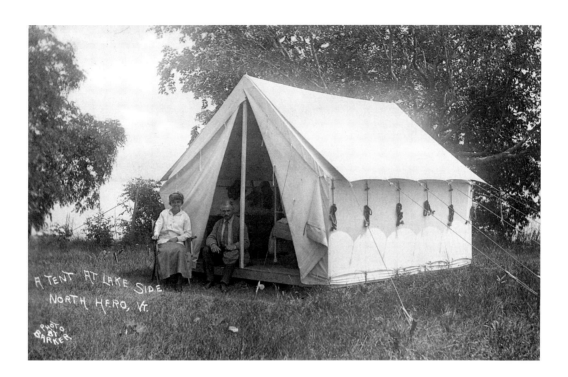

When people ventured out in their autos away from the hotels they often stayed in municipal campgrounds such as the one in Burlington (*top left*). Or they improvised by draping canvas over their cars, as with the campers at Lake Bomoseen (*bottom left*). But tents could contain most of the comforts of home, like the one in North Hero (*above*).

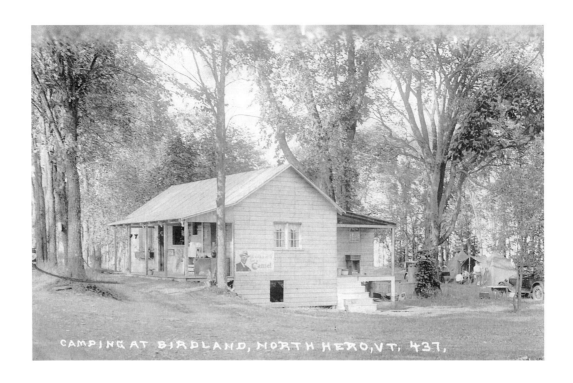

CAMPING AT BIRDLAND, NORTH HERO, VT, 437,

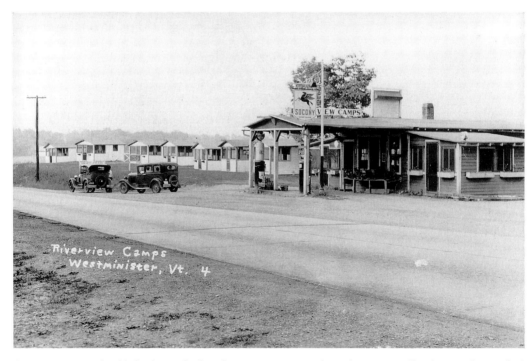

Riverview Camps
Westminister, Vt. 4

Some campgrounds added cabins, which at first were just a step above the tents. Birdland at North Hero had both camps and tents, as well as an administration building (*top*) that sold food, drink, and Camel cigarettes to the campers. Soon the cabin owners added a restaurant and gas pumps. At the Riverview Camps in Westminster (*bottom*), campers could buy regular Socony gasoline for 21.7 cents and premium for 24.5 cents per gallon.

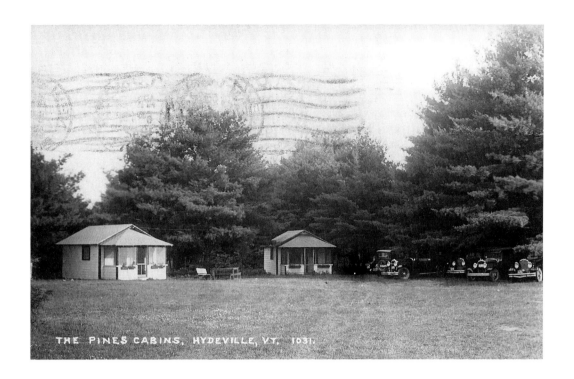

THE PINES CABINS, HYDEVILLE, VT. 1031.

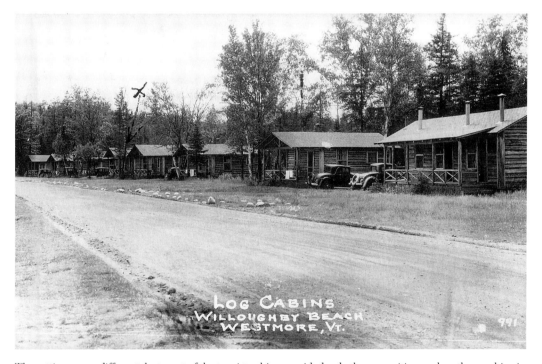

LOG CABINS
WILLOUGHBY BEACH
WESTMORE, VT.

The settings were different, but most of the tourist cabins provided only the necessities, such as these cabins in Hydeville (*top*). But the tourist cabins at Lake Willoughby in Westmore (*bottom*) were made to look like log cabins.

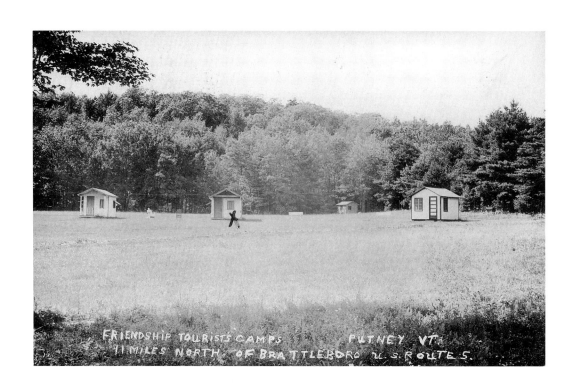

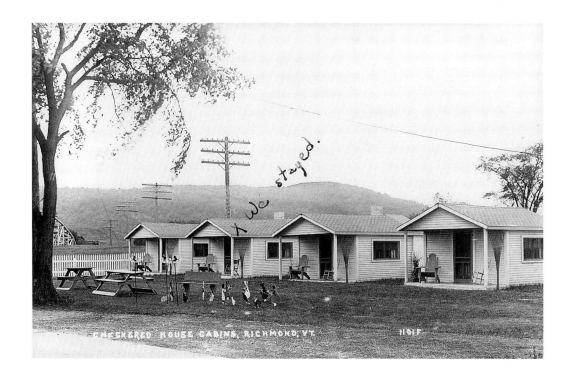

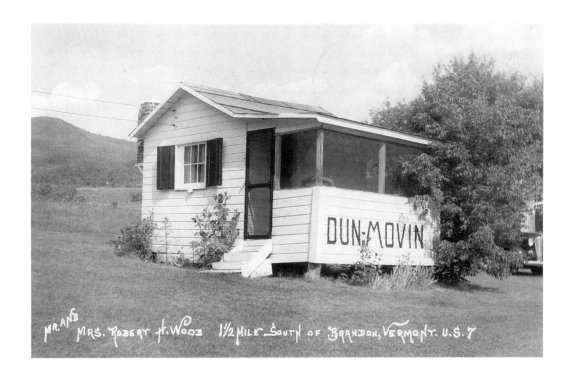

MR.AND MRS. ROBERT H.WOOD 1½ MILE SOUTH OF BRANDON, VERMONT. U.S. 7

Most tourist courts sold postcards in part to advertise themselves, and most travelers could not resist the impulse to buy a few cards and to mark them with crosses to indicate where they stayed (*top and bottom left*). The card of the Friendship Tourist Camps in Putney has a typical message: "Arrived here safe and made good time. Stayed at this cabin Sat. night, the one with the cross." Some owners thought up cute names for the cabins, such as "Dun-Movin'" in Brandon (*above*). The message reads: "Dear Jo, couldn't find 'Hav-A Kwikee,' but this was the next best."

Outdoor Life: Camping, Hiking, Hunting, Fishing

During the period from 1880 to 1920 there was an upsurge of interest in hunting, fishing, hiking, camping, and other outdoor activities. Men, and sometimes women, had always camped out of necessity or for fun. They built fishing and hunting camps, and tramped through the wilderness as Henry David Thoreau, Francis Parkman, and others had done at mid-century. But with the growth of cities and increased leisure time for the middle and upper classes in the decades after the Civil War, many Americans felt the need to set up a tent or build a simple camp near a lake or stream. The increased interest in camping may also have had something to do with a generation of Civil War veterans who had experienced the pleasure and the pain of living in a tent. But the bad memories faded, and as they got older they helped to teach a younger generation about the pleasures of the outdoor life.

Camping outdoors also seemed to improve the health of busy and overstressed Americans. William H. H. Murray, the author of *Adventures in the Wilderness* (1869), who lived in Burlington for a short time and founded the Burlington Yacht Club, wrote that camping in the wild would cure exhaustion, consumption, dyspepsia, and a great many other ills. Many physicians and experts concluded that vigorous outdoor activity would be beneficial for overcivilized young men; eventually they added young women as well, but initially they argued that too much exercise might damage girls and prevent them from becoming mothers.

Vermont did not have the rugged peaks of New Hampshire nor the wilderness of the Adirondacks, but in the 1890s the state attracted be-

tween 50,000 and 60,000 visitors each summer. They stayed in hotels, in boardinghouses, and on farms. The Vermont State Board of Agriculture aggressively promoted tourism and touted the virtues of the hills, mountains, and lakes in the state. It also promoted campgrounds, boardinghouses, and hotels, and it especially stressed the advantage of buying lakeside lots, abandoned farms, and wilderness acres. The Board also urged visitors to stay with farm families and enjoy a "real rural vacation." Not everyone liked the "plain country fare" served in the boardinghouses and on the farms, but many fell in love with the Vermont landscape and returned each summer.

One variation on the boardinghouse that some visitors and residents alike were forced by ill health to go to was the tuberculosis sanatorium. Vermont, like the rest of the nation, was faced early in the twentieth century with an epidemic of tuberculosis, often called consumption, which frequently struck down young adults, both men and women. It was caused by the tubercle bacillus, but that was not identified until later, and there was no real cure until streptomycin was discovered in 1944.

Experts disagreed early in the twentieth century about the cause of TB, but one treatment recommended by all the experts was plenty of rest and fresh air, which led to the establishments of sanitoriums, often in the mountains and sometimes close to fashionable resorts, where upper-class patients could relax and hope for a cure. Vermont never had a sanitorium as prominent as Davos, Switzerland, made famous by Thomas Mann in his novel *The Magic Mountain*, or even the equal of Saranac Lake in the Adirondacks, but Vermont had a number of private sanitoriums. Perhaps the most important was in Pittsford, north of Rutland, provided by a gift from Senator Redfield Proctor and opened on December 16, 1907. It was finally turned over to the state in 1921.

The popular treatment for TB, fresh air, exercise, and sleeping outdoors, even in the coldest weather, led to the popularity of the veranda, the sleeping porch, and the hammock strung between two trees, and it also helped to promote general outdoor activity, especially camping and hiking. There was a hiking trail on Mt. Ascutney in Windsor as early as 1820, and a stone hut was constructed on the summit in 1858. In 1903 the Ascutney Mountain Association restored the hut and built new trails. Hikers had cut trails on Mt. Mansfield and other Vermont

mountains by the mid-nineteenth century, but the real hiking craze came in the early part of the twentieth century as part of the "strenuous life" philosophy promoted by Theodore Roosevelt.

In 1908 a group of businessmen founded the Camel's Hump Association. They cut two trails and built a hut on the mountain in 1912. More important, however, was the Green Mountain Club, founded in 1910 by James P. Taylor, the headmaster of Vermont Academy in Saxtons River, with the help of a group of businessmen and civic leaders. Taylor tried and failed to get the cooperation of the Appalachian Mountain Club, founded in 1876 in Boston to promote hiking and wilderness camping. Not discouraged, Taylor and his group set out to cut a trail between Mt. Mansfield and Camel's Hump, and they planned a "Long Trail" that would go from the Canadian border to the Massachusetts line. Ten years before Benton MacKaye, a Harvard graduate and regional planner, conceived the idea of the Appalachian Trail, the Vermonters started to cut their trail. It was not easy. Using mostly volunteers and working for only a few months each summer, the trail was finally competed in 1930.

Just as hiking became organized, so did camping. The first boys' camp, Chocorua, situated on an island in Squam Lake in New Hampshire, was founded in 1885 by Ernest B. Balch, a sophomore at Dartmouth College, with the help of his brother and a classmate. Balch conceived the notion of a summer camp while hiking in the New Hampshire mountains the year before. During its first year the camp enrolled five boys, and there were more the next year. Balch sensed that the sons of upper-class families were bored while they traveled with their parents to fashionable hotels in the United States and Europe. The new camp would be rigorous. There would be no servants; the boys would have to do the work. They would be trained to "master the lake," which meant learning to swim and sail.

The summer camp idea caught on rapidly. Two or three camps were founded within the next few years. There were twenty-six camps in 1900 and more than 700 in 1924. Soon the YMCA (Young Men's Christian Association) introduced summer camps as an important part of its mission. The Boy Scouts (founded in the United States in 1909), the Camp Fire Girls, private schools, religious organizations, and other groups

founded camps. In the beginning the campers and counselors slept in tents, but at most camps the tents were replaced by rustic cabins. But living close to nature and appreciating outdoor life remained the central purpose of the camps.

The first summer camp in Vermont was St. Ann's, a Roman Catholic camp supported by the Marist Brothers of New York, located on Isle La Motte and founded in 1892. The first girls' camp in the state was Camp Barnard on Mallets Bay, Lake Champlain, founded in 1903 and associated with the Barnard School of New York City. The Vermont YMCA established Camp Abnaki on North Hero in 1901, and the YWCA (Young Women's Christian Association) began Camp Hochelaga for girls on South Hero in 1920. Vermont had sixty-three camps in 1927, making it third in New England behind New Hampshire and Maine.

Some of the young campers were taught to hunt and fish. But the state's mountains and valleys had been so cut over by loggers in the nineteenth century that few deer and other wild animals survived. At the same time, many of the rivers and streams had been dammed and were so filled with silt that the trout population had declined drastically in some places. The state banned deer hunting in 1865, and the first Fish and Game Commission was established the next year. In 1878 the commission imported seventeen deer from New York State in an effort to replenish the herd. In 1897 a limited deer season was established and 103 deer were killed. The state appointed game wardens for the first time in that year to enforce the new hunting rules. In 1921 hunters took over 1,500 deer, and deer hunting seemed to be reestablished in the state.

The state officials realized that to attract tourists and sportsmen they needed to regulate hunting and fishing, but they also needed to advertise the fact that good hunting and fishing could be found in Vermont. Postcards showing trophy trout and deer helped to get that message across to the many who received them in the mail. Postcards along with other advertising helped to create the impression that Vermont in the twentieth century was a sporting paradise, and a place where visitors could engage in a great variety of healthy outdoor activity.

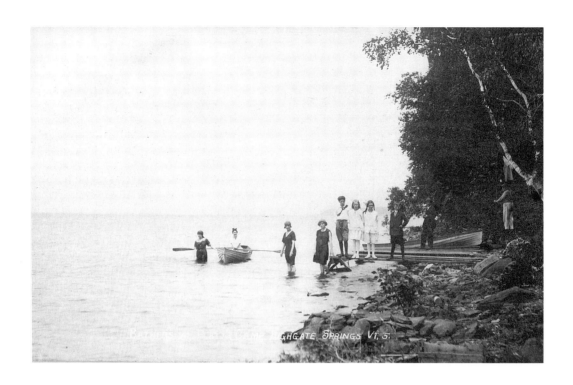

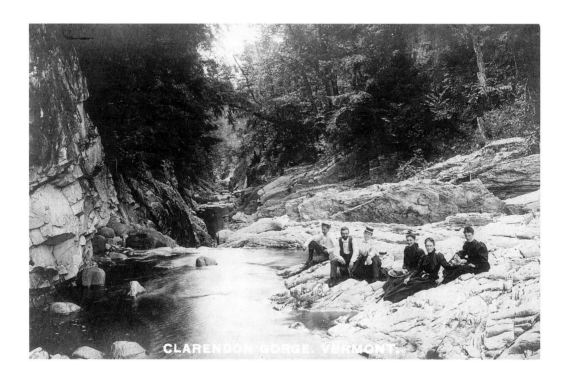

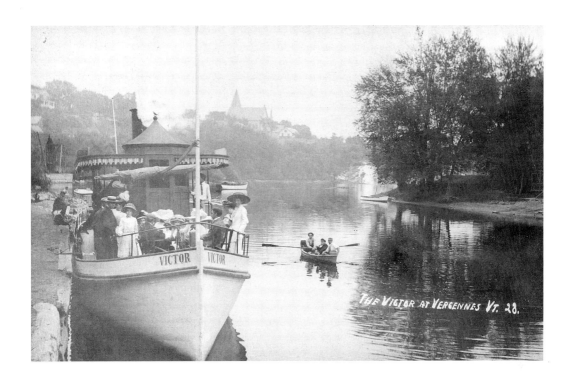

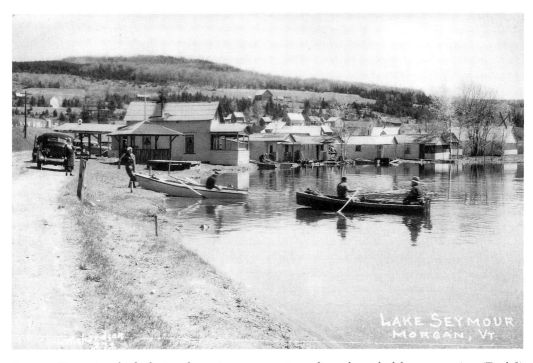

For many Vermonters the fresh air and exercise craze meant spending a day at the lake or near a river. (*Top left*) Enjoying Lake Champlain at Highgate Springs, circa 1915. (*Bottom left*) Well-dressed hikers relax at Clarendon Gorge, near Clarendon Springs, 1908. Notice the styles of bathing suits and vacation clothes. (*Above*) Boating at Vergennes, circa 1910, and at Lake Seymour in Morgan, 1935.

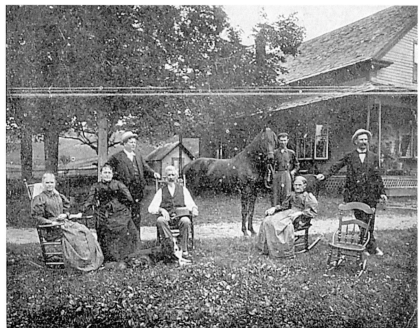

Typical Farmer's Home for Summer Boarders, So. Royalton, Vt. 673

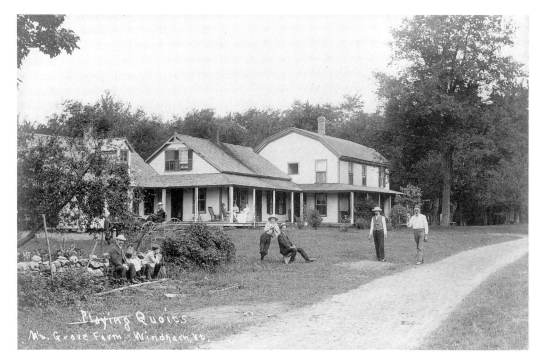

Playing Quoits
M*. Grove Farm - Windham, Vt.

The Vermont State Board of Agriculture tried to promote farm vacations. (*Top*) A commercial card published by Buswell's Bookstore, Montpelier, circa 1905, seems more like a caricature than a promotion, but at least the farm in South Royalton had electricity—as indicated by the electric line—something most Vermont farms did not get until the late 1930s. (*Bottom*) A more typical farm, which took boarders, in Windham, circa 1910. The men and boys play horseshoes while the women relax on the extensive porch.

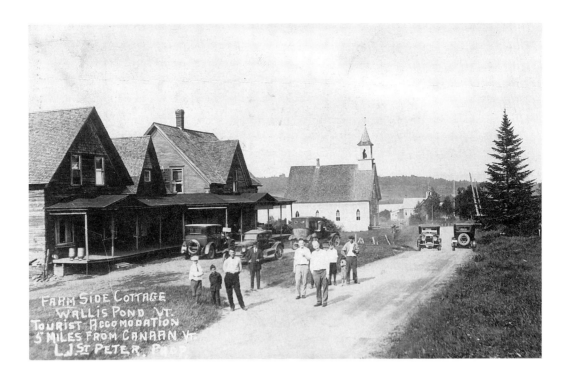

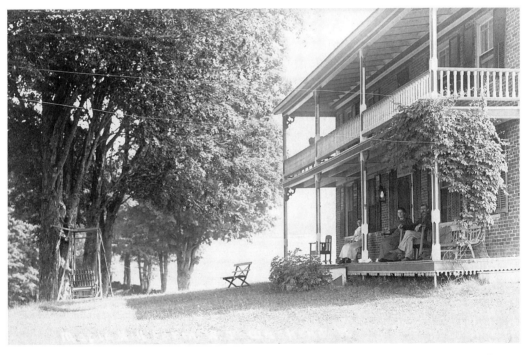

(*Top*) Family and friends gather in front of farm cottage at Wallis Pond (after 1954 called Wallace Pond) near Canaan. The card, mailed to Rhode Island August 9, 1926, reads: "Having a good time, you will have to come next time." (*Bottom*) Maple Hill Farm, West Townshend, circa 1910. The message on the card reads: "Mr. and Mrs. Jones on the porch. Our room has three large windows and the door on second floor is left open nights so it is very cool and nice on warm nights. Mrs. Jones is very nice and we are having a good time."

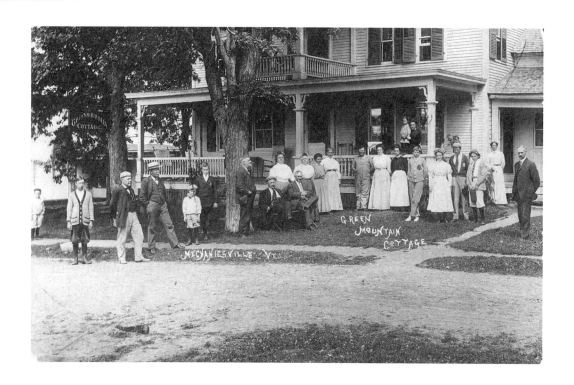

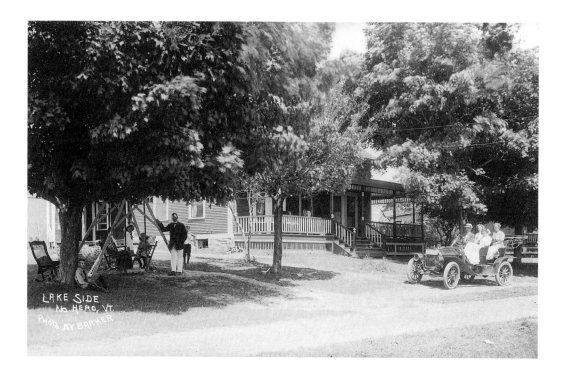

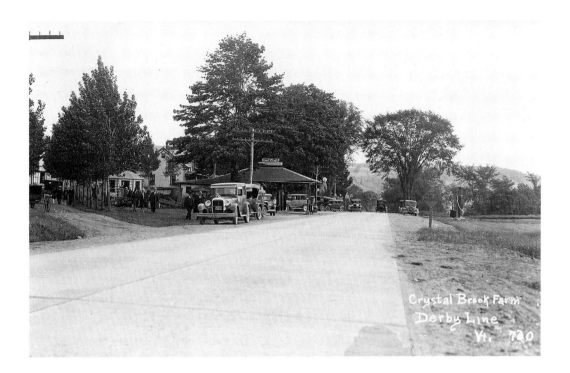

More popular than farm vacations after a few years were boardinghouses, small inns, and cottages. Often families from New York, New Jersey, or Massachusetts would live in a boardinghouse, or rent a cottage before building one of their own. (*Top left*) Guests gather for a carefully posed portrait in front of a boardinghouse in Mechanicsville, circa 1910. (*Bottom left*) Another posed vacation portrait complete with automobile in front of a Victorian cottage, circa 1910, North Hero. (*Above*) Tourists gather at the Crystal Brook Farm in Derby Line. The message on the back of the postcard reported: "Oct. 4, 1935 Evening. Rain when we arrived at camps and rained all night. Left Oct. 6, 1935. Fair day."

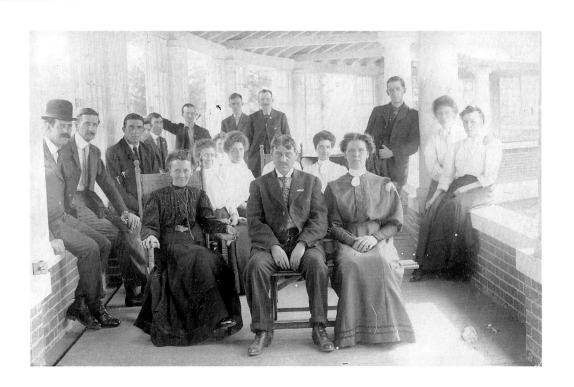

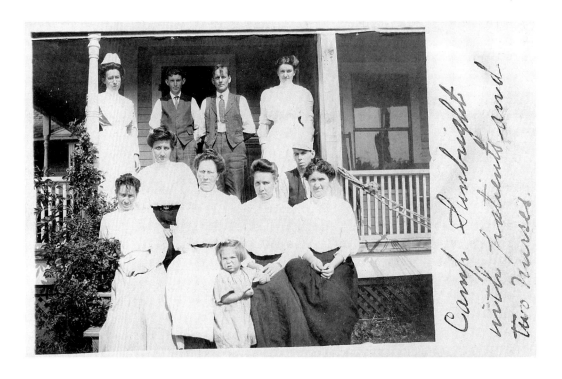

Camp Sunlight with friends and two nurses.

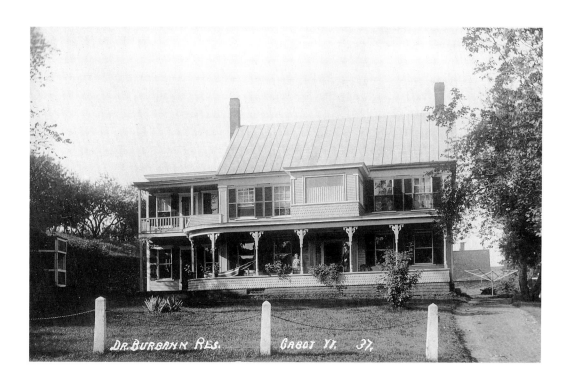

The tuberculosis sanitarium was another kind of boardinghouse. (*Top left*) A group of patients at the Pittsford Sanitarium, given as a gift by Senator Redfield Proctor and opened December 16, 1907. Later it was further endowed by the Proctor family and turned over to the state in 1921. There were many other private sanitariums in the state. The postcard was mailed July 3, 1908, by a young woman only a few months after the facility was opened and was sent to her mother in Felchville, a village in the town of Reading, about forty miles away. The message on the back of the card identifies all the people in the photo, mostly young adults. "Mrs. Richy in the wicker is the lady that coughed so . . . am feeling good and will write more next time." (*Bottom left*) "Camp Sunbright in Brattleboro with patients and two nurses." The postcard is dated August 21, 1910: "Am feeling good and still gaining." (*Above*) The residence of Dr. Lester Warren Burbank of Cabot, showing his house in 1913 with a special porch room built onto the house for a relative with tuberculosis. Special kits could be purchased to build these porch rooms, with windows that could be opened to the fresh air even in subzero weather. Porches were also important, and the disease popularized large verandas where patients and other people could relax during the day and sleep at night.

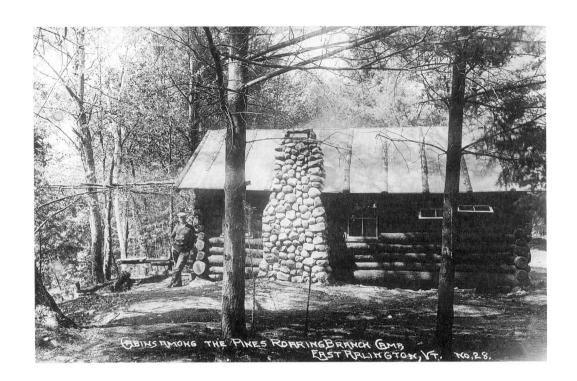

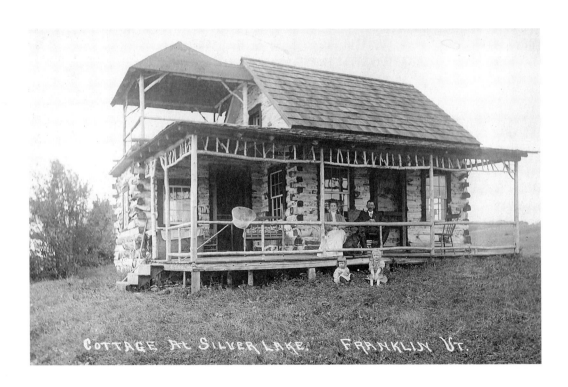

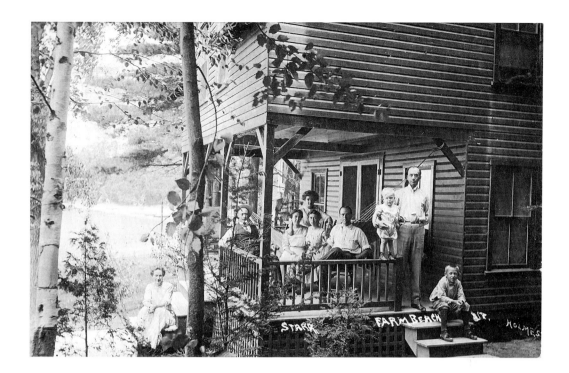

Few Vermont cottages, usually called camps, could compete, either in size or decoration, with the great camps of the Adirondacks, but many were made of logs and decorated with sticks to create a rustic look. (*Top left*) A log cabin with natural stone fireplace in East Arlington. The proud owner stands casually nearby. (*Bottom left*) Cottage with rustic decoration in Franklin, circa 1910. Well-dressed parents pose on the porch with two children in front. (*Above*) Family and friends gather on the inevitable porch at camp on Lake Champlain.

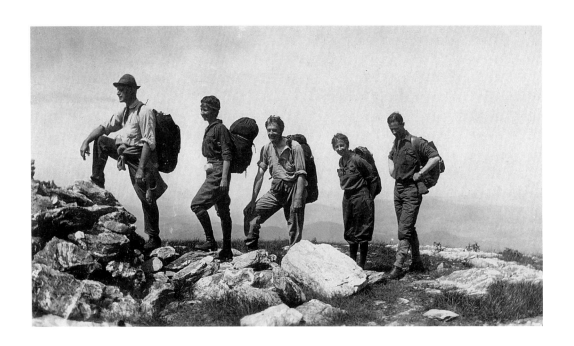

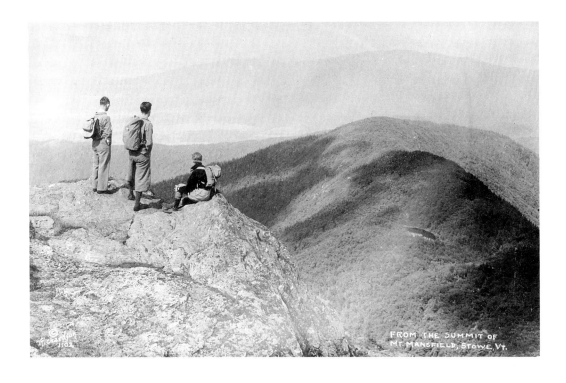

FROM THE SUMMIT OF
MT. MANSFIELD, STOWE, VT.

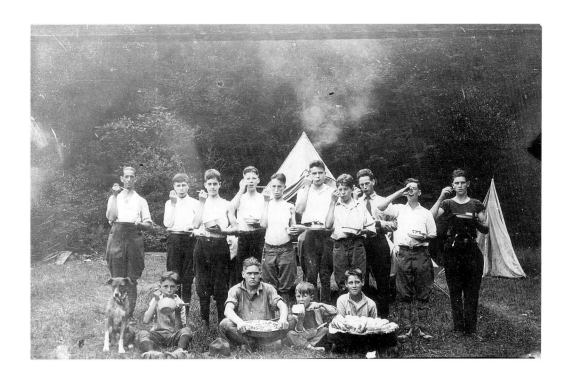

(*Top left*) Hikers pose dramatically in August 1920 on top of Mt. Abraham, along the Long Trail near Lincoln and Warren. Notice the clothing, the packs, and the alpine hat. (*Bottom left*) Three hikers on top of Mt. Mansfield. (*Above*) A Boy Scout troop from Hardwick, circa 1918, on a camping trip. It is chow time, and all — including the Scout leader Perley Shattuck and the dog — pose for the camera.

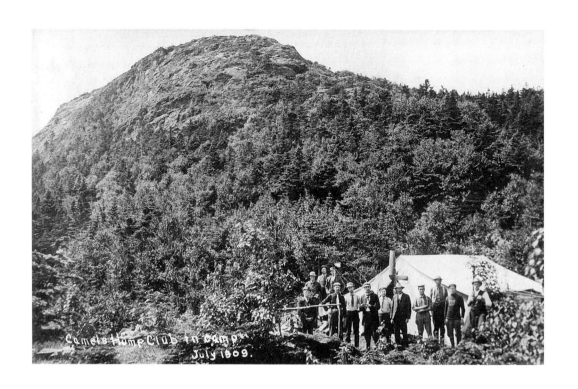

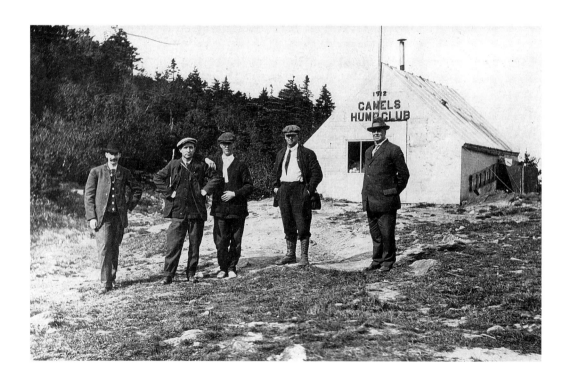

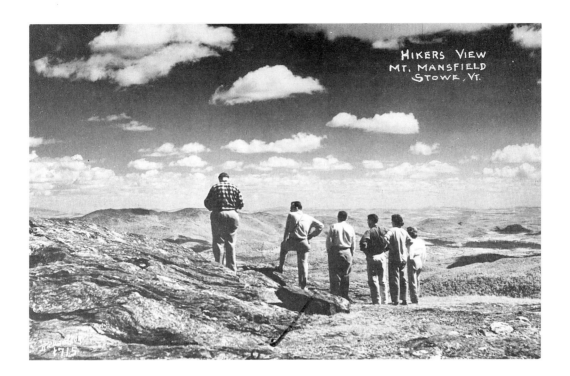

A group of businessmen founded the Camel's Hump Club on June 20, 1908, to develop the mountain as a resort and to encourage hiking. At first they erected four large tents. Three could sleep twelve people each and the largest could sleep twenty. The tents were equipped with stove, lanterns, dishes, and utensils, as well as "fragrant boughs for bedding." Seven hundred hikers used the tents in 1910 and over a thousand in 1911. In 1912 they built a 14 × 20 foot building and called it "The Camel's Hump Club." (*Top left*) Hikers in front of one of the tents, July 1909. (*Bottom left*) Five hikers in front of the Camel's Hump Club shortly after its completion in 1912. Does the clothing seem overly formal? With no special outdoor garb available, most wore an old business suit, and many could not resist wearing a tie. (*Above*) These hikers (circa 1940) wore more informal clothes and no hats. In fact they may not have been hikers at all but tourists who drove up the auto road to the top of Mt. Mansfield.

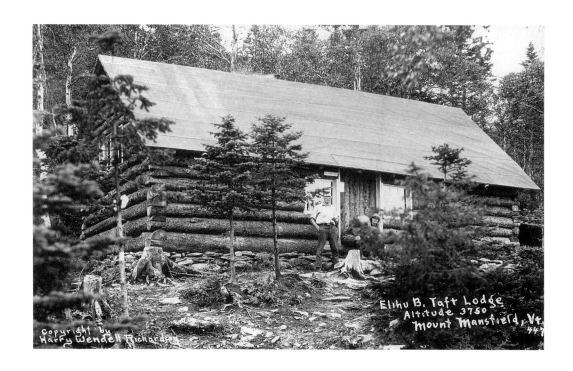

More important than the Camel's Hump Club was the Green Mountain Club, founded in 1910 by James P. Taylor, the headmaster of Vermont Academy in Saxtons River. The club was responsible for completing the Long Trail from the Massachusetts line to the Canadian border in 1930. (*Top left*) Taft Lodge at Mt. Mansfield, one of many shelters on the trail. This photo was taken shortly after the shelter was completed in 1920. (*Bottom left*) The Long Trail Lodge at Sherburne Pass with its Adirondack-style interior, completed about 1923. (*Above*) A photo postcard showing the exterior of the Long Trail Lodge in winter (circa 1930) in the town of Sherburne, not far from the present Killington ski area.

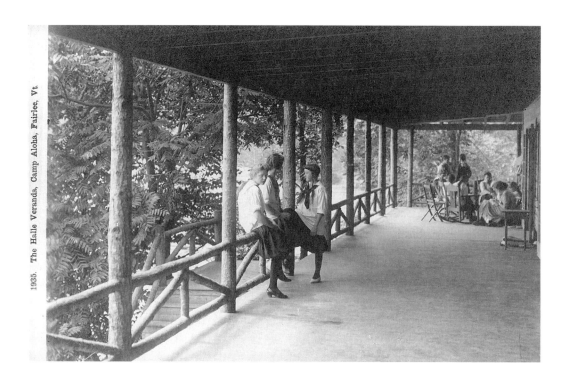

1935. The Halle Veranda, Camp Aloha, Fairlee, Vt.

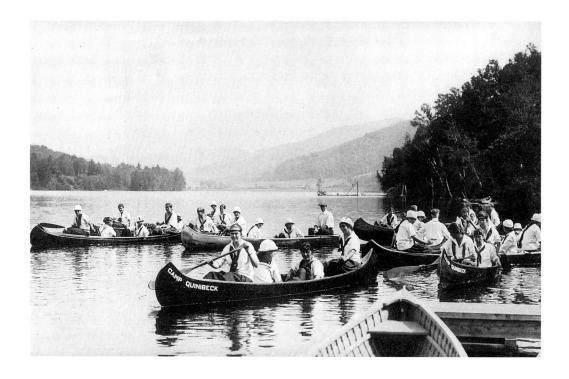

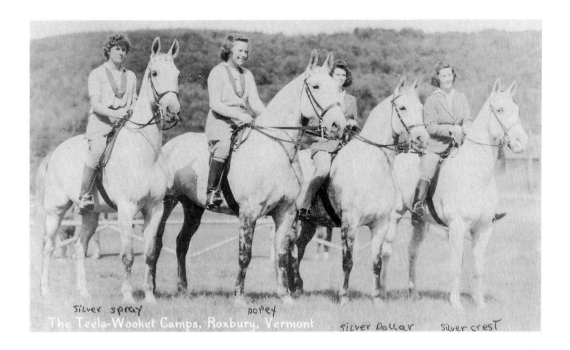

Silver spray popey

The Teela-Wooket Camps, Roxbury, Vermont Silver Dollar Silver crest

(*Top left*) Young women, circa 1910, sitting on the porch of the main building at Camp Aloha, Fairlee. The camp was established in 1905 by Harriet Farnsworth (Mrs. Edward Gullick), A. B. Wellesley, 1887. A camp guidebook reports: "The campers live in tents, or shacks on the hillside. The pottery kiln is hidden in the woods, and not far away is the Wedding Ring, a natural amphitheatre where entertainments and plays are frequently given." (*Bottom left*) Canoes at Camp Quinibeck, Lake Fairlee, established 1911. The message on the postcard mailed in 1916 reads, "This is such a pretty place, and girls, girls, girls, everywhere." A camp guide reports: "Riding, tennis, golf, and crafts are taught and gypsy trips and canoe trips on the Connecticut are taken. Lessons in vocal music, piano, violin or cello are optional. French conversation and lesson are under a native councilor." (*Above*) Teela-Wooket in Roxbury, a girls' camp that specialized in teaching horse riding. The camper who mailed this postcard in the summer of 1941 provided the names of the horses.

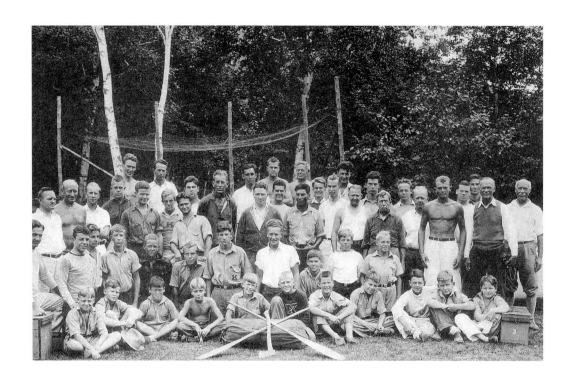

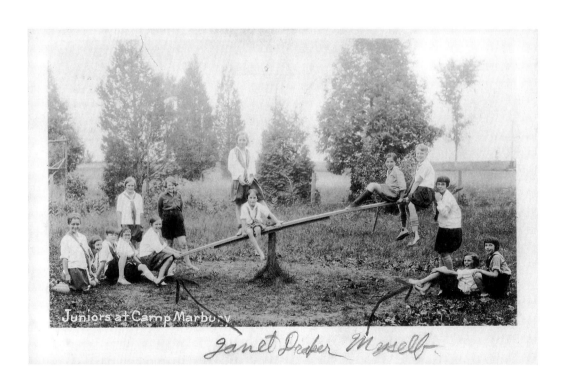

Juniors at Camp Marbury

Janet Draper Myself

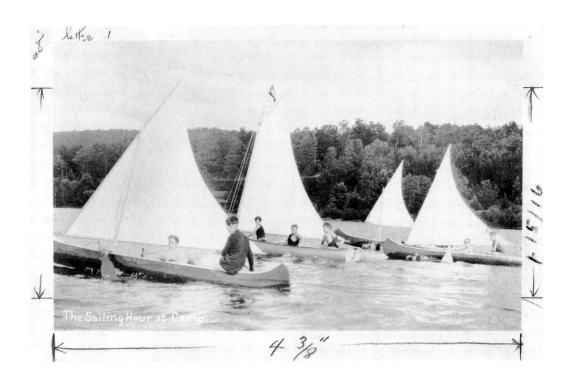

The Sailing Hour at Camp.

(*Top left*) The honor council at Keewaydin Camp, Lake Dunmore, circa 1920. This group has just completed an 800-mile canoe trip. (*Bottom left*) Junior girls on the see-saw, Camp Marbury, Vergennes, established 1920. The camper who mailed this card in 1929 labeled herself and her best friend on the face of the card. (*Above*) Boys sailing canoes at Camp Passumpsic, Lake Fairlee. Someone has marked the card for reproduction, perhaps for a camp brochure.

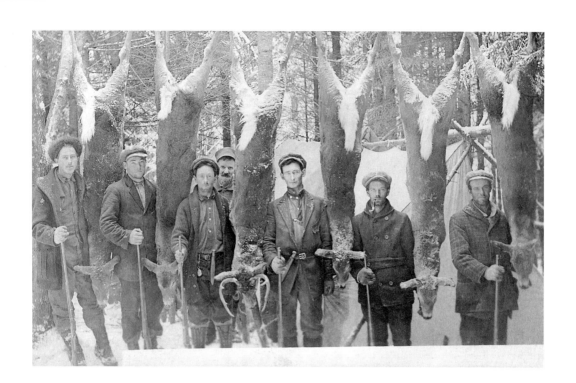

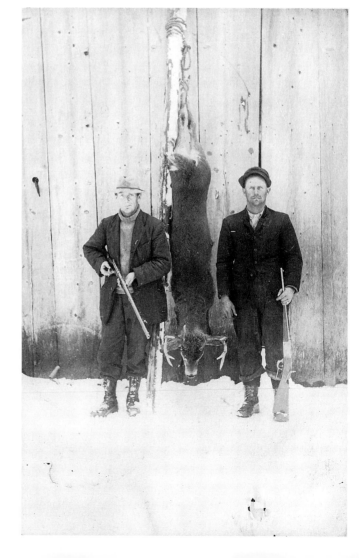

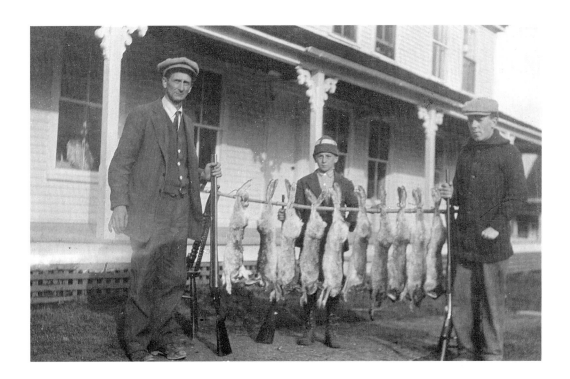

Hunting was an important male activity in Vermont. Even though for years there had not been enough deer to shoot, by 1910 the deer population had been partially restored. To shoot a deer during deer season and then to pose proudly with rifle next to the carcass was an important moment in a man's life. Even to shoot a rabbit, especially for a young boy, was a defining event. (*Top left*) Deer camp, Eden, circa 1915. (*Bottom left*) "The first day of the hunt," Bradford, 1915. (*Above*) A successful rabbit hunt, father, son and friend, Greensboro, circa 1910.

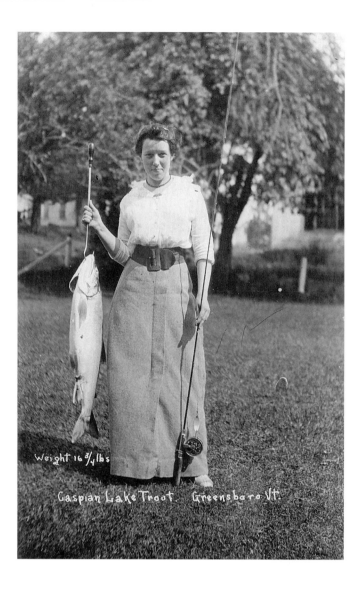

Weight 16¾ lbs

Caspian Lake Trout. Greensboro Vt.

Hunting may have been a male sport, but women could take part in the quest for trophy trout. (*Above*) A young woman proudly displays a large trout from Caspian Lake. Notice the fishing outfit, the rod and reel, and the ease with which she holds the heavy fish. (*Top right*) A boy and girl do not seem very happy about their catch at Lake Seymour in 1925. (*Courtesy Vermont Historical Society.*) (*Bottom right*) A young woman proudly holds a big fish caught in Lake Willoughby, 1939. A good catch brought out the local photographer, who turned the event into postcards, which then could be sent home by tourists with the message: "How would you like to catch a fish like this?"

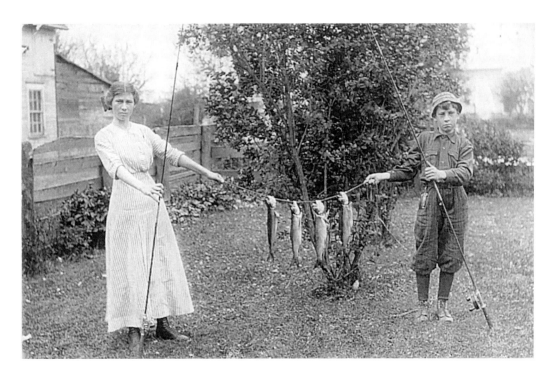

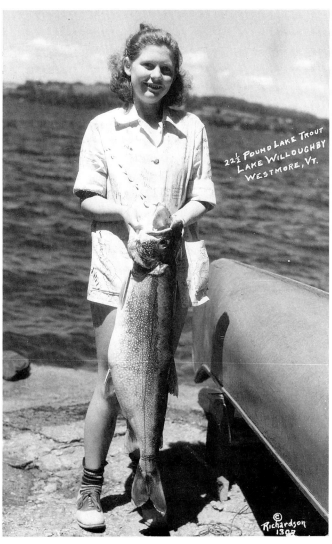

22½ Pound Lake Trout
Lake Willoughby
Westmore, Vt.

Richardson
1307

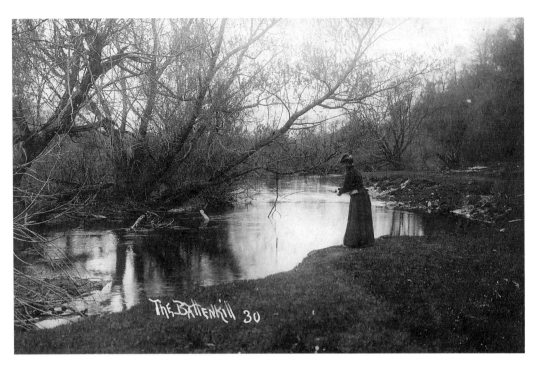

A woman dressed in a long skirt casts her fly for a trout in the famous Battenkill where the stream flows through Manchester.

FISHING FOR BEAVER TROUT
ICEBERG COVE

MEMPHREMAGOG FUR BEARING TROUT (BEAVER TROUT)
LAKE MEMPHREMAGOG, NEWPORT, VT.

The famous beaver trout. In 1927 Charles Flint, who ran a resort on Lake Memphremagog, asked photographer Ralph Sessions to create a novelty Christmas card to send to his regular guests. Sessions took a perch, wrapped it in a raccoon fur, photographed it, and turned it into a postcard that he labeled, "the fur-bearing fish of Memphremagog." It made a good card, but to his surprise many actually believed that there was a fur-bearing fish. In 1930 Sessions sold his photo shop to Harry Wendell Richardson (1894–1960). He liked the joke, so he had a taxidermist cover a mounted fish with fur. He took a photograph of the fish, and a photograph of himself fishing through the ice, and thus he created the "Memphremagog Fur-Bearing Trout," or the "Beaver Trout." He made the photograph into a postcard and it still fools a few tourists. Richardson, who worked as a photographer based in Newport for thirty years, created some of the most compelling real photo postcards produced in Vermont.

winter in vermont

To live in Vermont was to experience winter, long and unrelenting. Snow covered the land often several feet deep from Thanksgiving to Easter. Temperatures often fell to twenty or thirty degrees below zero. Winter with its stark whiteness could be beautiful, but it required great energy and perseverance to survive and greater ingenuity to enjoy the cold and snow. The legendary winter of 1816 lasted all summer. Snow fell in June, and frost, even in midsummer, killed most crops. The famous blizzard of 1888 struck in March. It snowed for thirty hours, and then winds of more than 40 miles an hour left drifts in some places 30 or 40 feet deep. Some towns dug tunnels rather than paths through the snow. Not all winters were this difficult, but all were harsh and cold when measured against the experience of most of the early settlers who came from southern New England. Cold winters as well as poor land caused many Vermonters to move West in the nineteenth century.

Those who stayed behind learned to deal with winter. They cut plenty of wood for their stoves and fireplaces, and they slept under piles of quilts. Some activities were easier in winter. Sleighs moved over snow-covered roads better than wagons over rutted and muddy dirt roads, so winter was the preferred time for hauling and moving. Winter was also the best time to cut and skid logs, but the snow often caused problems for the railroads and the trolleys, even though they had snowplows attached to clear a path. Often a gang of workmen had to shovel the tracks. Before the auto, roads were packed down in the winter by horse-drawn snow rollers to make them passable for sleighs. It was a lot easier

and more efficient than plowing, but when the snow started to melt in the spring the roads become impossible for travel of any kind. Some automobile owners early in the twentieth century preferred to avoid travel in the winter; they put their cars up on blocks and waited for summer. Those who did drive in the snow always carried a shovel and a set of chains.

The movement to promote the enjoyment of winter in Vermont began in the 1880s with winter carnivals in St. Johnsbury, Burlington, and other cities. Brattleboro became a center for winter sports, especially skiing, because Fred H. Harris grew up there. He experimented with skiing on homemade skis during the winter of 1903–1904 while still a high school student. He continued to ski as a college student at Dartmouth, where he founded the Dartmouth Outing Club in 1909 and helped organize the first Dartmouth Winter Carnival with various outdoor sporting activities. In a 1912 article in *The Vermonter* he argued for the use of skis rather than snowshoes. "The snowshoe simply affords a means of travel and enables one to conquer natural difficulties in winter, the ski not only does this but offers at the same time a wonderfully fascinating 'sport.'" He went on to write that "skiing is a sport for men, men who have real red blood in their veins and men who will spend enough time to conquer the difficulties, and who are willing to take a chance." After graduating from Dartmouth he returned to Brattleboro, where he founded the Brattleboro Outing Club in 1922. He also designed and built the first ski jump in the East. Thanks to Harris, Brattleboro hosted the first national ski jumping championship held in the East in 1924.

Woodstock was a center of winter sports activity from 1892 when the Woodstock Inn opened and sponsored snowshoe parties, skating, tobogganing, and sleighing expeditions. But it was a small inn across the square, the White Cupboard Inn, that created skiing history in January 1934, when three New York businessmen staying there talked about the need for some method to move skiers uphill. Their hosts, Robert and Elizabeth Royce, had heard of a successful experiment in Canada. Within a week the Royces adapted the idea. They used a Model T Ford engine and a system of pulleys to move an eighteen-hundred-foot rope in an endless loop. They designed and built the first ski tow in the

United States on Gilbert Hill in Woodstock. It wasn't always wonderful, however. The tow broke down frequently; the rope often dragged on the ground and was difficult for the skiers to hang on to. Sometimes skiers were suspended in the air or worse, they caught a scarf or jacket in the rope and were nearly strangled. The Royces never got much credit for their invention. It was a Dartmouth graduate, Wallace "Bunny" Bertram, who adapted a superior motor and registered the term "ski tow." Woodstock, with the first ski tow and slopes like "Suicide Six," became famous in the history of winter sport, but not nearly as famous as Stowe.

Stowe, because it nestled under Mt. Mansfield, became the "Ski Capital of the East." As early as 1921 Stowe held a winter carnival with ski jumping, tobogganing, and skating to celebrate Washington's birthday. Local legend has it that there were skiers on Mt. Mansfield as early as the first decade of the twentieth century, and there certainly were a number of skiers by the 1920s. But it was the 1930s and the aid of New Deal dollars that laid the groundwork that made Stowe into a major winter resort. Charles Lord, an engineer in charge of a Civilian Conservation Corps unit, cut the Bruce Trail, and later surveyed the line for the first chair lift. Albert Gottlieb, in charge of another CCC unit, laid out the Nose Dive Trail in 1935. Sepp Ruschp, escaping the turmoil in Europe, settled in Stowe in 1936 and started the Sepp Ruschp Ski School. He taught the Arlberg technique, a low crouch, then lift and swing into the turn. Along with other foreign-born instructors he taught a new generation of skiers to "bended ze knees." Ruschp later became president of the Mt. Mansfield Company, and he remained in Stowe until he died in 1990.

Frank Griffin, a Burlington businessman, built the Toll House Ski Lodge in 1936, and buses met the ski trains in Waterbury. Other trails were cut on the mountain, a rope tow was installed on the Toll House slope, and in 1940 the first chair lift in Vermont opened on Mt. Mansfield. In 1938 Stowe played host to the United States National Alpine Championships. By the time World War II stopped the construction of ski resorts, Stowe deserved its title of Ski Capital of the East. Other ski areas developed in the 1930s were Big Bromley, Hogback in Marlboro, and Pico Peak.

Charles Crane published *Winter in Vermont* in 1941. In contrast to

Wallace Nutting's *Vermont Beautiful*, published in 1922, which did not include one photograph or description of Vermont in winter, Crane celebrated the glories of winter in Vermont. He argued that Vermont was a haven from a world gone mad and should be visited in winter as well as summer. "Skiing," Crane maintained, "has made the winter's snow on Vermont mountains almost as popular as summer surf at Atlantic beaches." Vermont's image as a winter wonderland far removed from urban problems and the nightmare of global war was further enhanced by the release in 1942 of the movie *Holiday Inn* with Bing Crosby singing Irving Berlin's "White Christmas" (a later version of the same film was released as *White Christmas* in 1954 with Crosby still singing the title song). The original film was set in Connecticut, but many associated the song with Vermont. In 1944 the song "Moonlight in Vermont," with the phrase "ski trails on a mountain side," was first played on the radio show "Hit Parade." The song added to the nostalgic image of the state that seemed, during the war, to represent the best of American rural virtues. Some of the same winter wonderland images also appeared on postcards, but there were other cards that reminded those who received them of the harsh reality of winter in Vermont.

Springfield, Vt. Well Lighted Streets.

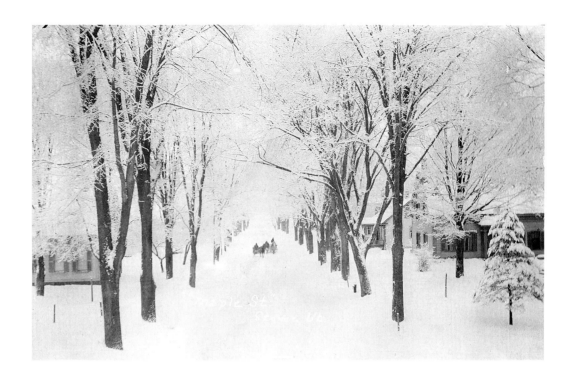

Winter in Vermont could be beautiful. Two rare nighttime photographs of (*top left*) Springfield (card mailed 1914) and (*bottom left*) looking east on Center Street, Rutland, circa 1915. (*Above*) A winter wonderland on Maple Street in Stowe, as shown on a real photo postcard mailed in 1909, long before Stowe became a famous ski resort.

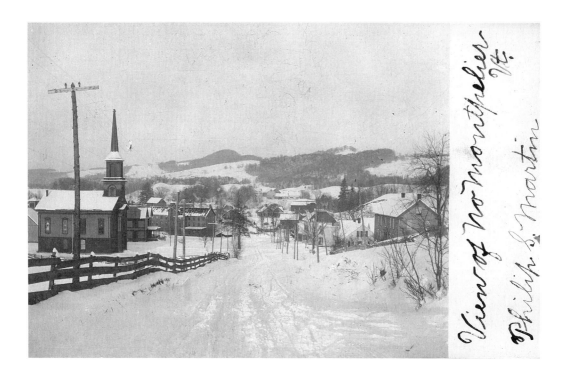

Views of No. Montpelier Vt. Philip S. Martin

Smith St. Ludlow Vt.

Feb. 14 + 15. 1914.

Vermont winter scenes. (*Top left*) North Montpelier, 1906; notice the unplowed roads. (*Bottom left*) After a big snowfall in Ludlow, February 10, 1914. (*Above*) A plowed rural road near Newport, circa 1925. The photographer used the telephone poles and the road to center his artistic photo.

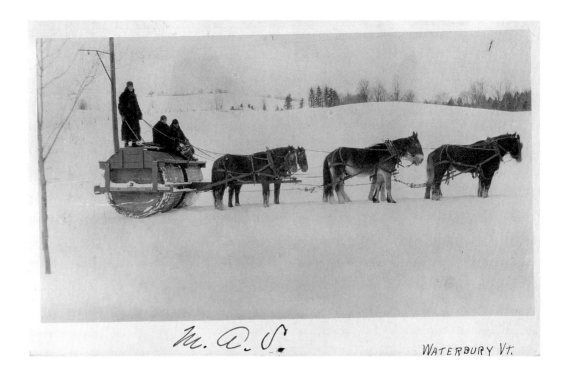

M. A. S.

WATERBURY VT.

One way to make the roads passable after a snowstorm was to pack the snow with horse-drawn snow rollers. Driving one of these rigs was considered the coldest job in Vermont. Packing the snow allowed horses with sleighs to move easily through the streets, but it created a mess in the spring when the snow started to melt. The automobile eventually made the snow roller an antique. (*Above*) Waterbury, circa 1906. (*Top right*) Even with snow rollers, and later with plows, many streets and sidewalks had to be shoveled, as in Montpelier, 1906. (*Bottom right*) Workers take a break to pose for the camera while clearing an ice jam near the White River in Hartford in February 1908. Notice that the supervisors or town officials on the snow bank to the right are dressed very differently from the workers.

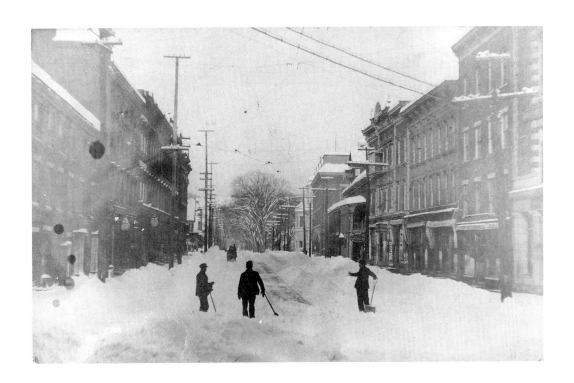

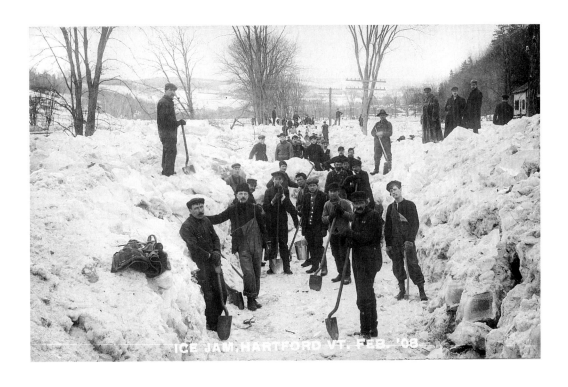

ICE JAM HARTFORD VT. FEB. '08

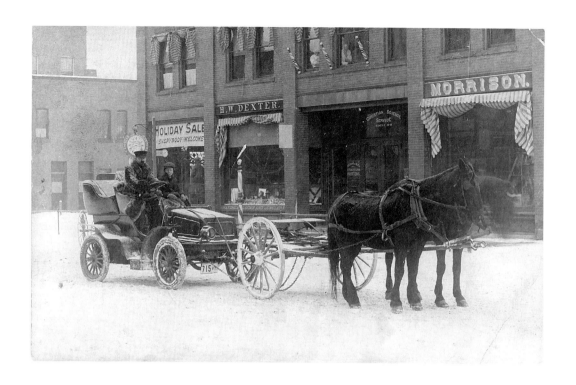

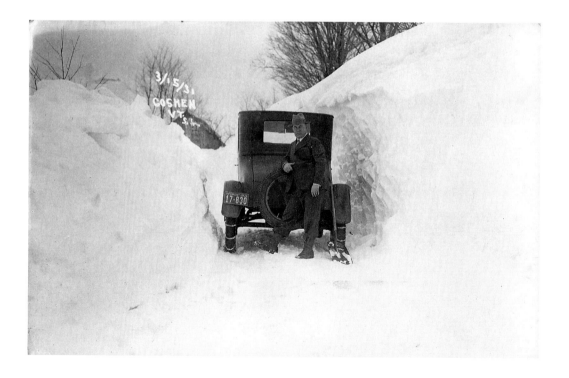

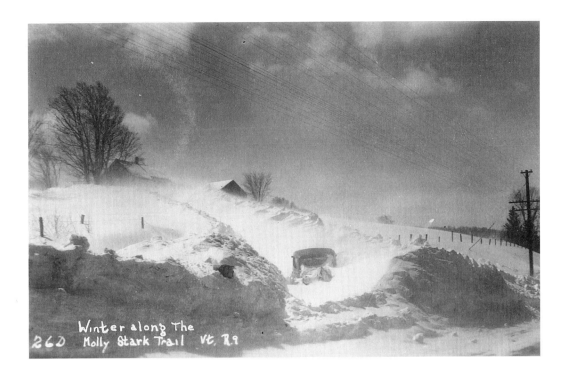

Automobiles and snow went together with much difficulty and discomfort well into the 1930s in Vermont. (*Top left*) An embarrassing situation in an unidentified Vermont town, a car owner having car towed by a horse, circa 1910. This auto owner compounds his embarrassment by having his picture taken in his broken-down car, but he is well bundled up in his fur coat. (*Bottom left*) A well-dressed man in Goshen, the smallest town in Addison County, with his car surrounded by a snow drift on March 15, 1931. Notice the chains on the tires, his overshoes, and his shovel, all necessary for winter in Vermont. (*Above*) Car caught in a snowdrift on Route 9 between Brattleboro and Bennington, circa 1935.

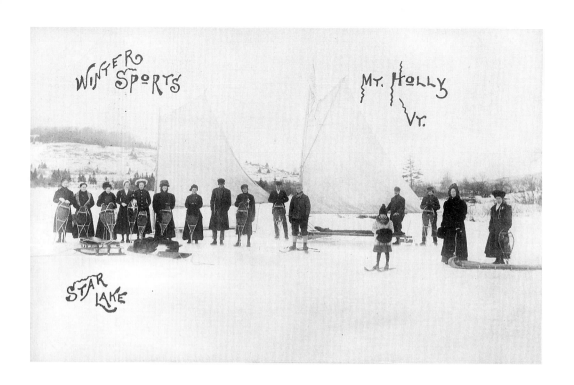

WINTER SPORTS — MT. HOLLY VT.

STAR LAKE

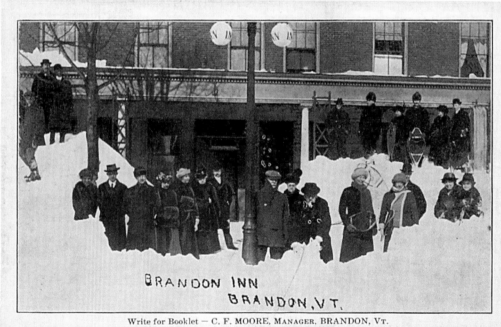

BRANDON INN
BRANDON, VT.

Write for Booklet — C. F. MOORE, MANAGER, BRANDON, VT.

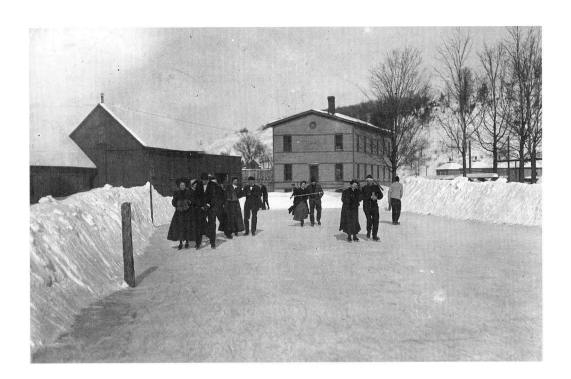

As Vermont tried to attract winter visitors, postcards played a major role in advertising how it was possible to have fun in the snow. (*Top left*) A carefully posed photograph in Mt. Holly in 1910 showing several winter sports, with an ice boat, a traverse (two sleds connected to carry six or more people), a toboggan, and even a little girl in front with skis. (*Bottom left*) The Brandon Inn used a postcard, circa 1910, showing a well-dressed group of guests with snowshoes, to advertise the fact that it was open in the winter. (*Above*) Ice skaters in Bradford. This postcard was mailed on August 23, 1909, to a young man serving in the Army in San Francisco. The message reads: "Received your card O. K. Everything as usual here, deader than *hell*."

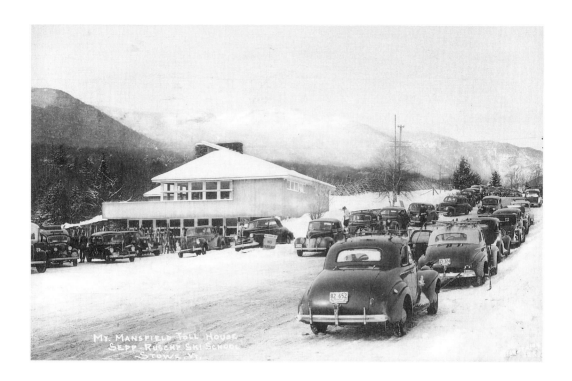

(*Above*) The Toll House and the Sepp Ruschp Ski School at Mt. Mansfield, 1941. A few cars have ski racks, but most people have to fit their skis in their rather small cars. Notice the stacked skis near the Toll House. (*Top and bottom right*) The first chair lift in Vermont, shortly after it opened in 1940. Skiers are bundled up for the cold ride to the top. The skier going down on the lift either lost courage at the top of the mountain or just went along for the ride.

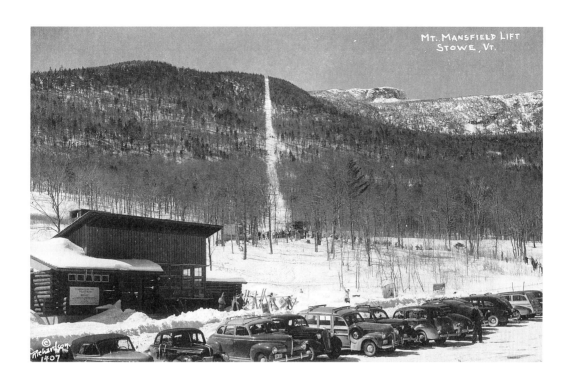

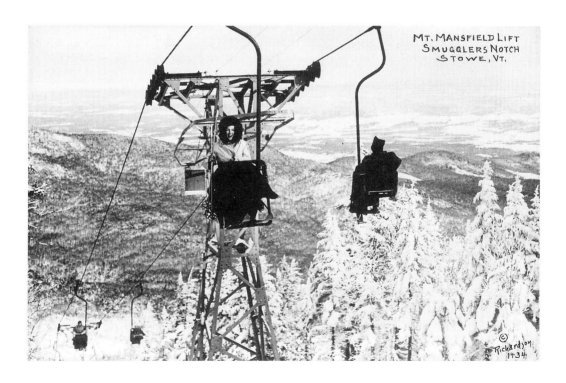

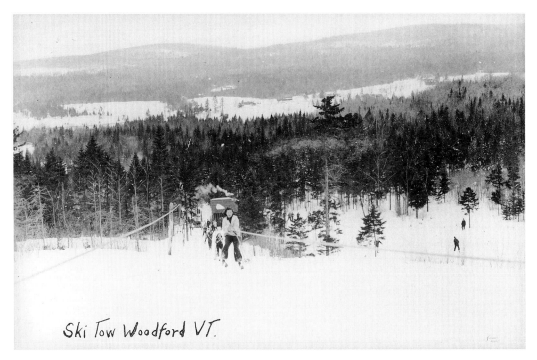

Ski Tow Woodford VT.

Rope tow at Woodford, a sparsely settled town along Route 9 in the southern part of the state. This was one of many rope tows constructed in small towns around the state in the late 1930s and 1940s. It was similar to the original tow built at Woodstock in 1934. Rope tows made going uphill easier, but hanging on to the rope could be strenuous work.

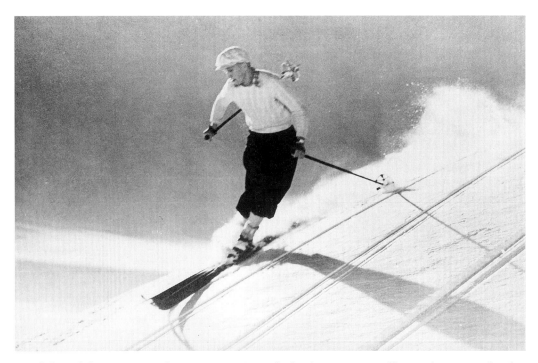

A well-dressed skier at Big Bromley, circa 1940. Notice the knickers, sweater, golf cap, ridge-top wooden skis, square-toe boots, and the bamboo poles with large baskets. He has good Arlberg form with skis together and knees slightly bent.

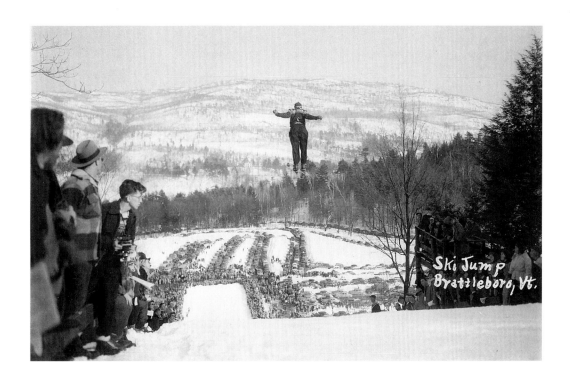

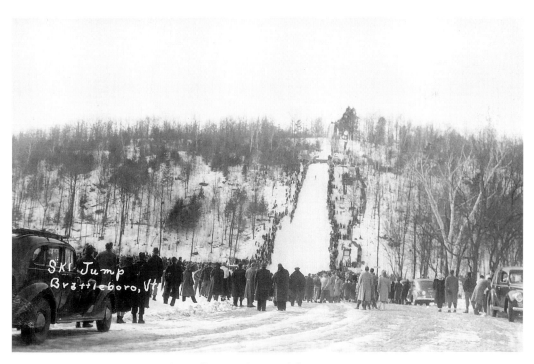

(*Top and bottom*) Ski jumping in front of big crowd in Brattleboro, circa 1940.

13

Fairs and Festivals

A few Vermonters journeyed to Chicago in 1893 to see the World's Columbian Exposition. They were thrilled by a ride on a Ferris wheel, amazed by the spectacle of electric lights, and impressed by the thousands of exhibits from around the world. They may even have visited the Vermont pavilion, which promoted the glories and the commercial and recreational opportunities in the Green Mountain State. But for most Vermonters, going to the fair meant the Vermont State Fair held in White River Junction in mid-September beginning in 1907, or one of many smaller fairs organized around the state in August or September. The first fair in Vermont was probably held in Middlebury in the 1840s. In 1911 there were fairs in Middlebury, Manchester Center, St. Johnsbury, East Hardwick, Barton, Northfield, Swanton, Morrisville, Tunbridge, Rutland, Springfield, Brattleboro, Fair Haven, and South Wallingford. Some of these fairs disappeared after a few years, but others replaced them. Country fairs were important local events in the first decades of the twentieth century, and photographers were quick to record them and to produce photo postcards that could be purchased as souvenirs or sent to friends as mementos of the occasion.

Those attending the Vermont fairs could visit exhibits of prize horses and pigs, marvel at the largest pumpkin, and see the best apple pie. They could also display their own animals and vegetables and compete with their neighbors for prizes. They could attend horse races, watch a baseball game, and visit the midway where there were games of chance, as well as booths with food and drinks for sale. The men frequently paid

their money to see dancing girls and lady wrestlers. Manufacturing companies displayed the latest farm machinery. In 1909 at the state fair the International Harvester Company exhibited an automobile fitted with hard rubber tires, high wheels, and a long body of use in carrying heavy loads. It also showed several different sizes of gasoline engines and three types of spreaders, as well as a husker and shredder. The Vermont State Department of Agriculture promoted improved seeds and demonstrated new techniques of plowing or haying. In addition, new products were on display. Rural Vermonters often saw their first automobile or their first airplane, attended their first movie, and witnessed a demonstration of an electric washing machine at a fair. They also marveled at the Ferris wheel and the other rides powered by electricity. At a time long before most rural Vermonters had electricity in their house and barn, they could look in wonder at the midway illuminated at night by thousands of light bulbs. The fair was a place to be introduced to the modern world, but perhaps just as important, it was an occasion to meet old friends and to celebrate the end of summer. For many farm families living many miles from the nearest city or large town, going to the fair was the most exciting day of the year.

The fair often coincided with other celebrations and events. Old Home Week, first created by the governor of New Hampshire in 1899 as an effort to promote tourism and to persuade former residents of the state to return to their home towns, became very popular in Vermont in the first decades of the twentieth century. In 1900 the Vermont State Legislature designated the week that included Bennington Battle Day (August 16) as Old Home Week, but after the first few years most towns celebrated Old Home Day, rather than Old Home Week. Memorial Day and the Fourth of July were excuses for parades and patriotic display, but many towns created special historic pageants to celebrate the anniversary of their founding. Vermont played an important role in the development of the historic pageant, but these celebrations were also part of a general wave of patriotism that swept the nation in the two decades before World War I. Many towns organized historical societies, wrote their histories, and in other ways celebrated their pioneer heritage. Part of the rise of patriotism and the admiration of all things colonial was caused by the realization that immigration, the rise of industry,

and the growth of urban centers were changing America dramatically. Some of the enthusiasm was simply civic pride and a commitment to use history to teach a new generation about the values of their ancestors. But there was also a desire on the part of organizations such as the Daughters of the American Revolution, the Society of Colonial Dames, and other patriotic organizations to set themselves apart from the recent immigrants and to celebrate a particular version of the past.

There were many celebrations and pageants held at the end of the nineteenth century, but in many ways the most important pageant (nationally and locally) was held in Thetford, Vermont, on August 12 to 15, 1911. More than two thousand people gathered at 3 P.M. each day in an outdoor arena between the Connecticut River and the railroad tracks to observe the 150th anniversary of Thetford's founding. The opening scene featured young dancers representing "nature spirits" and the "wilderness." Then Indians emerged briefly before the first white settlers arrived. Dancers, and local citizens dressed in period costumes, depicted events from Thetford's history. The Revolution and the Civil War played large roles in the pageant, but social life, agriculture, and the coming of the railroad and industry were also represented, as was the decline of the town as many citizens moved west. The final scenes represented the revival of Thetford thanks to aid from the federal government and the new Country Life Movement.

The Thetford Pageant was directed by William Chauncy Langdon, a graduate of Brown University, whose father had been born in Burlington. Langdon taught at the Pratt Institute in New York City and had cooperated on many projects with Luther Gulick, an expert on play and a veteran leader of the YMCA. Langdon had been attracted to Thetford by Charlotte Farnsworth of the Horace Mann School in New York City, who, with her husband, ran a girls' camp in Fairlee. Although the town provided some support for the pageant, most of the money came from a grant from the Russell Sage Foundation "to demonstrate whether or not the pageant may be used successfully as an agent in social advancement."

In 1912 Langdon staged a similar pageant in St. Johnsbury, followed in 1913 by one in Meriden, New Hampshire, and in 1914 by one on Cape Cod. Other towns quickly followed with their own pageants,

borrowing from Thetford. There had been celebrations before, but the Thetford Pageant became the model not only for a nostalgic review of a town's history, but also for an event that looked to the future and tried to revitalize the rural community.

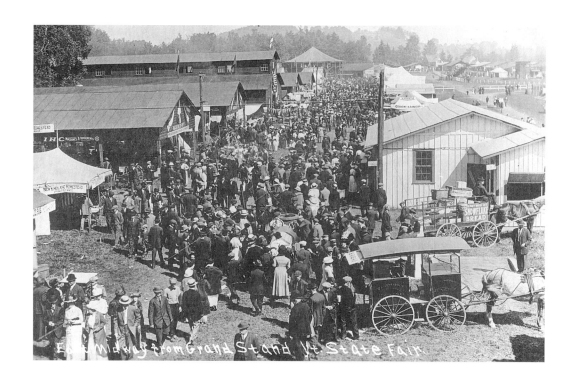

East Midway from Grand Stand Vt. State Fair.

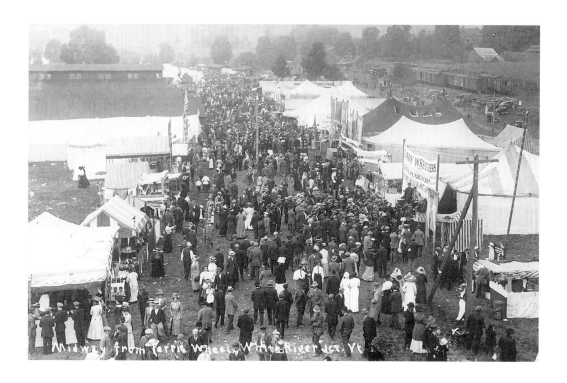

Midway from Ferris Wheel, White River Jct. Vt.

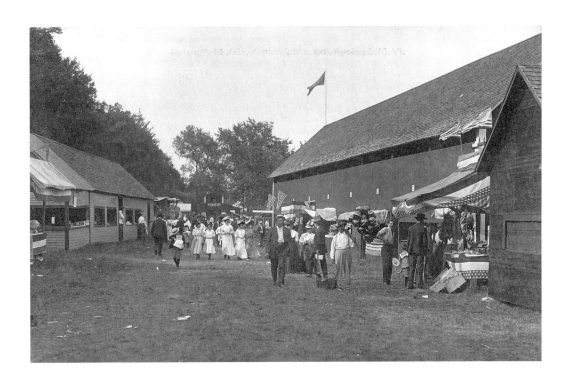

Two views of the Midway at the Vermont State Fair, circa 1910, one taken from the grandstand (*top left*) and the other from the Ferris wheel (*bottom left*). The crowd is well dressed; women wear long skirts and hats, and men are mostly in suits with summer straw hats. Even the occasional child seems dressed up for the occasion. One of the delivery wagons in the first photo advertises Snow Flake Bread. The exhibit halls to the left feature "New England Homestead," and "I H C Machines and Implements." There is also a sign for "Quick Lunch." (*Bottom left*) In this photo there is a sideshow labeled "Lady Wrestlers." (*Above*) Springfield Fair, September 2, 1908. For many, the country fair was the big event of the year and they dressed for the occasion. Notice the mother and her three daughters all dressed in white and the little boy wearing a straw hat. Elsewhere in the crowd here, and in the photos of the state fair, are men dressed more like farmers. The fair was a place, like Main Street, where rural and urban folk mixed and mingled. On the right is a stand selling bananas, among other treats, and further back balloons are for sale. What would a fair be without balloons? In the background are livestock displays. One building is labeled "Poultry."

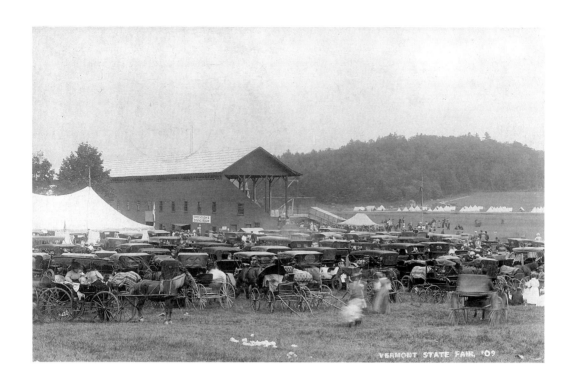

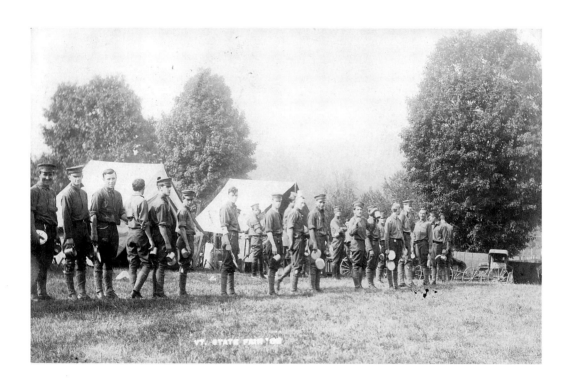

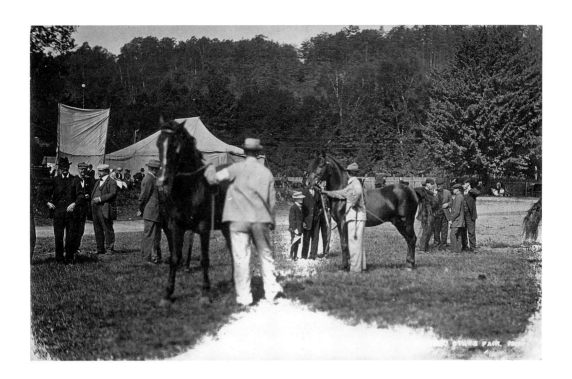

(*Top left*) The parking lot at the 1909 State Fair displays a mixture of autos and horse-drawn vehicles. The message on the back of the card, written by a Norwich University Cadet to Shelburne, Massachusetts, reads: "This will give you a faint idea of how our camp looked from a distance. I was in the last row to the left next to the last tent or second this way. We had a lot of prospective Freshmen down to the house today and perhaps we didn't have a fine dinner. Fair was all to the left of these teams." (*Bottom left*) The Norwich Cadets lining up for chow at the fair in 1910. (*Above*) Morgan horses being judged at the Vermont State Fair, circa 1910. The Morgan horse later was chosen the official Vermont state animal, and Vermonters believed it could outpull and outrun all other breeds. It was brought to the state from Massachusetts in 1791 by a music teacher named Justin Morgan. All Morgan horses are descendants of that original horse.

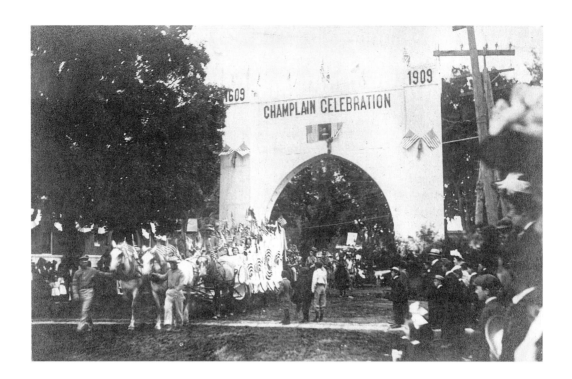

(*Above*) Triumphal arch erected in Burlington in 1909 to commemorate the 300th anniversary of Samuel de Champlain's "discovery" of the lake that bears his name. (*Top right*) At the Thetford Pageant, August, 1911: A settler holds off a band of Indians. (*Bottom right*) Local citizens in Revolutionary-era costumes.

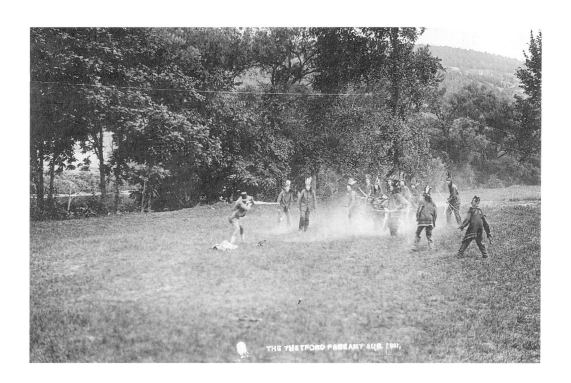

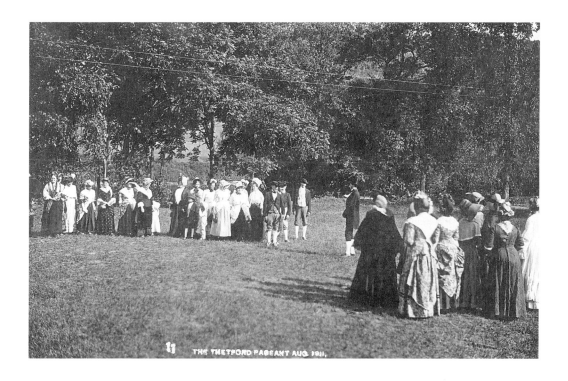

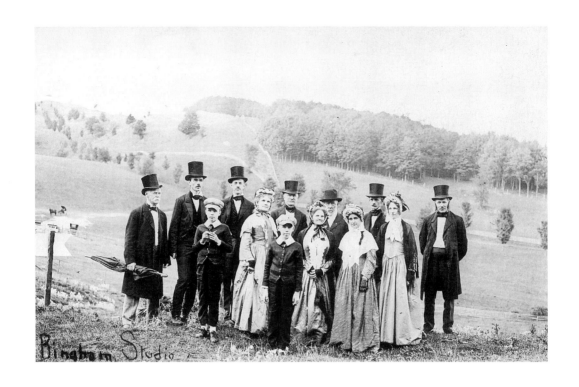

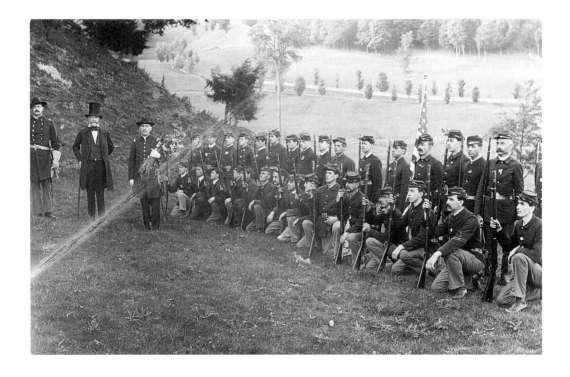

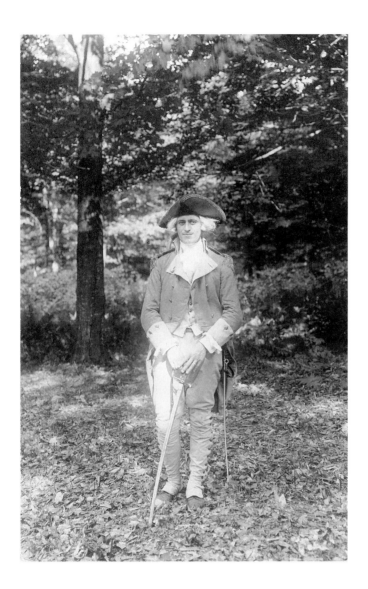

The St. Johnsbury Pageant, 1912. The organizers of the event announced that "this pageant will attempt to express the essential character of the town." (*Top left*) Local citizens in period dress gather to celebrate the coming of the railroad in 1850. (*Bottom left*) Young men in Civil War uniforms go off to fight for the Union as the town rallies to support them. (*Above*) The Bennington Pageant, circa 1915. A local citizen dressed as Seth Warner, one of the heroes of the Battle of Bennington, 1777.

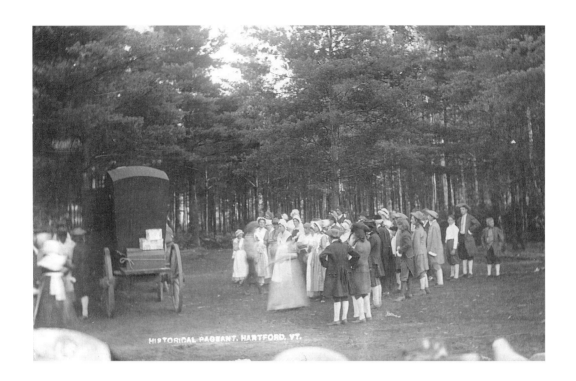

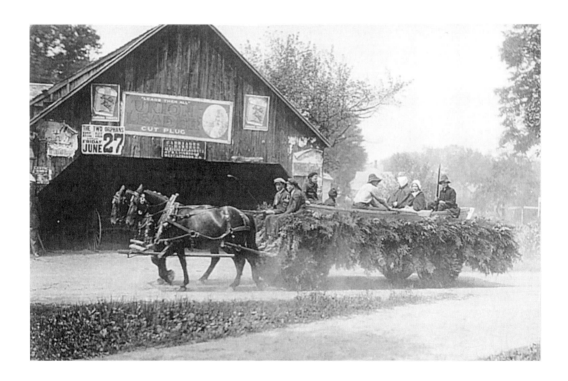

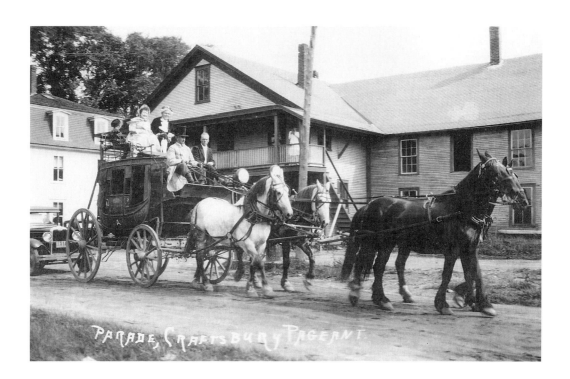

PARADE, CRAFTSBURY PAGEANT

(*Top left*) Hartford Historical Pageant, 1912. The message on the back of the card, sent to Rutland, reads: "This shows Madam Wheelock (wife of Pres Wheelock of Hanover) [and Dartmouth College] just arrived in her London coach with her daughter and negro servant. It was one of the best shows we have ever attended." (*Bottom left*) Hartland Festival, circa 1914. The advertisements are for Union Leader Cut Plug, for cigarettes, and for a carriage shop in West Lebanon, New Hampshire. (*Courtesy Vermont Historical Society.*) (*Above*) Craftsbury Pageant, 1929, to celebrate the 1789 founding of the town. A 1929 Ford follows an old Concord Coach that has been brought out for the occasion. This was one of many Vermont pageants based on the Thetford model.

14

parades and celebrations

Vermont cities and towns, even small villages, organized parades several times a year—Memorial Day (Decoration Day), the Fourth of July, and Bennington Battle Day (August 16). Often the parades coincided with other events or celebrations—Old Home Day, the circus coming to town, Chautauqua, the county fair, soldiers marching off to war or returning from war. Some parades early in the twentieth century seem to have been an excuse for decorating and displaying the best horses or the newest automobiles and trucks, and parades were an excuse to come to town to meet friends and to take part in the excitement. Parades also brought out the local photographers, who recorded the events and in the process captured the texture of Main Street.

The traveling Chautauqua visited many Vermont towns and cities between 1904 and 1932. All a town needed was a railroad and enough paying customers to support the seven-day event. The name "Chautauqua" comes from the institution founded on Lake Chautauqua in western New York State in 1873. There, middle-class Americans gathered in the summer to study, listen to lectures, participate in nondemominational Protestant services, and combine a vacation with reading and learning. Chautauqua was so popular that James Redpath organized traveling Chautauquas to visit the small cities and towns of America, first in the Midwest and then across America. In 1920 there were ninety-three Chautauqua circuits reaching 8,580 towns in the United States and Canada. The company provided the talent, the tent, and the advertising. Chautauqua week was an important event in many Vermont

towns. There might be a Shakespearean play, lectures on ethics and community organizing, musical performances of various kinds, and, by the 1920s, movies.

There were other events and occasions for celebrations—conventions of the Elks, the International Order of Odd Fellows, the Knights of Columbus, or the Masons. There were also Sunday school conventions and religious revival meetings. The arrival in town of politicians and celebrities, and baseball and football games were all occasions for parades and celebrations. All these events brought out the professional and amateur photographers to record formal and informal shots of the crowds and the action.

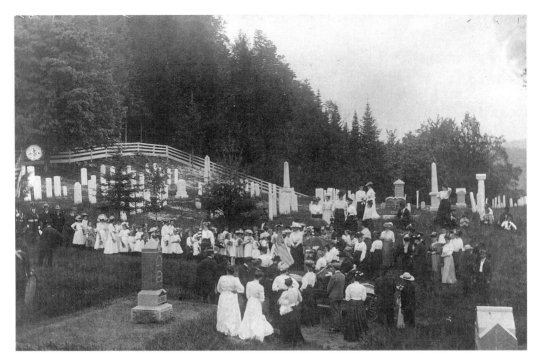

Decoration Day, or Memorial Day, was first celebrated in 1869 as a holiday to bring the nation together after the Civil War. It was observed primarily in the North, but it was always an important occasion in Vermont. It was not only a time for decorating the graves of fallen soldiers, but also an occasion for picnics and parades. Here citizens (mostly women) in 1908 decorate graves in a cemetery in East Corinth.

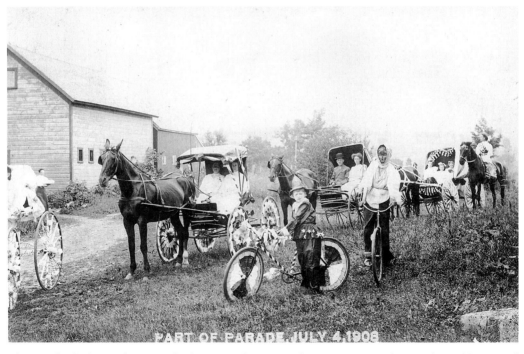

The Fourth of July was also a time for decorating the town and organizing a parade. Bicycles and horses and buggies carefully decorated wait in South Shaftsbury for the parade to start.

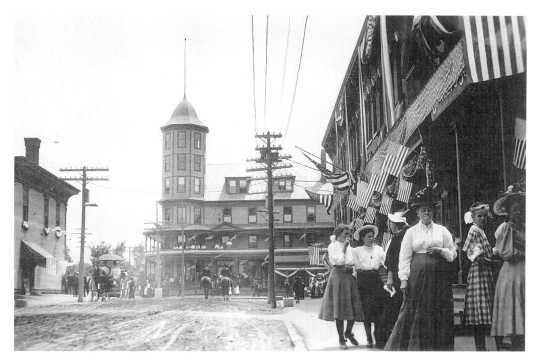

Morrisville in 1908 decorated with American flags. The young women have shorter skirts than the older women, but all are properly attired with fashionable hats.

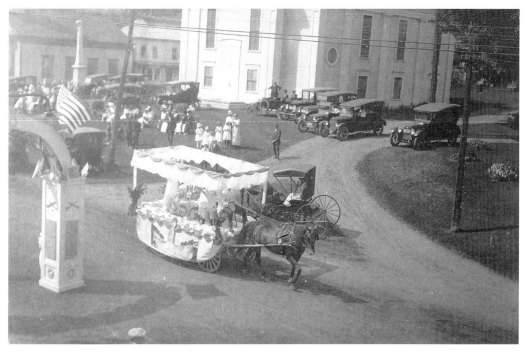

A horse-drawn float passes by the church in Williamstown, circa 1915, as people gather on the lawn in front of their parked automobiles.

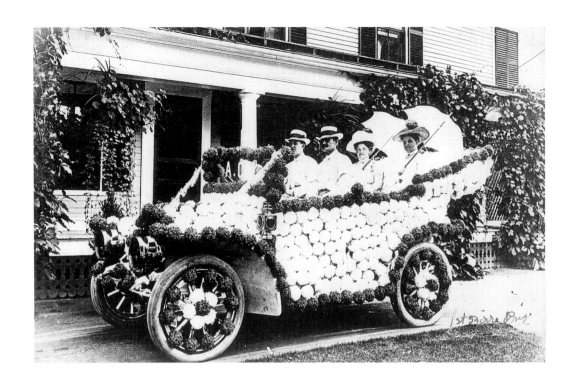

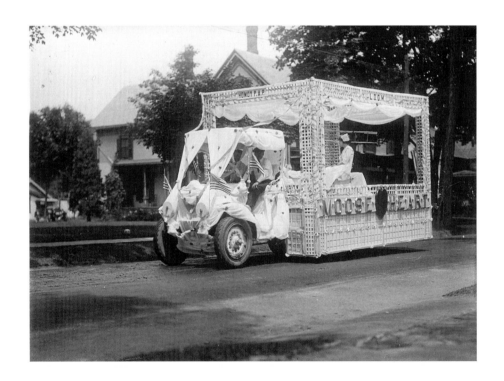

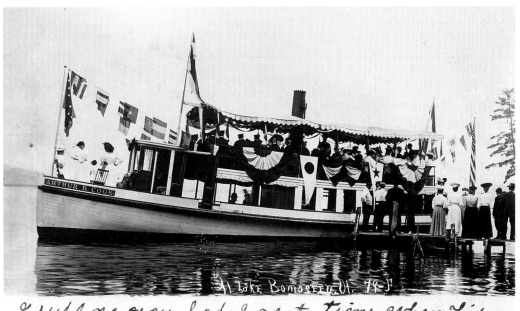

At Lake Bomoseen, Vt. 79-F

I suppose you had a great time when Lida was up there. CL-761

A parade was the perfect occasion to decorate a car like the first-prize winner in Barre, circa 1910 (*top left*), and the truck in St. Johnsbury, circa 1915 (*bottom left*). Sometimes even boats got decorated for festive occasions. (*Above*) The *Arthur B. Cook* at Lake Bomoseen in 1907. The message on the undivided-back card reads: "I suppose you had a great time when Lida was up there." The small space at the bottom of the photo was the only place for a message.

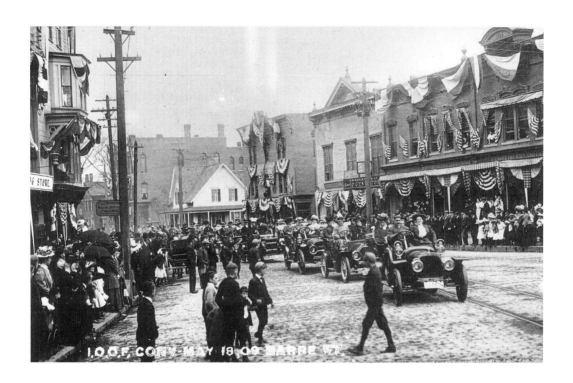

I.O.O.F. CONV. MAY 18, 09 BARRE VT.

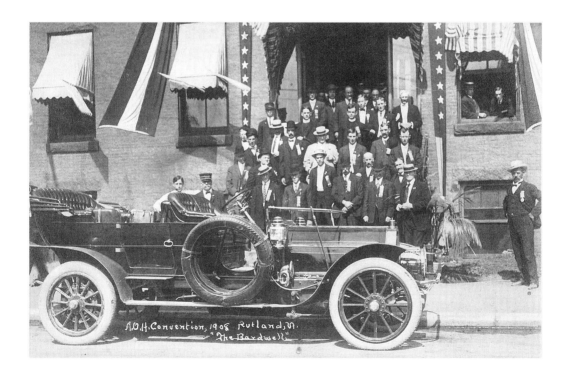

A.O.H. Convention, 1908 Rutland, Vt.
"The Bardwell"

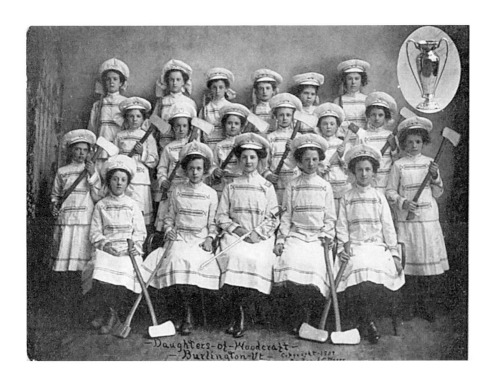

The early part of the twentieth century was a time when everyone seemed to join clubs and fraternal organizations, ethnic, religious, and social, including the Elks, the Masons, the Grange, the Knights of Columbus. (*Top left*) The International Order of Odd Fellows celebrates with a parade in Barre in 1909. Notice the brick pavement, the trolley tracks, the Woolworth five and ten cent store, and the patriotic decorations. (*Courtesy of the Aldrich Public Library, Barre, Vermont.*) (*Bottom left*) The Irish organization the Ancient Order of Hibernians meets for a convention in Rutland in 1908. (*Above*) The Daughters of Woodcraft of Burlington display their axes in this 1909 formal portrait.

(*Above*) The Chautauqua tent in Ludlow in 1914. (*Top and bottom right*) Another kind of culture under a tent, a Holiness camp meeting in Lyndonville, circa 1910.

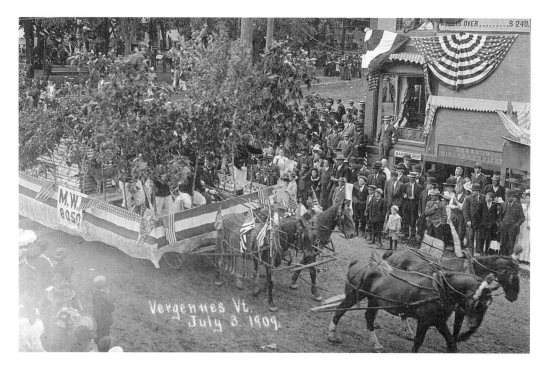

At the Vergennes Fourth of July Parade (held on July 3, 1909), the Modern Woodsmen float passes a bank decorated for the holiday as an attentive audience looks on.

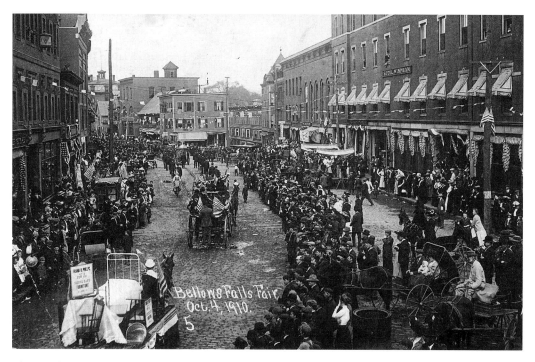

The parade to launch the Bellows Falls Fair, October 4, 1910, proceeds along the brick streets of Bellows Falls.

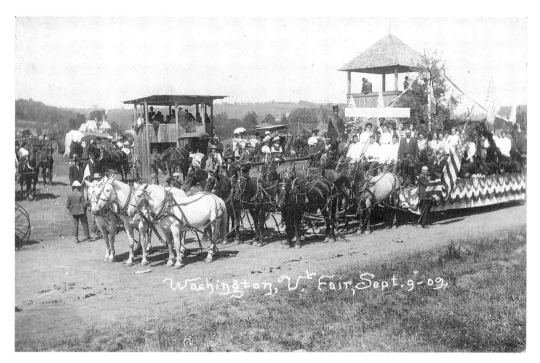

The Washington Fair Parade, September 1909, gets ready to start at the fairgrounds with a float pulled by an eleven-horse team.

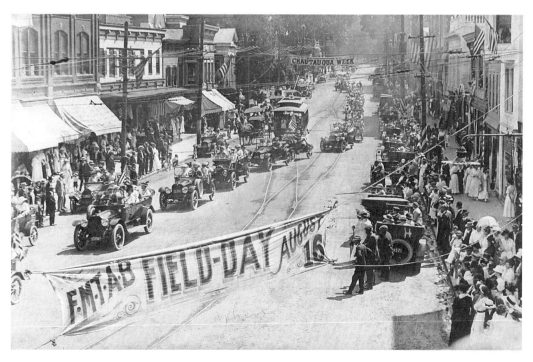

A parade in Bennington, circa 1912, to celebrate Bennington Battle Day, a field day, and Chautauqua Week. A line of autos mixes with horse-drawn vehicles and the trolley as hundreds gather to watch.

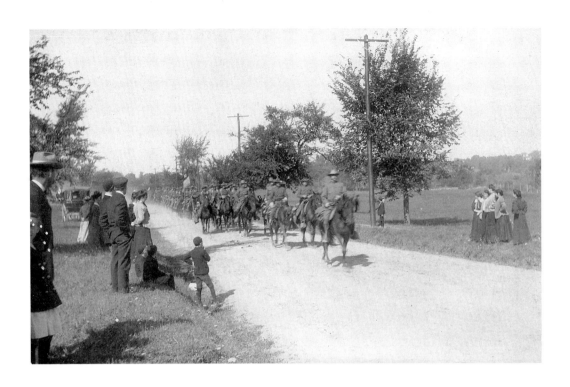

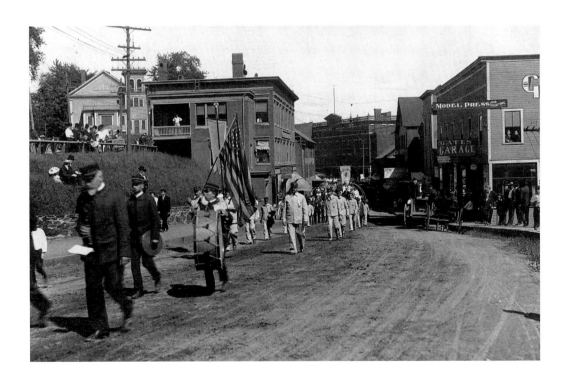

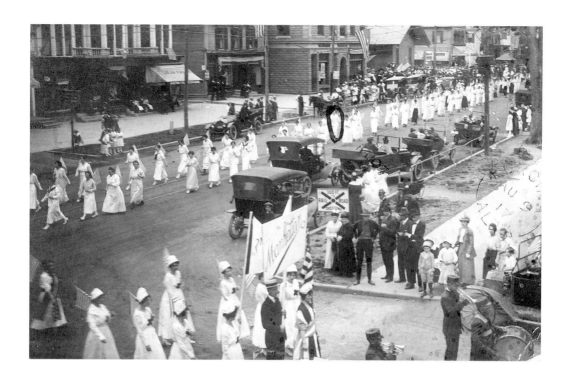

(*Top left*) A unit of the U.S Cavalry stationed at Fort Ethan Allen in Colchester made many appearances at parades and fairs around the state. The cavalry was located at Fort Ethan Allen beginning in 1894 through the influence of Senator and ex–Secretary of War Redfield Proctor. Here the cavalry marches on a road near Bennington while admirers watch, circa 1910. (*Bottom left*) A parade in Bellows Falls staggers along as people perch in apartment windows and stand along the street. The organization behind the band is a unit of the Woodworkers of America from Keene, New Hampshire. (*Above*) June 5, 1917, parade in Poultney to support Woman Suffrage. The message reads: "The Manhattan girls took the prize, have marked myself." She may be referring to a club at the local Troy Conference Academy.

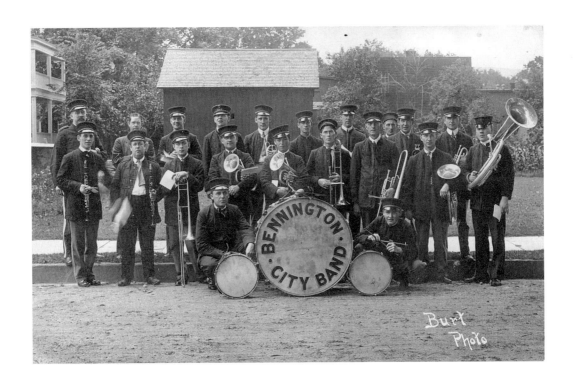

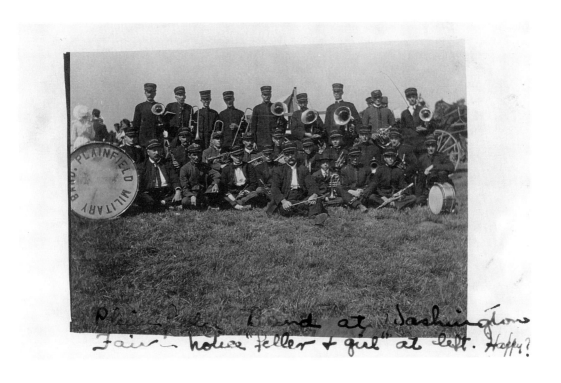

Plainfield Band at Washington
Fair. notice "feller + girl" at left. Happy?

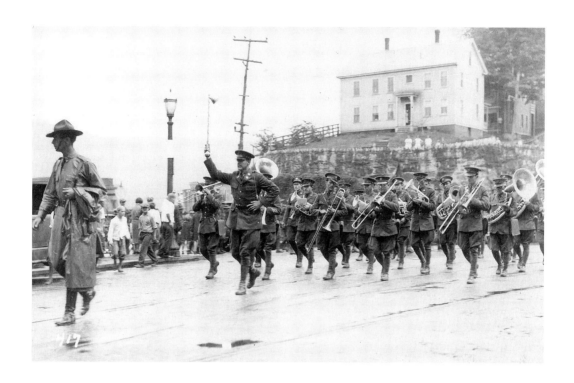

"What does a band mean to a town?" Sherwood Anderson asked. "Better to ask what is a town without a band." Most Vermont towns, even those that were quite small, had bands in the early part of the twentieth century. (*Top left*) The Bennington Band posing for a formal portrait in 1910, and (*bottom left*) the Plainfield band posing a little less formally in 1909. The message scrawled on the front of the photo reads: "Plainfield Band at the Washington [Vt.] Fair. Notice 'feller and girl' at left. Happy?" (*Above*) The U.S. Cavalry Band, performing in the rain at a parade in Brattleboro, added class to any parade, and they all seem to be in step.

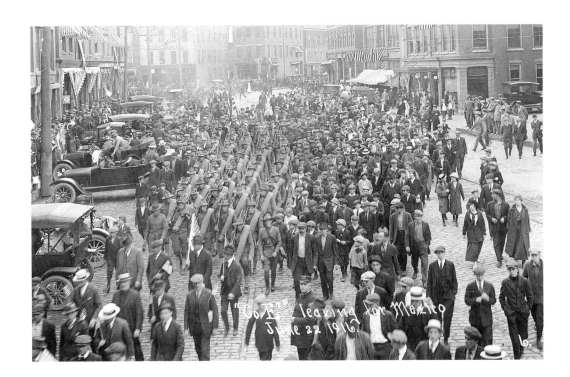

Members of Company E of the Vermont National Guard were among the 100,000 National Guardsmen called to active duty in June 1916 to help guard the Mexican border. President Woodrow Wilson had sent the U.S. Army deep into Mexico in pursuit of General Francisco "Pancho" Villa, after he had raided Columbus, New Mexico. Many Americans opposed Wilson's intervention in Mexico, but the citizens of Bellows Falls turned out in great numbers (*above*) to watch their guardsmen march through the street and board a train for the trip south. They had uniforms far too heavy for the Texas climate, and their duty, which lasted for three months, was filled with boredom, drudgery, and loneliness, but this scene captured by a local photographer and made into a postcard conveys the excitement on the day the Guard left for active duty. (*Top right*) Less than a year later, Vermont National Guard units were called to active duty when the United States entered World War I. Shown is Company A of the Vermont National Guard marching through the streets of Rutland after being called to active duty on the day the United States declared war on Germany. They became part of the 26th Division, called the Yankee Division because there were so many soldiers from New England in it. They saw action and took many casualties at Meuse-Argonne and Cantigny during the Allies' final offensive in the fall of 1918. (*Bottom right*) Volunteers march through the streets of Springfield on their way to enlist shortly after the United States declares war in 1917. Someone has constructed a wooden tank to inspire the men and the crowd.

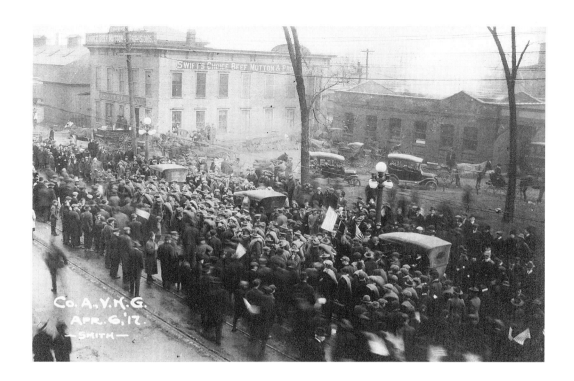

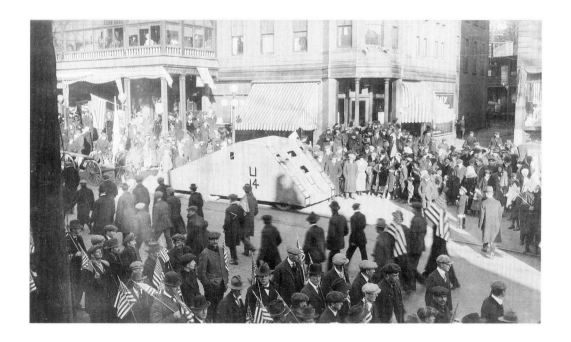

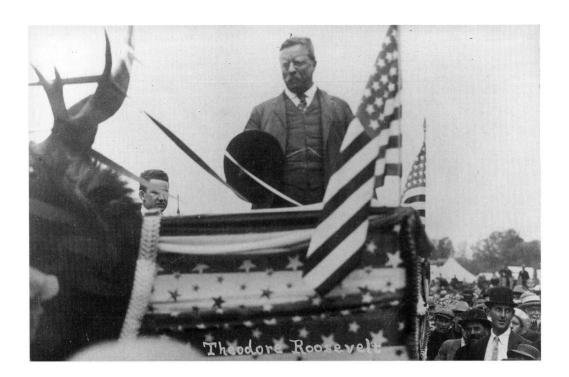

Theodore Roosevelt

Vermont did not usually see many presidential candidates during election campaigns because of its small size and traditional Republican voting record, though Monroe, Grant, Hays, Cleveland, and Harrison did visit the state. Theodore Roosevelt made an extended trip through Vermont in 1902 after he became president. In 1912 Roosevelt, blocked from getting the Republican nomination, walked out of the convention and formed the Progressive Party. He spent three days campaigning in Vermont and made speeches in sixteen towns to enthusiastic audiences. Here, he speaks in Morrisville at the train station next to a moose head, the symbol of the "Bull Moose" Progressive Party. William Howard Taft also campaigned in Vermont.

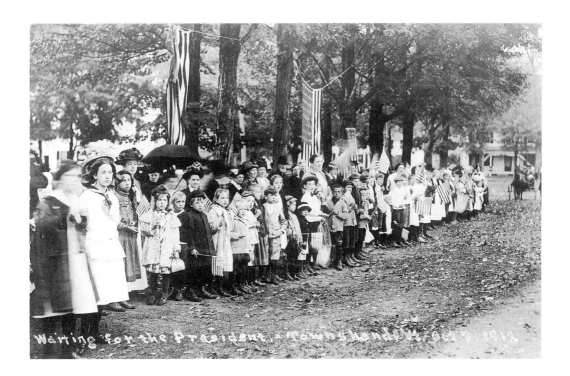

Waiting for the President - Townshend, Vt. Oct. 1912

Schoolchildren wait to greet the president in Townshend. He visited his father's birth-place in West Townshend and also the grave of his great-grandfather. He spent the night of October 7, 1912, in Manchester at Hildene, the home of Robert Todd Lincoln. For all of Roosevelt's efforts, Taft carried Vermont in 1912 by 1,200 votes. The only other state he won that year was Utah, but because Roosevelt split the Republican Party, Woodrow Wilson was elected President.

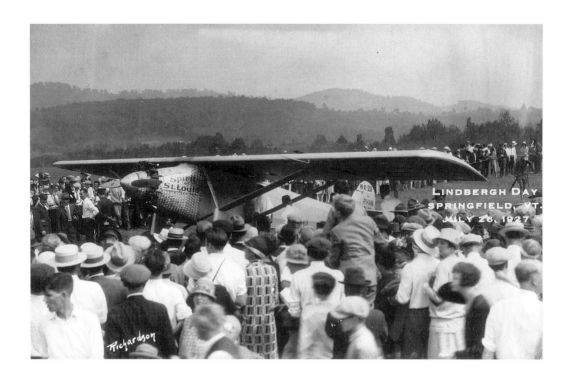

Politicians were not the only celebrities who came to Vermont. After his return from his triumphal flight to Paris in 1927, Charles Lindbergh went on a barnstorming tour around the United States to promote commercial aviation. He started his tour from Mitchell Field on Long Island on July 20, 1927, and a few days later, on July 26, he landed at Springfield, his only stop in Vermont. For this stop, 30,000 people gathered to see the American hero and his plane, *The Spirit of St. Louis*.

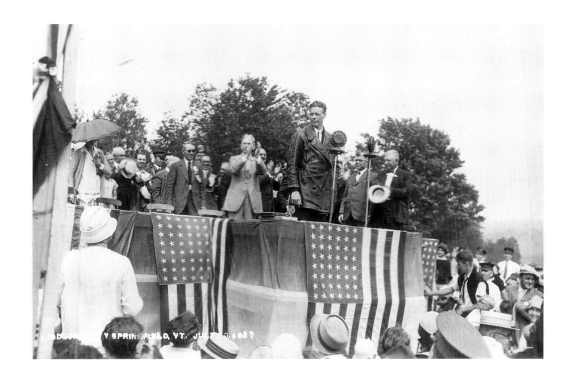

In his speech, he praised the Springfield airport and urged that it be enlarged. He predicted that within a few years one would fly from Springfield to Boston and from there to anywhere in the country. Lieutenant Governor of Vermont S. Hollister Jackson, who introduced Lindbergh, is seen in the light suit clapping in this photo. A few months later he was drowned in Barre during the 1927 flood.

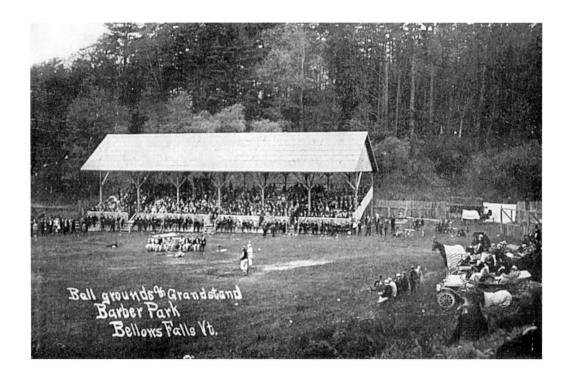

Baseball was an important sport in Vermont early in the twentieth century, despite the short season. In Vermont, players had to wait until the snow melted before swinging at the first pitch. High schools and colleges fielded teams, but often attracting more attention were the town teams made up of players aged eighteen to forty or older. Mills and factories also sponsored teams. Frequently these teams had a paid "ringer" who might turn up playing for one team one week and another the next. One of the famous "ringers" was "Whiskey" Jack Bishop, who pitched for the championship Richford team in 1905 and for Barton in 1908. Legend has it that he could have pitched in the major leagues except for his habit of drinking too much. (*Above*) The ball field at Barber Park between Bellows Falls and Saxtons River. The trolley ran special excursions for baseball games. But not everyone arrived at the game by trolley. The parking lot is filled with a mixture of horses and autos (circa 1910). (*Top right*) The Ludlow town team poses in 1915 in front of a poster for the Rutland Fair. (*Bottom right*) The Barton team is the famous championship team of 1908. Their record was 22–13 with victories over Ludlow, Woodstock, and Barre. The message on the back, sent to Dean Academy in Massachusetts by a ringer from college or prep school, reads: "BL [Barton's Landing] 2, Barton 1, BL 1, Barton 6. Conley of Lawrence [Mass] pitched the first game, I got 1–2 and a single off him. Hatch pitched for us today and Barnicle yesterday. Will be there Saturday morning."

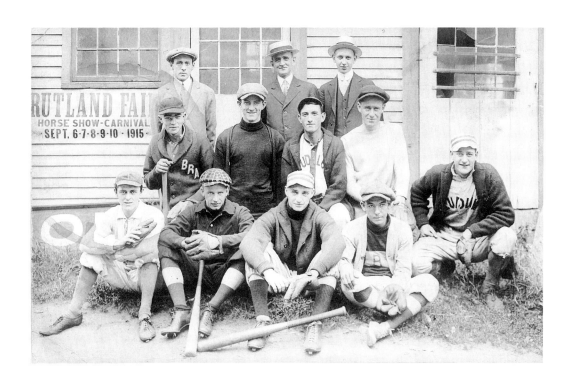

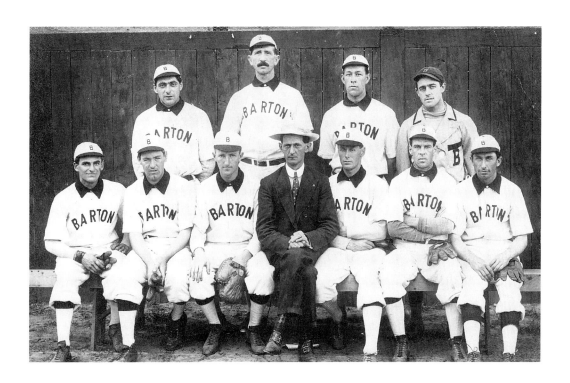

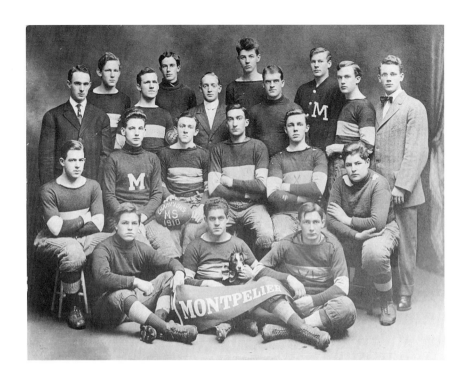

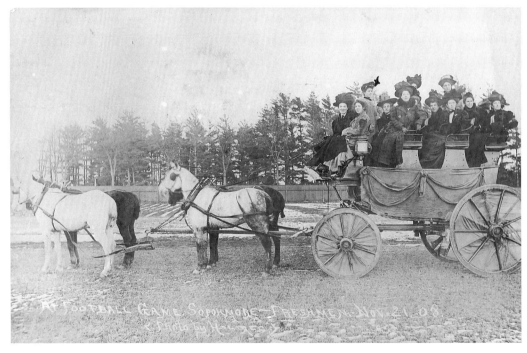

Football was not nearly as popular as baseball in Vermont, but a number of high schools fielded teams. (*Top*) The 1910 Montpelier Seminary team. Notice the uniforms and the shape of the ball. The year 1910 was when Walter Camp began to create the modern game at Yale, but the new plays and the forward pass had probably not reached Vermont. (*Bottom*) Well-dressed coeds ride in style to a Freshman-Sophomore game in 1908 at the University of Vermont.

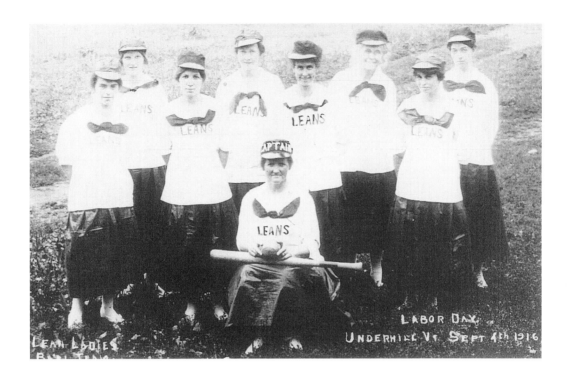

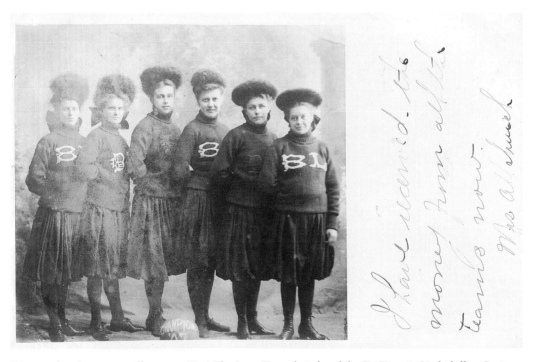

Women played sports as well as men. (*Top*) The Lean Team that played the Fat Team in Underhill on September 4, 1916. *(Courtesy Vermont Historical Society.)* (*Bottom*) Interestingly dressed young ladies posing for the camera in Barton's Landing (now Orleans) in 1907. Are they cheerleaders or basketball players?

15 ≈

The Postcard as Photojournalism

Vermont photographers rushed out to cover disasters. They took pictures of fairs, festivals, and parades, but there was something exciting and especially newsworthy about a train wreck, a fire, or a flood. Nationally, the invention of the halftone process in the 1880s revolutionized journalism. Although illustrators and engravers resisted the new technology, by 1900 halftone prints made from photographs illustrated most of the stories in the major magazines and newspapers.

The halftone process created a new visual reality, as important as the later development of television, but the process was expensive, and most small-town newspapers were slow to adopt the new technique. This allowed the local photographers to fill the need for illustrations, by converting their photographs into postcards, often in a matter of hours. Before the train wreck could be removed, or while the fire still smoldered, the photographer was on the scene selling postcards to the curious observers. They could buy a few cards and send them to their friends, or add them to their own collection. Well into the 1920s, small-town newspapers often could not afford the halftone process so they went without illustrations. Even when the weekly newspaper published halftone illustrations, the photographer could get there first with his postcards, and the photo postcard was clearer and sharper than the halftone print. Years after a disaster, postcard photos of the event would sell well in the photographic shop or the drugstore.

Postcards provide a record of disasters. As late as 1927, when a disastrous flood devastated Vermont, and most local newspapers were capable of publishing halftone illustrations, many photo postcards were

produced and sold. Photographers even turned out sets of postcards to document the damage to Montpelier and other cities and towns. Postcards usually depicted peaceful and pretty scenes, but they could also illustrate the ugliness and fascination of tragedy and disaster.

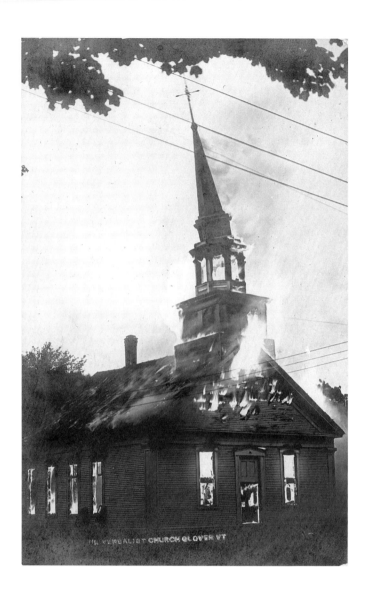

UNIVERSALIST CHURCH GLOVER VT

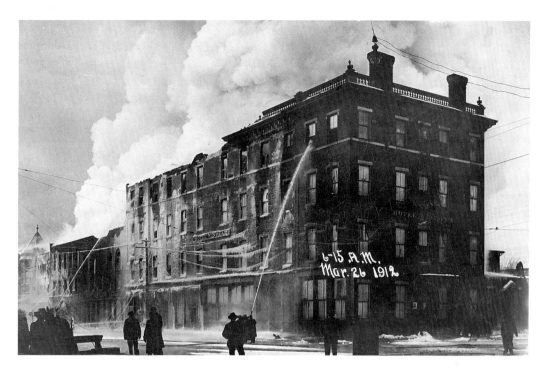

(*Left*) A photographer in Glover captures the steeple of a burning church just as it begins to topple to the ground. (*Above*) In Bellows Falls, a photographer records the Hotel Windham in flames with the firefighters still pouring water on the building. This postcard, sent to Troy, New York, on March 29, 1912, three days after the fire, illustrates the speed with which the postcards could be produced. The message reads: "A picture of the fire at Bellows Falls Monday night." (*Below*) A horse and sleigh silhouetted against the smoldering ruins of a business block in Rutland, February 18, 1906.

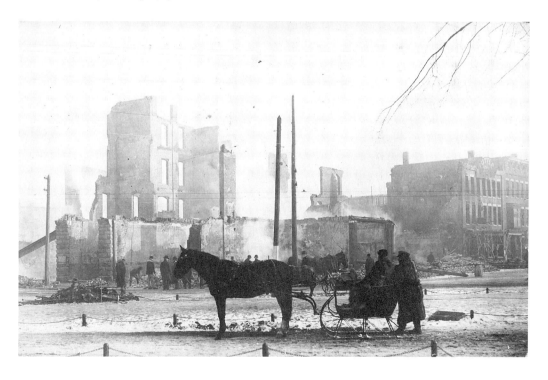

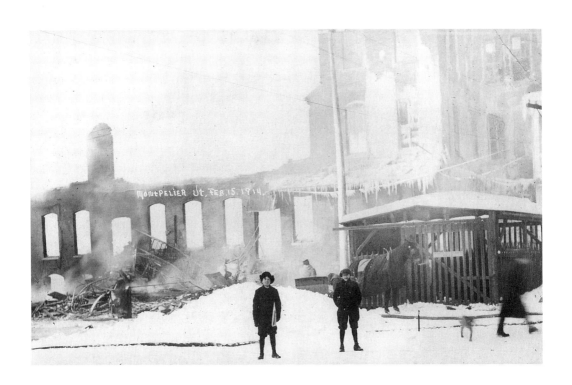

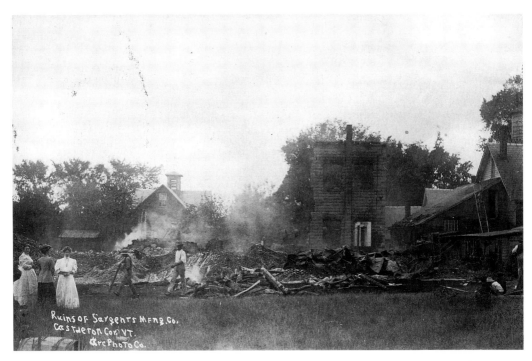

Fires attracted people who stood in front of the ruins to have their picture taken. (*Top*) Two young boys pose in front of a smoldering ruin in Montpelier, February 15, 1914. (*Bottom*) Women in long dresses study the ruins of a manufacturing plant in Castleton, circa 1910.

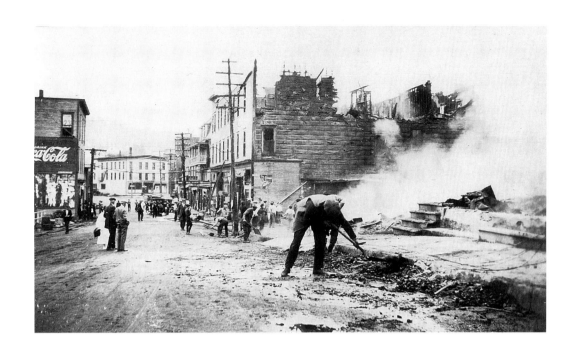

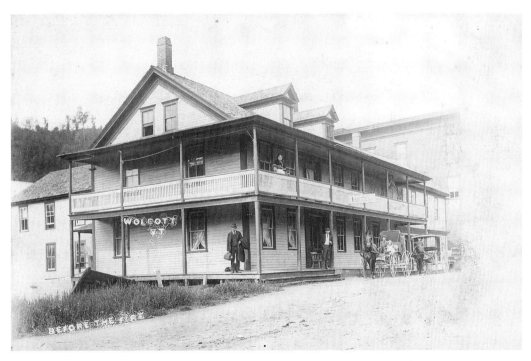

(*Top*) A large portion of the business section of Hardwick burned in July 1923, when fireworks, on sale in one of the stores, exploded. (*Bottom*) After a fire, photographers searched their files for old negatives and turned them into postcards so people could recall what a building once looked like. A hotel in Wolcott "before the fire."

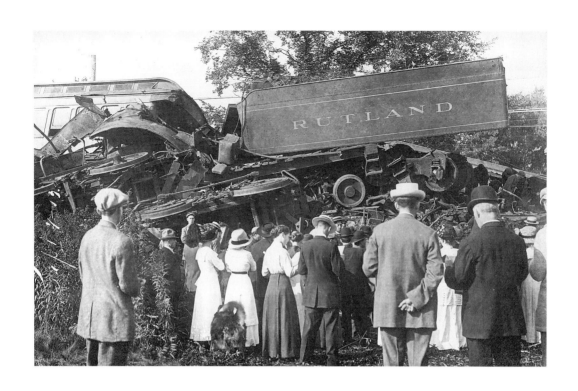

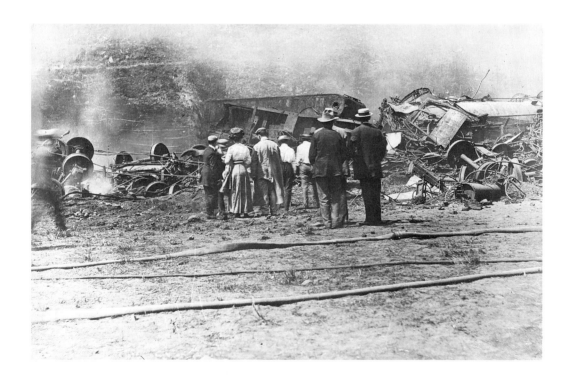

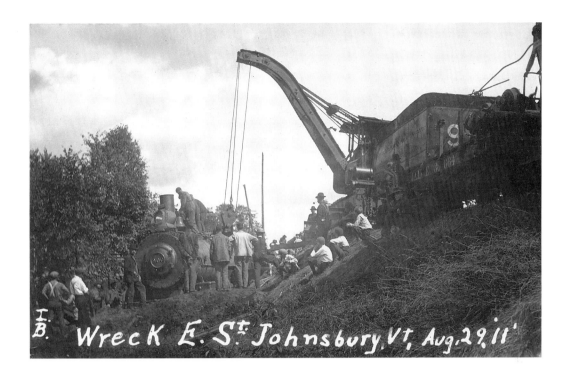

Train wrecks always attracted a crowd. (*Top left*) A wreck on the Rutland Railroad near Bennington, September 17, 1912. Some of the well-dressed observers seem to be reading newspapers, perhaps describing the accident, but at the same time a photographer recorded the scene and made them part of the news. (*Bottom left*) Wreck on the Central Vermont Railroad, August 1910. The message on the card reads: "Worst wreck CV has had for a good many years, only 8 miles from Montpelier." (*Above*) An elaborate crane, mounted on a railroad car, tries to lift a locomotive back onto the track in East St. Johnsbury, August 29, 1911, to the amusement and fascination of a group of young boys and some adults as well.

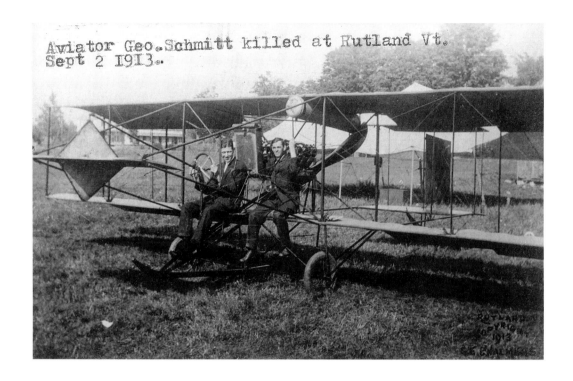

Aviator Geo. Schmitt killed at Rutland Vt.
Sept 2 1913.

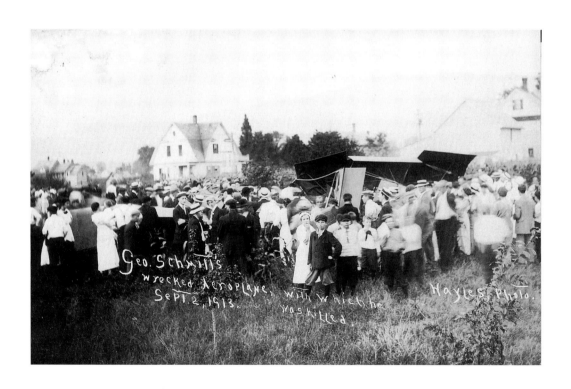

Geo. Schmitt's
wrecked aeroplane, with which he
Sept 2, 1913. was killed. Hayles, Photo.

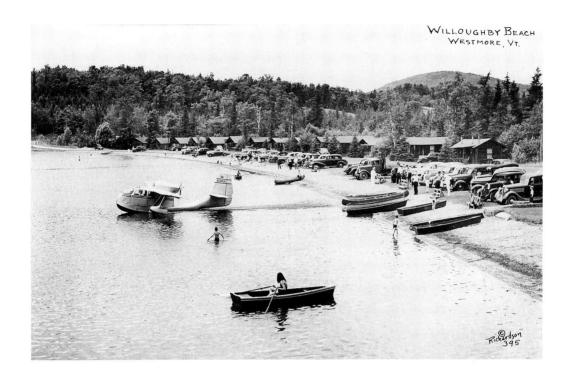

The first airplane flight in Vermont was probably made on September 24, 1910, when Charles Willard of New York landed and took off at the Caledonia Country Fairgrounds in St. Johnsbury. In the years before World War I there were many barnstorming pilots in Vermont. One of them, George Schmitt of Rutland, was killed September 2, 1913, when his plane crashed in Rutland. An enterprising photographer, who had taken a picture of Schmitt and his plane earlier, typed the grim news on a postcard (*top left*). (*Bottom left*) A crowd gathers at the site of the crash. (*Above*) Although not as exciting as a plane crash or the arrival of the *Spirit of St. Louis*, a seaplane that landed on Lake Willoughby in 1935 caused quite a stir.

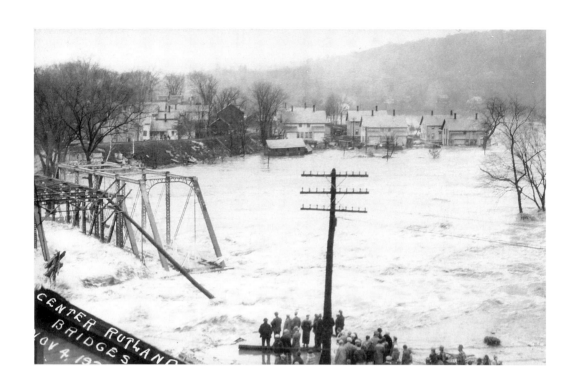

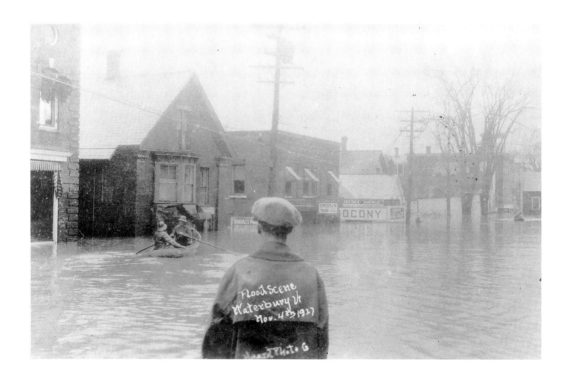

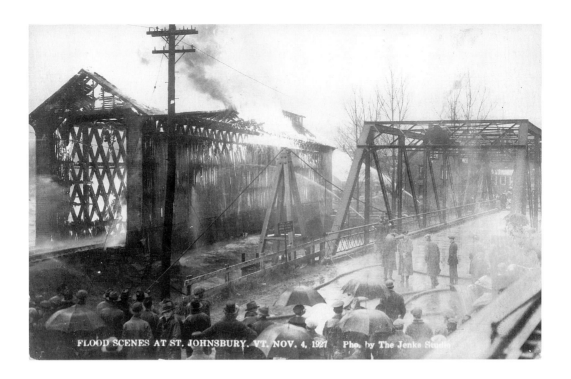

FLOOD SCENES AT ST. JOHNSBURY, VT. NOV. 4, 1927 Pho. by The Jenks Studio

The Flood of 1927 was one of the worst disasters ever to strike Vermont. October had been an unusually wet month in the state, and on November 2 it started to rain and continued for forty-eight hours. Rivers and streams overflowed, destroying houses, factories, and businesses. Eighty-four people were killed, including the Lieutenant Governor of the state, S. Hollister Jackson; fifty-four died in the Winooski Valley alone. Over 1,200 bridges were washed out, and the Central Vermont lost more than 250 miles of track. The property loss was placed at over 30 million dollars (in 1927 dollars.) The flood waters in Montpelier were 12 feet above the sidewalks, and at the state hospital in Waterbury the water rose to the second floors of the buildings. Nationally, the Vermont flood did not compare to the Mississippi Valley flood of the spring of 1927, but it was the greatest natural disaster to strike Vermont. The flood brought out the photographers in large numbers, and they turned their photographs into postcards. (*Top left*) The raging flood at Rutland. (*Bottom left*) Boats try to rescue stranded people in Waterbury, while one observer looks on. (*Above*) In St. Johnsbury, a fire destroying a covered bridge compounds the disaster. The bridge was set on fire to prevent it from crashing into and destroying the new bridge.

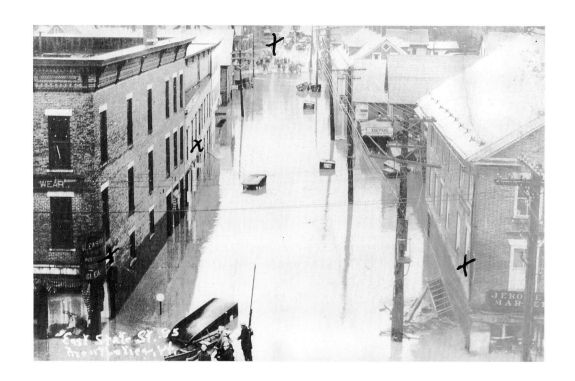

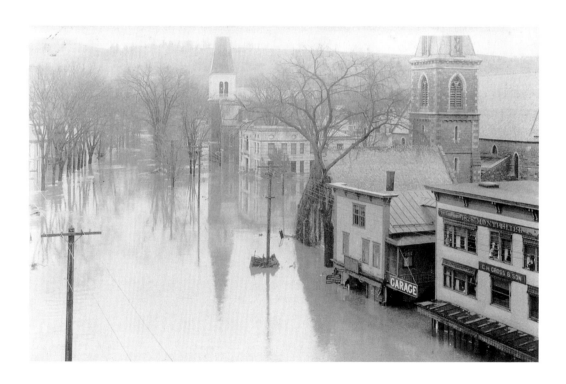

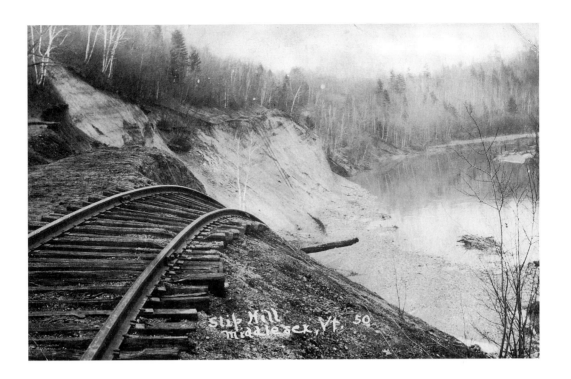

(*Top and bottom left*) The water rose rapidly in Montpelier, covering trucks, cars, and the first floors of many businesses. (*Above*) The tracks of the Central Vermont Railroad at Middlesex disappear, symbolizing the massive destruction to the railroads in the state.

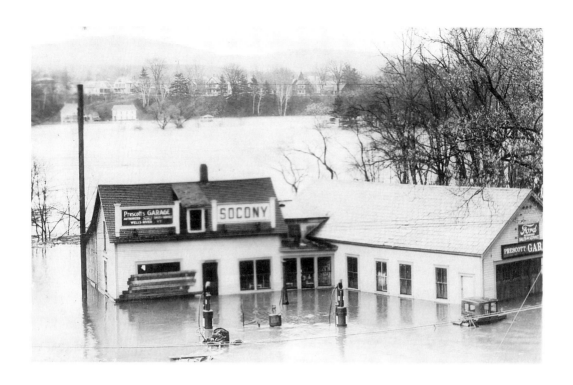

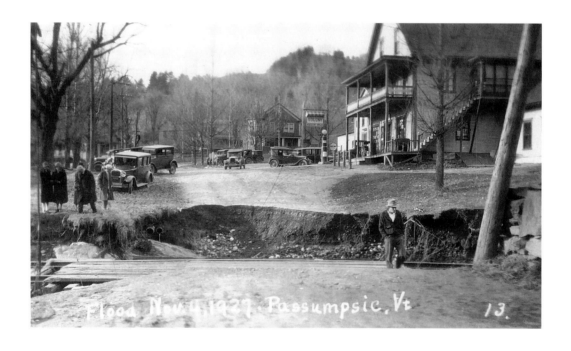

Flood Nov 4 1927 Passumpsic, Vt 13.

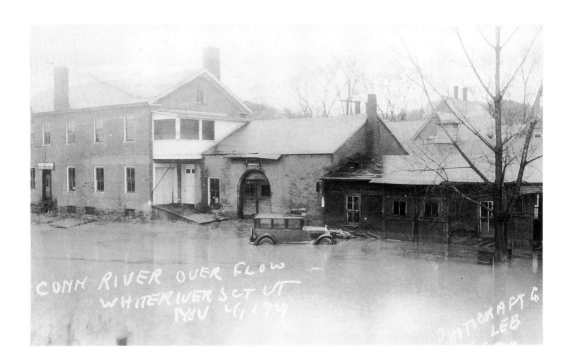

(*Top left*) The Connecticut River engulfs Prescott's Garage in Wells River. (*Bottom left*) Many towns discovered huge craters when the flood waters receded, like this one in Passumpsic. (*Above*) Both the White River and the Connecticut overflowed in White River Junction.

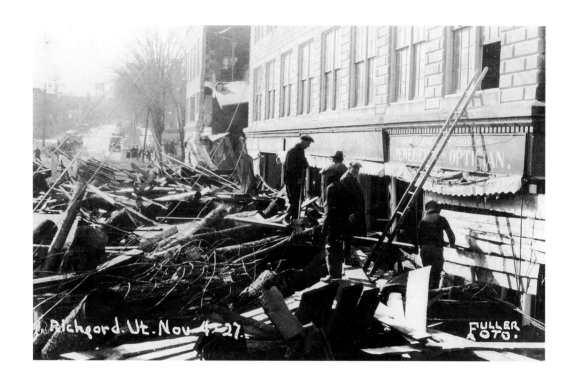

Richford. Vt. Nov. 4-27. FULLER FOTO.

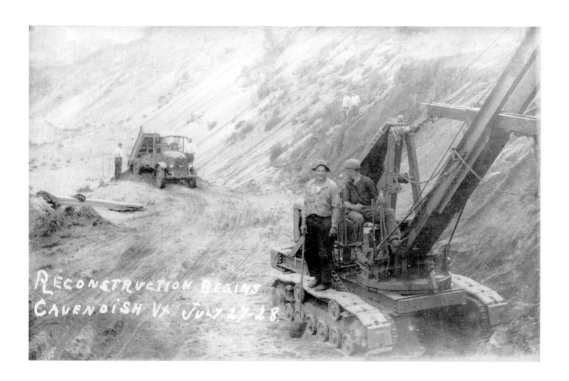

RECONSTRUCTION BEGINS
CAVENDISH VT. JULY 27-28.

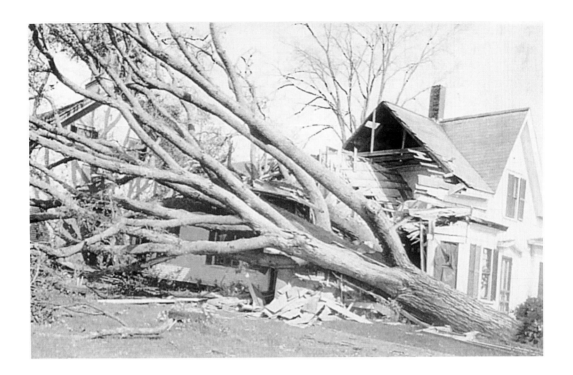

Vermont recovered quite rapidly from the flood. (*Top left*) Debris on Main Street in Richford after the Flood of 1927. (*Bottom left*) Men and modern equipment get to work in Cavendish in the summer of 1928 to repair the damage. Despite the myth that Vermonters recovered from the flood because of their "indomitable spirit," and the working of the free enterprise system, most of the cost of rebuilding was contributed by the state and federal governments. In some ways the flood was a blessing in disguise, because the washed-out dirt roads were replaced with concrete or asphalt roads and more than 1,000 modern bridges were constructed. (*Above*) Another major disaster occurred in the fall of 1938, when a freak hurricane devastated New England. There was massive destruction along the coast on September 21, 1938, and 680 lost their lives. Only five were killed in Vermont, but the estimated damage ran to over 12 million dollars. Huge numbers of trees were uprooted, like this giant elm in Fairlee, and a great many sugar orchards destroyed. But in contrast to the 1927 flood, very few postcards were produced. Perhaps this was because, with modern equipment and the halftone process, newspaper and magazine illustrations replaced the photographic postcards as a way to record disasters. (*Courtesy Vermont Historical Society.*)

16 ≈≈≈

Vermont Faces

Professional photographers recorded Vermont faces in the age of the postcard. Some families still went to the photographer's studio for formal portraits, wedding pictures, or that special photo when a child turned one year old, or a twelve-year-old girl had her first communion. But increasingly, in the early part of the twentieth century, the photographer went out into the community to record a family standing proudly in front of their house, members of a Sunday school class standing stiffly in their best clothes, a basketball team, or the cast of a high school play. Many of these photographs made by local professionals were produced in a postcard format so they could be sent out to friends. In addition, a great many amateurs took up photography. They recorded family reunions, took casual portraits of young children, and developed their photos on postcard paper to send out as Christmas cards or to put in their family albums. Most people were more relaxed when a friend or family member was behind the camera rather than a professional, but by 1910 almost all, including the children, were comfortable having their picture taken.

As we look at these photo postcards today, we see faces from the past. The clothes look old-fashioned, the hairstyles a little strange, and the artifacts antique. The camera has preserved a moment in time and frozen men and women, boys and girls, smiling, laughing, or looking serious at the camera. There is something arresting about family photos even if we don't know the family members, and something intriguing about people looking out at us from the past.

Photographers also took pictures of politicians and celebrities and

then marketed them in a postcard format as souvenirs. Probably the most famous Vermont face of the first half of the twentieth century was Calvin Coolidge. He was born on the Fourth of July, 1872, at Plymouth Notch, Vermont, a village consisting of a store, a school, a church, and three houses. Coolidge was a fifth-generation Vermonter. But like so many Vermonters he left home, first to attend Black River Academy in Ludlow, and, briefly, St. Johnsbury Academy, and then to go to Amherst College. He read law in Northhampton, Massachusetts, and eventually became governor of Massachusetts, and in 1921 vice-president of the United States. He became President in 1923 when Warren G. Harding died suddenly. Coolidge rose to political prominence in Massachusetts, but he was always associated with Vermont, not only because it was his birthplace, but also because he was sworn in as President of the United States in his native state. He happened to be visiting his father in Plymouth Notch when word came that Harding had died. His father, a justice of the peace, swore in his son to the highest office in the land in the family homestead early in the morning of August 3, 1923, by the light of a kerosene lamp. It was the kind of event that created an instant legend, and it added to Coolidge's image as a taciturn, simple native of Vermont who represented all of the rural virtues that were fast disappearing in an urban, industrial age. Coolidge endeared himself to Vermonters when he visited the state the year after the disastrous flood of 1927 and announced at Bennington: "Vermont is a state I love. . . . I love Vermont because of her hills and valleys, her scenery and invigorating climate, but most of all because of her indomitable people."

Dorothy Canfield Fisher, the noted writer who lived in Arlington, argued that it was the Coolidge presidency that put Vermont on the map. The Coolidge homestead became a tourist attraction, almost a shrine, and photos of the homestead, the local store, and the church were turned into souvenir postcards, as were photographs of the President pretending to be a farmer. Coolidge was actually more comfortable around the corporate executives and captains of industry than he was talking to Vermont farmers, but the image of Coolidge the simple, rural Vermonter persists to this day and helps to define what it means to be a Vermonter for many people.

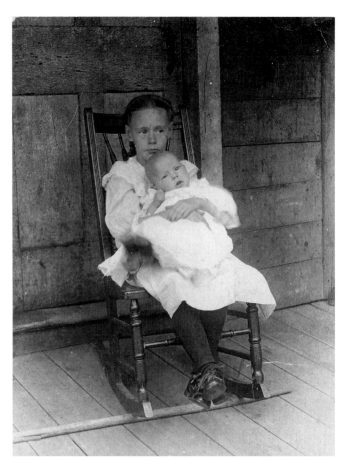

A young girl with baby brother, Wardsboro Center, 1909.

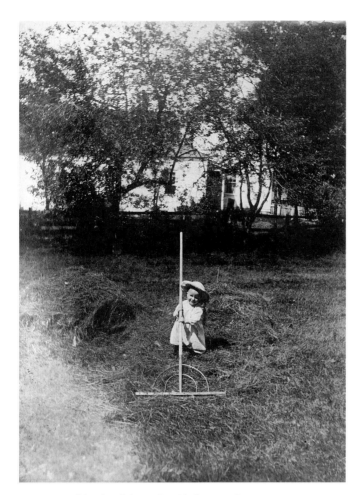

A one-year-old girl with hay rake, Chelsea, 1908.

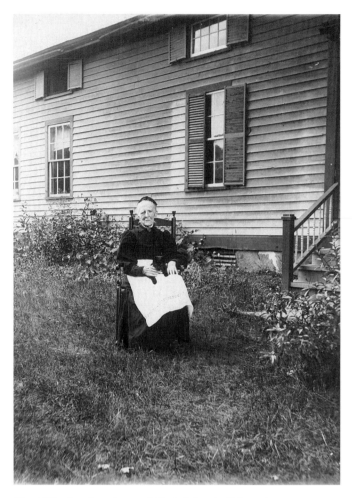

"Aunt Eliza" and a cat named "Judiah Sambo," August 1909.

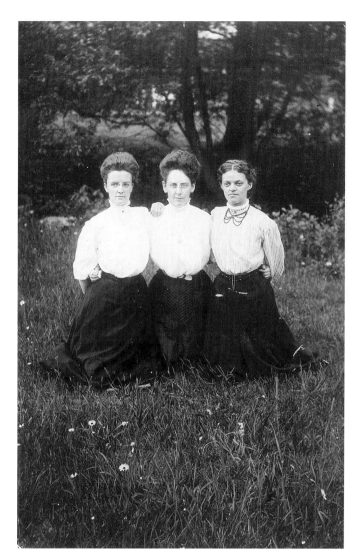

Three friends in Washington, Vermont, June 30, 1909. "This is Bernice Colby and Ida Washburn with me. We had them taken at Washington just for fun. Lots of love, Edna."

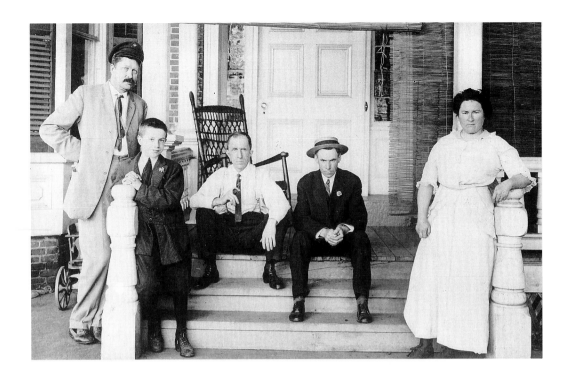

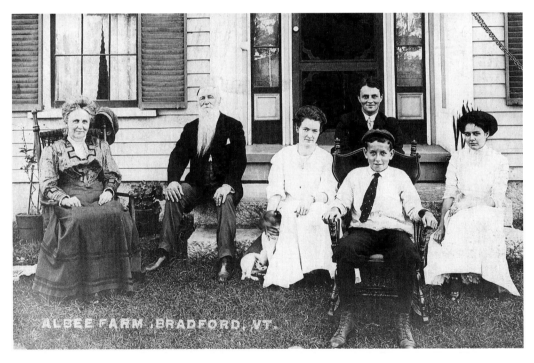

(*Top*) A family gathers on the front porch in Ludlow, circa 1910. (*Bottom*) The Albee family poses for a family portrait on the steps of their farm house in Bradford, circa 1910.

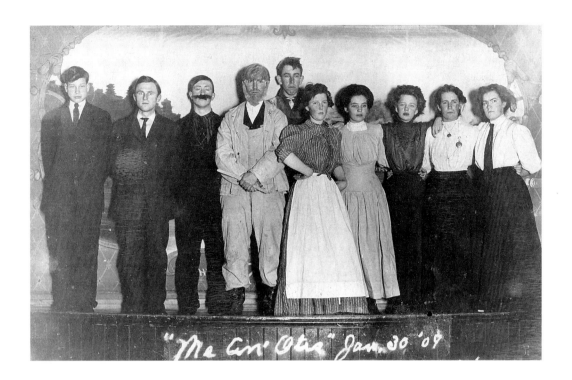

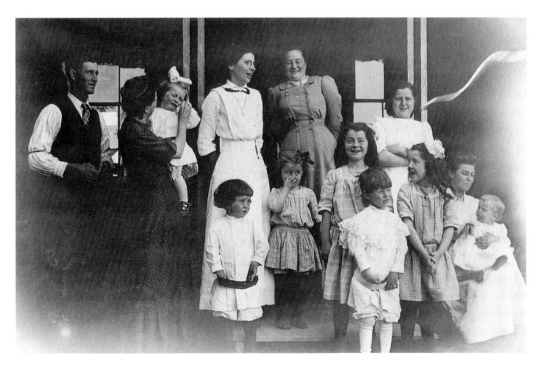

(*Top*) A high school play in Danville, January 30, 1909. (*Bottom*) An unusual family portrait because the photographer caught most of the family members in an unguarded moment, crying, laughing, frowning. Probably Peacham, circa 1910.

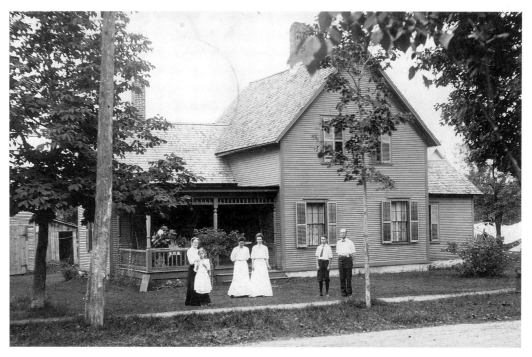

A carefully posed family in front of their house in Bristol, 1909. The message on the card sent to Schroon Lake, New York, reads: "Dear Millie, I thought by this time you would like to look at some old friends."

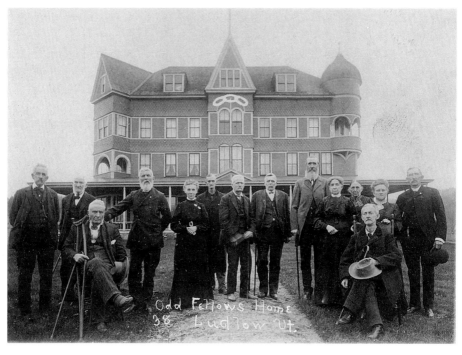

The residents of an "old folks home" in Ludlow, run by the International Order of Odd Fellows, pose formally and with dignity, circa 1910.

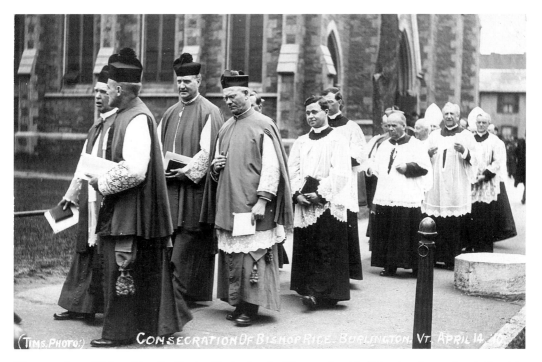

"Consecration of Bishop Rice, Burlington Vt. April 14, '10." In 1910 about half the church members in the state were Catholic.

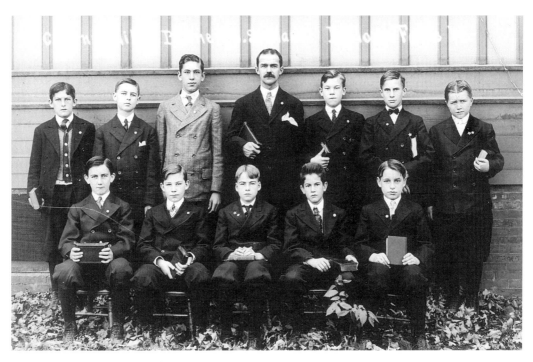

C. B. Underhill's Banner Sunday School Class in Bellows Falls, circa 1910. The young men with carefully combed hair and their best Sunday suits, look almost too well-behaved to be authentic.

A studio portrait of a young, fashionably dressed woman in Brattle-
boro, 1908. Studio portraits were an important part of the postcard
phenomenon.

During World War I many servicemen had their photos taken in studios near where they were stationed. Many of the photos were produced in a postcard format so they could be mailed home. The young officer on the right is my father, Harold F. Davis (1894–1977). The photo was taken in Newport News, Virginia, in 1918 and mailed home to his family in Hardwick.

The faculty at Thetford Academy, circa 1910. "Young woman in back row, Helen Margaret Wood."

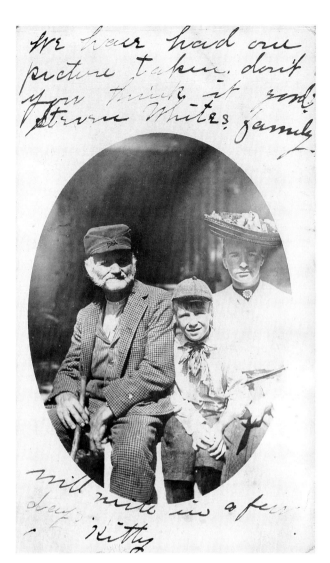

The Steven White family, West Rupert, 1907. "We have had our picture taken, don't you think it good."

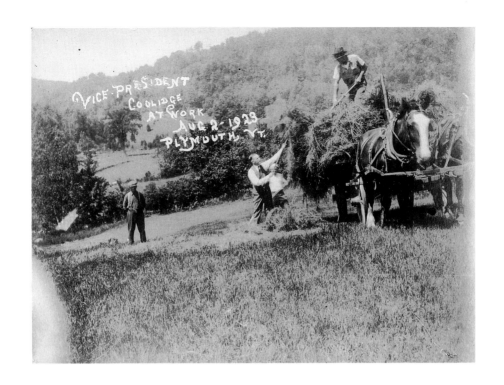

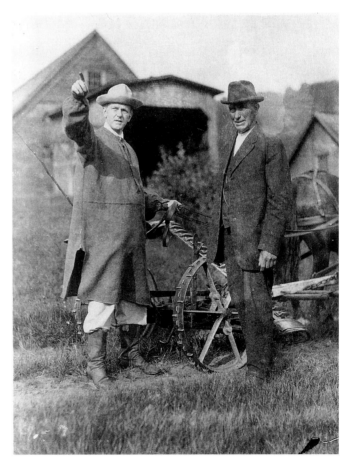

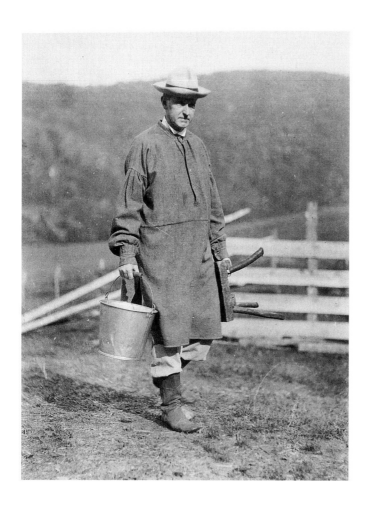

(*Top left*) Calvin Coolidge, dressed in shirt, tie, and vest, pitching a fork load of hay onto a wagon in Plymouth Notch on the day before he became President of the United States. (*Bottom left*) President Coolidge dressed in his farm smock and hat, talking to his father near a mowing machine, 1924. (*Above*) Another of the series of Coolidge in his smock. Here he is carrying a milk pail and stool, on his way to demonstrate that he remembers how to milk a cow.

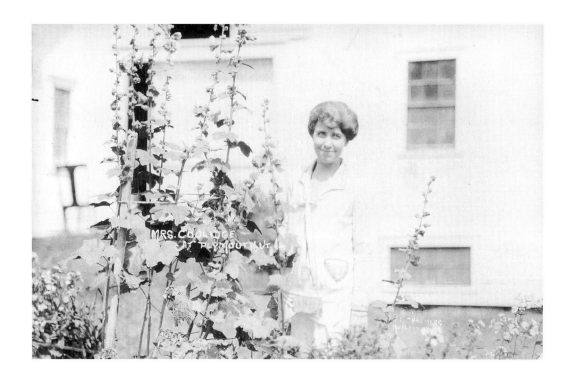

Grace Goodhue Coolidge (1879–1957) was born in Burlington and graduated from the University of Vermont in 1902. She learned sign language and taught at the Clark Institute for the Deaf in Northhampton, Massachusetts. She married Calvin Coolidge in 1905. She wore fashionable clothes, and her friendly, exuberant personality made her an excellent hostess. The president prohibited his wife from publicly expressing her political views, from speaking on the radio, or from giving interviews, but on one occasion at a luncheon for newspapermen she gave a five-minute address using sign language.

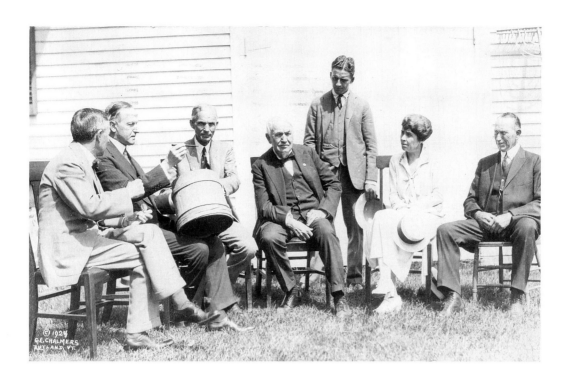

Beginning in 1920, Henry Ford, Thomas Edison, and Harvey Firestone went on auto trips together to various parts of the country. In the summer of 1924 they stopped in Plymouth to see President Coolidge, who was vacationing at the family homestead. G. E. Chambers, a Rutland photographer, took a series of photographs of the celebrities and made them into postcards. In this photograph, the President is autographing a wooden sap bucket to be placed in Ford's new museum at Greenfield Village near Detroit. From left to right: Harvey Firestone, President Coolidge, Henry Ford, Thomas Edison, Russell Firestone, Grace Coolidge, and John Coolidge, the President's father.

Epilogue

The postcards reproduced in this book represent only a tiny percentage of those manufactured. Postcards were often treated as worthless, throw-away items and were discarded. But many have survived, and they are out there waiting to be searched out and collected. Most of the postcards in this book come from the "golden age," 1907 to 1915, but I also have included many from the 1920s and 1930s as well as a few from the 1940s. With the exception of those in the color portfolio, all the cards are black and white, and most are real photo cards. However, some other categories are not included. A new process developed about 1930 led to the printing of cards on high-rag-content paper, which produced a linen-like finish. These "linens" were produced mostly between 1930 and 1945. Although many collectors regard them as gaudy and cheap, they record the way Vermont looked during the Depression and World War II. We are so accustomed to thinking of the 1930s and the war years in terms of black-and-white images that the linen postcards come as a shock. These bright, romantic, sometimes airbrushed, cards give us another view of this period. They should be collected, studied, and interpreted; and they are inexpensive—a dollar or less per card.

The last fifty years of postcard production have been dominated by the photochrome or color photo process. Most postcards now available in drugstores, hotels, and gift shops fall into this category and are sometimes called "rack cards" by the dealers. These cards are readily available, but, as with the "linens," they are in their own way just as fascinating as the early, real photo cards. They depict the continually changing

landscape, the vernacular and roadside architecture, the motels, gasoline stations, diners, fast-food restaurants, shopping malls, cars, urban sprawl, expressways, resorts, and condominiums.

The 1960s are as remote for today's college students as the first decade of the twentieth century is for those who lived through World War II. Postcards document the 1960s from protest marches to hairstyles. They record the pastel shades, mini-skirts, and autos with fins. We should be collecting postcards from the sixties and from other recent periods, for they will be just as interesting in fifty years as the postcards from the golden age are today. In addition to the color photo cards, local photographers are creating a new generation of real photo cards. Also, new cards made from old photographs are increasingly popular.

Cell phones, e-mail, and fax machines have taken over some of the functions of postcards in the modern world. We have other ways of staying in touch with friends and family, but we still buy postcards when we travel and send them off to our friends to announce: "Having wonderful time. Wish you were here."

Selected References

POSTCARDS

Allen, James T., et al. *Without Sanctuary: Lynching Photography in America.* Santa Fe, N. Mex.: Twin Palms Publishers, 2000.

Blake, Jody, and Jeannette Lasanky. *Rural Delivery: Real Photo Postcards from Central Pennsylvania, 1905–1935.* Lewisburg, Pa.: Union County Historical Society, 1996.

Bogdan, Robert. *Exposing the Wilderness: Early-Twentieth-Century Adirondack Postcard Photographers.* Syracuse: Syracuse University Press, 1999.

Evans, Walker. "Main Street Looking North from Courthouse Square: A Portfolio of American Picture Postcards." *Fortune* 37 (May 1948), 77–83.

Geary, Christraud M., and Virginia-Lee Webb. *Delivering Views: Distant Cultures in Early Postcards.* Washington, D.C.: Smithsonian Institution Press, 1998.

Miller, G., and D. Miller. *Picture Postcards in the United States, 1883–1918.* New York: Crown, 1976.

Morgan, Hal, and Andreas Brown. *Prairie Fires and Paper Moons: The American Photograhic Postcard, 1900–1920.* Boston: David R. Godine, 1981.

Philips, Tom. *The Postcard Century: 2000 Cards and Their Messages.* New York: Thames and Hudson, 2000.

Ryan, D. B. *Picture Postcards in the United States, 1893–1918.* New York: C. N. Porter, 1982.

VERMONT HISTORY

Albers, Jan. *Hands on The Land: A History of the Vermont Landscape.* Cambridge, Mass.: MIT Press, 2000.

Barron, Hal S. *Those Who Stayed Behind: Rural Society in Nineteenth-Century New England*. New York: Cambridge University Press, 1984.

Bassett, T. D. Seymour. *The Growing Edge: Vermont Villages, 1840–1880*. Montpelier: Vermont Historical Society, 1992.

Crane, Charles Edward. *Winter in Vermont*. New York: Alfred A. Knopf, 1947.

Graff, Nancy Price, ed. *Celebrating Vermont: Myths and Realities*. Middlebury, Vt.: Christian A. Johnson Memorial Gallery and Middlebury College, 1991.

Graffagnino, J. Kevin. *Vermont in the Victorian Age: Continuity and Change in the Green Mountain State, 1850–1900*. Rutland: Vermont Heritage Press, 1985.

Graffagino, J. Keven, Samuel B. Hand, and Gene Sessions. *Vermont Voices: 1609 Through the 1990s: A Documentary History of the Green Mountain State*. Montpelier: Vermont State Historical Society, 1999.

Hill, Ralph Nading. *Vermont Album: A Collection of Vermont Photographs*. Brattleboro, Vt.: Stephen Greene Press, 1974.

Jennison, Peter S. *Roadside History of Vermont*. Missoula, Mont.: Mountain Press, 1989.

Jones, Robert C. *Railroads of Vermont*, 2 vols. Shelburne, Vt.: New England Press, 1993.

Klyza, Christopher McGory, and Stephen C. Trombulak. *The Story of Vermont: A Natural and Cultural History*. Hanover, N.H.: University Press of New England, 1999.

Lipke, William C., and Philip N. Grime. *Vermont Landscape Images, 1776–1976*. Burlington, Vt.: Robert Hull Fleming Museum, 1976.

Meeks, Harold A. *Time and Change in Vermont: A Human Geography*. Chester, Conn.: Globe Pequot Press, 1986.

Morrissey, Charles T. *Vermont: A History*. New York: W. W. Norton, 1981.

Muller, H. Nicholas III, and Samuel B. Hand. *In a State of Nature: Readings in Vermont History*. Monpelier: Vermont Historical Society, 1982.

Nutting, Wallace. *Vermont Beautiful*. Framingham, Mass.: Old America Co., 1922.

Rozwenc, Edwin C. *Agricultural Policies in Vermont, 1860–1945*. Montpelier: Vermont Historical Society, 1981.

Stone, Arthur F. *The Vermont of Today: With Its Historic Background, Attractions and People*. New York: Lewis Historical Publishing Co., 1929.

Swift, Esther Munroe. *Vermont Place-Names: Footprints of History*. Monpelier: Vermont Historical Society, 1977.

Vermont, Federal Writers' Project of the WPA. *Vermont: A Guide to the Green Mountain State*. Boston: Houghton Mifflin, 1937.

Visser, Thomas Durant. *Field Guide to New England Barns and Farm Buildings*. Hanover, N.H.: University Press of New England, 1997.

Wilson, Harold Fisher. *The Hill Country of Northern New England: Its Social and Cultural History, 1790–1930.* New York: Columbia University Press, 1936.

Wriston, John A. *Vermont Inns and Taverns, Pre-Revolution to 1925: An Illustrated and Annotated Checklist.* Rutland, Vt.: Academy Books, 1991.

SOCIAL AND CULTURAL HISTORY

Allen, E. John B. *From Skisport to Skiing: One Hundred Years of an American Sport, 1840–1940.* Amherst: University of Massachusetts Press, 1993.

Atherton, Lewis. *Main Street on the Middle Border.* Bloomington: Indiana University Press, 1954.

Belasco, Warren James. *Americans on the Road: From Autocamp to Motel, 1910–1945.* Baltimore, Md.: Johns Hopkins University Press, 1979.

Brown, Dona. *Inventing New England: Regional Tourism in the Nineteenth Century.* Washington, D.C.: Smithsonian Institution Press, 1995.

Carlebach, Michael L. *American Photojounalism Comes of Age.* Washington, D.C.: Smithsonian Institution Press, 1997.

Flink, James J. *The Car Culture.* Cambridge, Mass.: MIT Press, 1975.

Glassberg, David. *American Historical Pageantry: The Uses of Tradition in the Early Twentieth Century.* Chapel Hill: University of North Carolina Press, 1990.

Hales, Peter Bacon. *Silver Cities: The Photography of American Urbanization, 1939–1915.* Philadelphia: Temple University Press, 1984.

Green, Harvey. *The Uncertainty of Everyday Life, 1915–1945.* New York: Harper Collins, 1992.

Jakle, John A., and Keith A. Sculle. *The Gas Station in America.* Baltimore, Md.: Johns Hopkins University Press, 1994.

Liebs, Chester H. *Main Street to Miracle Mile: American Roadside Architecture.* Baltimore, Md.: Johns Hopkins University Press, 1995.

Newhall, Beaumont. *The History of Photography.* New York: Museum of Modern Art, 1982.

Ohmann, Richard. *Selling Culture: Magazines, Markets, and Class at the Turn of the Century.* New York: Verso, 1996.

Schlereth, Thomas J. *Victorian America: Transformation in Everyday Life, 1876–1915.* New York: Harper Collins, 1991.

Stilgoe, John R. *Metropolitan Corridor: Railroads and the American Scene.* New Haven, Conn.: Yale University Press, 1983.

Truettner, William H., and Roger Stein, eds. *Picturing Old New England: Image and Memory.* New Haven, Conn.: Yale University Press, 1999.

Index